D1389754

LOCOMOTIVES

Hertfordshire

RAIL
Printed :

10/11

OVS
385.
094
FEN

Please renew/return this item by the last date shown.

So that your telephone call is charged at local rate, please call the numbers as set out below:

	From Area codes 01923 or 020:	From the rest of Herts:
Renewals:	01923 471373	01438 737373
Enquiries:	01923 471333	01438 737333
Textphone:	01923 471599	01438 737599

L32 www.hertsdirect.org/librarycatalogue

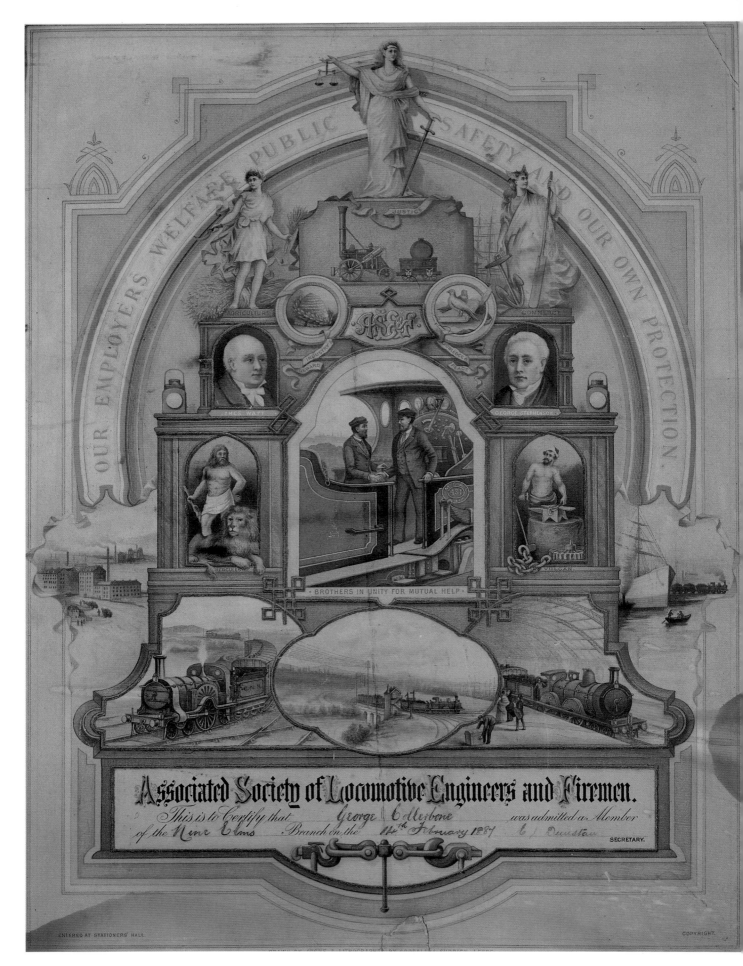

FRONT ENDPAPER
Poster, 1020 x 1240mm, 1961.

ABOVE
Membership certificate
420 x 317mm, 1887.
Courtesy Roy Chambers

RIGHT
Printer's trains by Caslon.
Actual size, 1854

RAILWAY
Printed Ephemera.

Being a tragi-comic picture of the rise and fall of the railways in Great Britain deduced from some of the bits and pieces of paper they left behind by

WILLIAM FENTON

With a foreword by John Lewis FSIA

THE ANTIQUE COLLECTORS' CLUB

© 1992 Ernest William Fenton.
World copyright reserved.
First published 1992.

ISBN 1 85149 137 6

385'.0941

All rights reserved. No part of this publication may be
reproduced, stored in a retrieval system or transmitted
in any form or by any means, electronic, mechanical,
photocopying, recording or otherwise, without the
prior permission of the publisher.

British Library CIP Data
Fenton, William
 Railway Printed Ephemera
 I. Title
 385.0941

Published by the Antique Collectors' Club Ltd.

Printed in England by the Antique Collectors' Club Ltd.
5 Church Street, Woodbridge, Suffolk, IP12 1DS.

Contents

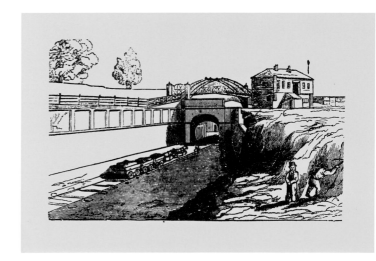

THIS PAGE
The West London Railway under
construction near Kensall Green.
Actual size, c.1843.

FACING PAGE
The entrance to Primrose Hill tunnel,
London and Birmingham Railway.
Actual size, c.1840.

Foreword

Printed ephemera really comes into its own in the nineteenth century and nowhere more so than in recording the birth and growth of the railways; with prospectuses, notices of meetings, share certificates, pamphlets, architectural and engineering plans and so on.

Once the railways were open for business endless notices, circulars, posters and instructions to staff etc. proliferated. These were followed by tickets and timetables for passengers as well as waybills, invoices, wagon and parcel labels and consignment notes for goods traffic.

As for the railway staff; the engine drivers and firemen, guards, station masters, porters, signalmen and linesmen, there was a mass of material ranging from uniform regulations to industrial disputes and strike notices.

Designs and plans for locomotives, carriages and other rolling stock provide another and rather special field for the collector. These can range from simple diagrams to the magnificent coloured drawings of Robert Stephenson and other engineers. They can even be found on the fronts of cigarette cards, with their usually accurate information on the reverse side. A potted history of locomotive design could easily be assembled from such sources.

Contemporary magazines and pamphlets such as *The Illustrated London News*, *The Penny Magazine* and *The Lady* can also give much background information with illustrations that are not always technically correct but which can be both atmospherically evocative and aesthetically pleasing.

It must be clear from this that anyone interested in the history of railways can amass a vast amount of material to do with their development, their years of prosperity and sometimes their demise. There is room for both illustrative and typographic examples. The history of railways has been well served by the printers in the first three-quarters of the nineteenth century. Typefounders of both Great Britain and the United States produced a wealth of display letters and stock blocks of which the jobbing printers made brilliant use in the material they printed for the railway companies.

William Fenton, a master draughtsman of railway subjects and author of various books ranging from printer's trains to locomotives, has here assembled a mouth-watering collection of railway printed ephemera, much of which is reproduced actual size. It should give much satisfaction to both collectors and those interested in railway history as well as inspiring the newcomer to the field of this fascinating subject.

If it provides not a little fun at the same time, who can complain?

John Lewis.

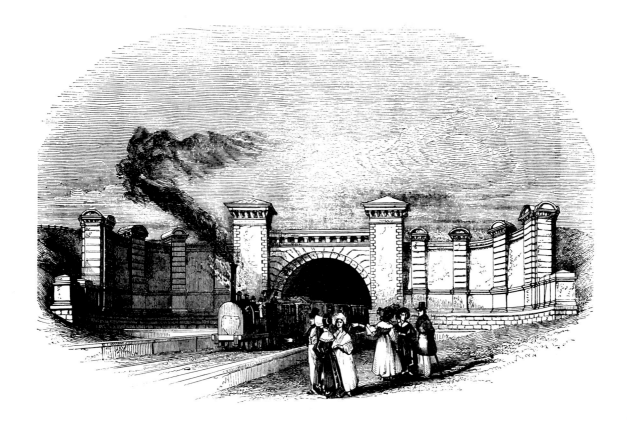

The heraldic device of the Great Central Railway was the first to be granted
by the Royal College of Arms to any railway company.
The upper part of the shield contains parts of the arms of
Manchester, Sheffield and Lincoln respectively.
The open cross and daggers represent London.
Paper transfer, 385 x 315mm, 1899.
Courtesy R. White

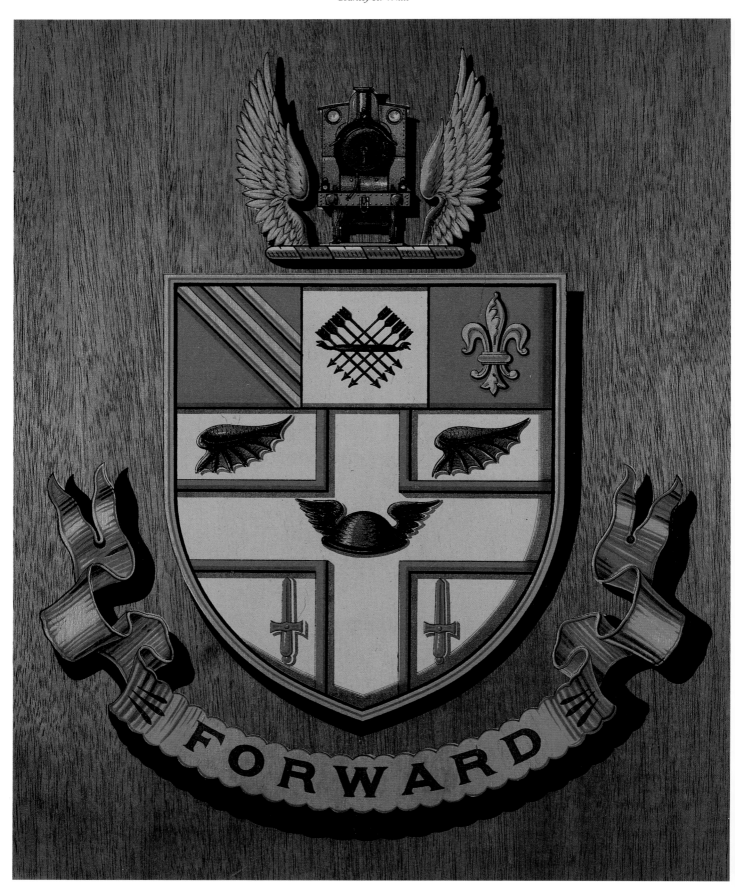

Introduction

Collectors of railway printed ephemera normally concentrate their search on particular subjects; tickets, timetables, hand-bills, posters, notices, etc., etc. As an artist/typographer my collection began as a search for reference specimens of different typefaces and ornaments. It quickly became evident that a high proportion of these, notably the Victorian ones, had a railway association. Some of the finest cartouches were found on railway maps, and the engraver's art surely peaked on share certificates. In contrast the lowly luggage label seemed to be produced by printers using any old wood block letters or obsolete typefaces that happened to be to hand or ready for the dustbin. A stern typographical exercise was to take a page from one of Bradshaw's railway timetables (page 127) and turn it into something comprehensible.

Together with a fascination for railways going back to travelling to school every day on a steam railcoach, it was inevitable that my collection would expand to anything 'railway' which, as any collector will confirm, is not the ideal method with so vast a subject. Came the time when I was inclined to agree and gave thought to some pruning...but what? Only then did I realise that what I was looking at was the rise and fall of railways in Britain.

This book, then, is a presentation of evidence for the prosecution or the defence, whichever point of view one cares to take. It is also a jigsaw puzzle made from interlocking pieces, some of which seem to fit into more than one place in the overall scene. Although it is assembled from collected printed ephemera it is not specifically about collecting. To call it a history would be presumptuous, notwithstanding the fact that the majority of the illustrations are historical artefacts.

Cartoon; 'full size drawing on stout paper as design for painting, tapestry, mosaic, etc.,' comes close to an acceptable definition. By no means a complete picture but rather an atmospheric outline of changing technology and social attitudes.

But is this change, for better or worse, as great as we are led to believe? When the Great Western Railway altered the style of their staff uniforms in 1900 (page 45) fashion was not a factor. Sound business husbandry suggested a means of saving a few pence, to the delight of the shareholders if not to the station master. Then, as now, aesthetic sensibility had no place in financial management.

Passengers arriving at the booking office are bewildered by the labyrinth of the fares structure of British Rail; an ongoing topic in the letters columns in the national press. A glance at some of the categories of tickets available on the London and North Eastern Railway in the late 1930s (page 142) proves the everlasting nature of the problem.

Concern for the environment is not a phenomenon of the late twentieth century. A proposal to build an embankment across Morecambe Bay in 1838 (page 11) was abandoned after meeting even more opposition than the recent Channel Tunnel link. Ironically, many railway viaducts and buildings, bitterly opposed at their inception, have become sites for preservation battles.

Despite the advent of mass movement on the motorway and its spectacular 'pile-ups', the media's morbid fascination with railway disasters has not diminished. The *Illustrated London News* front page engraving of the Hexthorpe accident (page 156) differs little from the coverage given by *The Times* to the Cannon Street crash of 1991. Significantly, only two weeks later, the same newspaper reported a much more horrific 60 vehicle motorway catastrophe with about ten column inches on a minor inside page.

The unfortunate passenger visiting any lost property office to recover a missing umbrella will be only mildly surprised to see the large numbers of these awaiting claimants. Market Bosworth's lost property book of over a century ago (page 171) confirms that umbrellas and walking sticks have always been the most forgotten pieces of personal luggage.

Even with the massive reduction in track mileage, have the fundamentals of running and using the railways changed significantly? The only answer that I can offer is yes and no. My hope is that this selection of railway printed ephemera will explain my equivocation.

WILLIAM FENTON
Beaconsfield, 1992.

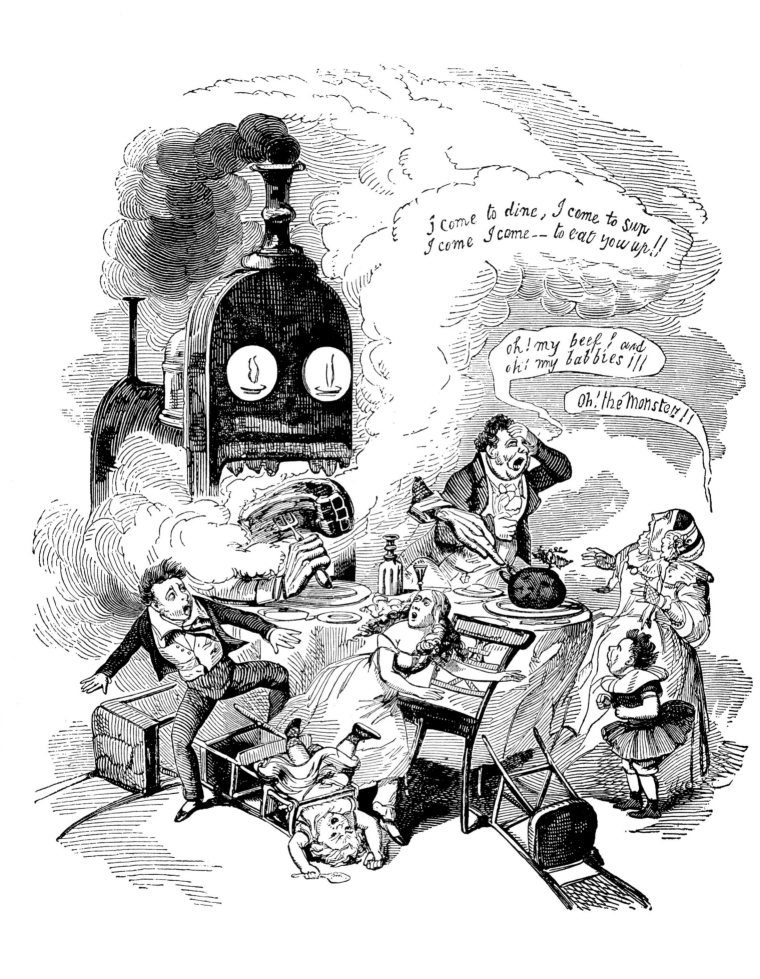

In the beginning

'*Men who propose and carry through, without regard to evil or to good report, such works as the Grand Junction Railway – who have overcome, not only the opposition which the stupendous operations of nature present, but the more stubborn and unbending resistance of haughty and interested minds – are far more worthy of the laurel crown than the victor of a hundred fights. The one confers on his country honour and prosperity – crime, devastation, woe, wailing and death attend the career of the other; which, at the best, ends in the attainment of but equivocal benefits.*'

Arthur Freeling, *The Grand Junction Railway Companion* 1837.

LONDON AND BIRMINGHAM RAILWAY.

Length.	111¼ miles.
Breadth of Way on Embankments and Viaducts	28 feet.
Viz. For double Line of Railway, width of each 5 feet ... 10	
Space between the two Lines ... 6	
Ditto outside ditto 6 feet each ... 12	—28 feet.
In the Cuttings, (1 foot additional being allowed on each side for a Drain)	30 feet.
Cuttings : greatest depth.	55 feet.
Embankments and Viaducts : greatest height	45 feet.
Tunnels. Space outside the lines of Rails 3 feet, making a total width of	22 feet.
Height to the Crown of the Arch	25 feet.

Levels of the Line above the Sea :—

Distance in miles from London :

Miles.		
—	London Station	120 feet.
2	Brent Valley	112
13	Oxhey Ridge (near Watford)	240
15½	Colne Valley.	229
30	Tring Ridge	420
53	Ouse Valley	259
59	Blisworth Ridge (near Northampton)	358
64	Nen Valley	319
76	Kilsby Ridge (near Daventry)	395
90	Avon Valley	263
97½	Reaves Green Ridge (near Coventry)	377
101	Blythe Valley.	320
111¾	Birmingham Station	368

Planes. Greatest Inclination, 1 in 330, or 16 feet in a mile.
Total length of Planes, with an inclination exceeding 14 feet in a mile.

Ascending from London	25½ miles.
Descending ditto	18¼
Total	44
Sum of Level Planes	9¾ miles.

Estimates. (Parliamentary)

COST.

For making the Railway (at full prices for the labor and materials	£1,882,553
For Land (1250 Acres)	250,000
For Engines, Carriages, Stations, and Contingencies	367,447
	£2,500,000

TRAFFIC.

Annual Passengers (persons now travelling) 488,342, at 2*d.* per head per mile	£447,646
Van, Waggon, and Fly Boat Goods (average now conveyed) 143,342 tons, at from 6*d.* to 5*d.* per ton per mile	345,761
	£793,407

TO OPPONENTS
OF THE
Ipswich, Norwich, and Yarmouth projected Railway.

IT is the intention of several influential Land-owners to oppose the above Railway, and they are desirous of being joined by other persons who may find themselves aggrieved by this project, a Meeting will therefore be held on Tuesday next, the 20th instant, at the King's Head Inn, at Bungay, at One o'clock precisely, at which meeting all persons interested in opposing the above Line of Railway are invited to attend either by themselves or their Agents.

Signed,
CALVERLEY RICHARD BEWICKE.
Barsham House, Suffolk,
14th Jan., 1846.

For any intermediate information which may be required, apply to Messrs. Margitson and Hartcup, Solicitors, Bungay.

LEFT
Leaflet accompanying a folder (overleaf) outlining the merits of building and investing in the London and Birmingham Railway. A contemporary comparison can be made with the construction of the motorway link between the two cities over a century later.
Actual size, 1832.

ABOVE
Press notice in the *Norfolk Chronicle.*
Actual size, 1846.

FACING PAGE
Railways arrived to a mixed reception by all classes of society. Robert Cruickshank in particular, was not amused.
Illustration from his *Table Book.*
160 x 130mm c.1835.

First. Cheap, safe, and expeditious conveyance of passengers and goods—passengers conveyed along any part of the Railway at *half* the cost, in *half* the time, and with *half* the fatigue which attend the *best* travelling on the *best* roads.

Second. A more extended interchange of commodities (the certain result of increased economy and facility in traffic) between the metropolis and the great manufacturing districts.

Third. The opening of the markets of the metropolis to the fertile districts, with which the Railway will afford the means of communication, for produce and provisions of all sorts which will not bear the expence or delay of the present modes of conveyance, to the reciprocal benefit of the consumer and producer.

Fourth. The increase in value, as a necessary consequence, of all estates to which these advantages will extend.

Fifth. The inducement which the establishment of a great Central Railway holds out to form Branch Railways connected with it; thus diffusing its benefits in all directions.

Sixth. A direct communication by Railways with Liverpool,—a Company being formed for a Railway from Birmingham to join the Liverpool and Manchester line, and thereby complete the line from London to Liverpool.

Seventh. The increased facility which will consequently be afforded for the intercourse with Ireland.

Eighth. The power of sending Troops by the Railway in half the time now required for a Government Despatch, particularly as the line passes close to the Military Depôt at Weedon.

And lastly. The relief which it will afford to the labouring classes; the greatest part of the expense of the undertaking (above two millions sterling), being for manual labour,— *a consideration of too much importance in these times to be lightly regarded by any well-wisher to his country.*

LONDON, 1st *February,* 1832.

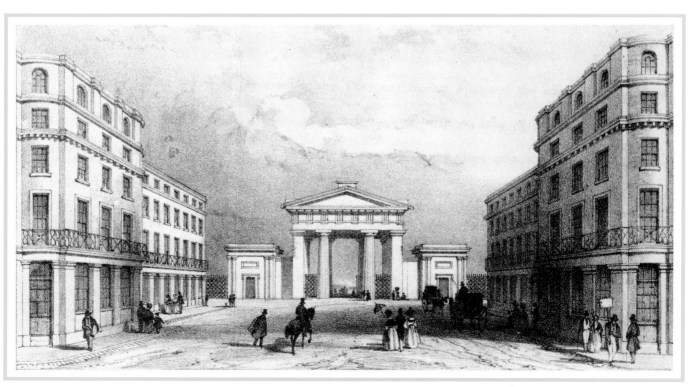

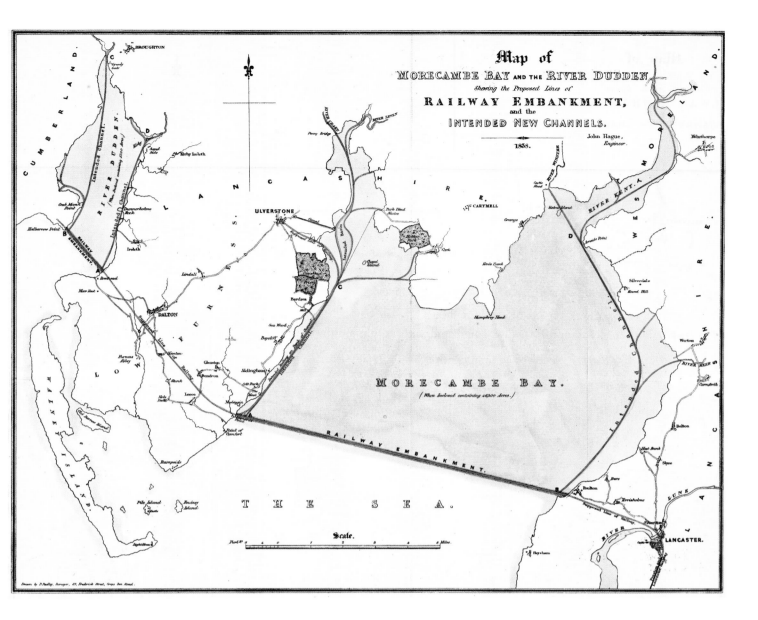

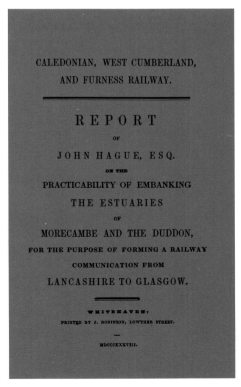

CALEDONIAN, WEST CUMBERLAND,
AND FURNESS RAILWAY.

REPORT

OF

JOHN HAGUE, ESQ.

ON THE

PRACTICABILITY OF EMBANKING

THE ESTUARIES

OF

MORECAMBE AND THE DUDDON,

FOR THE PURPOSE OF FORMING A RAILWAY

COMMUNICATION FROM

LANCASHIRE TO GLASGOW.

WHITEHAVEN:
PRINTED BY J. ROBINSON, LOWTHER STREET.

—

MDCCCXXXVIII.

ABOVE LEFT

Nine good reasons for building a railway . . .
Extract from *London and Birmingham Railway – Observations*.
Folder, actual size (full sheet size 340 x 420mm), 1832.

BELOW LEFT

Lithograph from *London and Birmingham Railway – Hotel and Dormitories*. The
dormitories are on the left with the hotel opposite. The view is looking south across
Drummond Street to Hardwick's late lamented Euston Arch.
Prospectus, actual size (full sheet size 394 x 480mm), 1838.

ABOVE AND RIGHT

What might have been . . .
Railway pioneers showed no lack of imagination. John Hague's proposals for an
embankment across Morecambe Bay must have had enormous appeal to investors,
if not conservationists. The figures suggested a 100% profit before the first train
was to move. Construction costs were estimated to be £434,131-19s-4d, whilst the
sale of reclaimed land at £23 per acre was to realise £1,196,000.
Booklet, 228 x 148mm with map insert 340 x 410mm. 1838.

RAILWAY.

The following Advertisement was copied from a Birmingham Paper, and sent in a Letter to a Gentleman of Newcastle.

SIR,

I must trouble you to insert the following RESOLU-TIONS of the **MEETING** held at the Royal Hotel, on the 24th ult. as it happened by a singular Mischance that the wrong Copy was forwarded to you last Week.

I am, Sir, &c.

QUIZ.

Birmingham, Sept. 1826.

"*Resolved Unanimously,*

"That this meeting being fully satisfied of the utility of *things in general*, and of *Rail roads in particular*, and taking into consideration the present *flourishing state* of trade in this town and neighbourhood, and the *great super-abundance* of money, are of opinion that a *most favourable opportunity* is now afforded for the establishment of a Rail-road between the towns of Birmingham and Wolverhampton.

"That the *great success* which has attended similar projects, and the *eager desire* of the public *(after the experience of the past year)* to promote *new schemes*, and *Joint Stock Companies*, afford a well-grounded expectation that the present undertaking will be *most warmly supported*.

"That as the projectors of this scheme were also the promoters of the Birmingham and Liverpool Rail-road *(lately deceased)*, for which their estimate was L600,000, with *branches to the Staffordshire Potteries and Shropshire Ironworks*, and as they subsequently applied to Parliament for powers to raise *only* L900,000, *without any branches at all*, there cannot be the slightest reason to doubt the *accuracy* of the present estimated expences of completing the Railway to Wolverhampton for L150,000.

"That in addition to *all the other good things* to be expected from this Company, a *more economical* means of transit is to be afforded to the public, in proof of which they beg to refer to the rates of tonnage of the Stratford and Moreton Railway Company, as advertised in the Birmingham Gazette of last week.

"That as loco motive engines have been voted out of fashion by the common consent of all rational people, this meeting has learnt with great satisfaction, that the invention of a Mr Pocock, of Bristol, for carriages drawn by paper kites, promises to be eminently successful; they propose, therefore, to enter into treaty with that gentleman immediately, and entertain sanguine hopes not only of impelling merchandize upon the Railway at the rate of twenty miles per hour, but, by enlarging the size and power of the kites (with the assistance of the Stationers' Company) to convey passengers with ease and safety through the air, *in cars suspended from the tail.*

"That as a strong additional motive for subscribing to this scheme, the public are requested to notice the *gratifying fact*, that only *two pounds* out of every *three*, or L32,000 out of L48,000, subscribed to the Birmingham and Liverpool Rail-road, *has been spent.*

"That it appears to this meeting, that L130,000 will be *amply sufficient* to complete the line, yet as the BEDFORD is an expensive Hotel, and *certain salaries* must be paid, it is expedient to raise a capital of L150,000.

"That although this meeting deems it proper at the present time to limit its views, an ulterior object of the greatest importance is in the contemplation of the Committee of Management, which they hope at no distant period to accomplish—namely, an extended line, by which the Company may be enabled to *carry Coals to*

Newcastle."

What progress is your Rail-road making? I have heard nothing of it for some time. Please communicate with me on the subject. I suppose you cannot charge your Committee of Management with the *Bedford being an expensive Hotel?*

Newcastle, Sept. 22, 1826.

Yours, &c. QUIZ.

FORDYCE, PRINTER, 29, SANDHILL

WAVENEY VALLEY,
LATE
DISS, BECCLES, and YARMOUTH RAILWAY.

THE Owners and Occupiers of Land who intend to oppose the above scheme, are requested to communicate with Mr. Richard Ferrier, Burgh Castle, near Great Yarmouth.

WAVENEY VALLEY

The following MEMORIAL lies for Signature
At the TONNAGE-OFFICE, King Street, } Norwich
At JAMES DUNN'S, Fye-Bridge, Quay, }
At the BELL, St. Olave's Bridge,
At SAMUEL DARBY'S, Beccles Bridge,
And at WROXHAM CASTLE.

To the Lords Commissioners for executing the Office of Lord High Admiralty of the United Kingdom.

The respectful MEMORIAL of the undersigned Owners and Navigators of Vessels navigating the Rivers Waveney and Yare, in the Counties of Norfolk and Suffolk, and other Persons interested in such Navigation,

SHEWETH,

THAT in the last Session, a Bill was introduced into Parliament for making the "DISS, BECCLES, AND YARMOUTH RAILWAY."

That such Railway was to have crossed the River Waveney, near St. Olave's Bridge, in the parish of Herringfleet.

That the Bill was strongly opposed; and the Provisional Committee of the Company agreed with the opponents, and with the promoters of the Lowestoft and Reedham Railway, that if an Act were obtained for making a Railway from Lowestoft to Reedham, by a Bridge over the River Yare, the Company would not make their Railway beyond the River Waveney.

That the Diss, Beccles, and Yarmouth Railway Bill was subsequently abandoned by the promoters, and thrown out by the Committee.

That the Act for making the Railway from Lowestoft to Reedham was passed, and that Company are constructing their Works, with a Bridge over the River Yare, at Reedham, sufficient to accommodate all the traffic between Norfolk, Suffolk, Yarmouth, and Norwich.

That the Diss, Beccles, and Yarmouth Railway Company have increased their capital and the number of their Directors, and have taken the name of the "Waveney Valley Railway Company;" and by their Notices and deposited Plans, propose to make their Railway nearly in the same line as the Diss, Beccles, and Yarmouth Railway, crossing the River Waveney to the South of St. Olave's Bridge, and also crossing such River again at the mouth of it, opposite to Burgh Castle, in Suffolk, and crossing the River Yare at its entrance into Breydon Waters, in order to join the Norfolk Railway.

That three new Bridges will by this Company be constructed over the navigation in addition to the Bridge now being erected over the Yare at Reedham, and, from the width of such Rivers at their entrances, it will be necessary to construct such Bridges on piles, whereby the current of the streams will be impeded, and the deposit of mud on Burgh Flats and in the present shallow Channel greatly increased.

That the Waveney Valley Railway is not required by the locality—There is not sufficient traffic to support it—It is a small Line, without the support of any established Line to guarantee its being properly worked; and between Great Yarmouth and the point where it is proposed to cross the River Waveney, near St. Olave's Bridge, the Yarmouth and Norwich Railway runs nearly parallel to it, on the Northern side of the River Yare.

That the Company, by agreeing not to make their Line beyond the River Waveney, have admitted that such extension is not necessary, and that the Rivers need not be farther impeded.

That Bridges at all times increase the difficulty and expense of the navigation, and cause great damage to the sails and tackle of the craft; and any addition to the present Bridges will so encumber the navigation, that Vessels using these Streams

EXTREME LEFT

Go fly a kite...
Privately printed notice drawing attention to the eternal optimism of construction engineers when estimating building costs. The ridicule heaped on the locomotive engine is hardly surprising three years before the 'Rocket'.
375 x 165mm, 1826.

LEFT

If at first you don't succeed...
Newspaper notice, typical of the period of the 'Railway Mania', from the *Norfolk Chronicle*.
Actual size, 1846.

RIGHT

Permission granted...
to hold a meeting.
Notice, 382 x 257mm, 1833.
Courtesy John Lewis.

BELOW

The highly expensive compromise necessary when building a railway of two gauges between I.K. Brunel's sphere of influence and the others.
Prospectus, 416 x 530mm, folding to 265 x 104mm, 1845.

Public Meeting

RESPECTING

GLOUCESTER, WORCESTER,

Kidderminster, Stourbridge, Dudley,

AND

BIRMINGHAM

RAILWAY.

TO THE

HIGH BAILIFF

OF THE BOROUGH OF

KIDDERMINSTER.

SIR,

WE, the undersigned, request that you will call an early MEETING of the Inhabitants of this Town, and any other PERSONS in this NEIGHBOURHOOD feeling interested, to take into consideration the Plan of a RAIL ROAD by Mr. WOODDESON, Civil Engineer, to communicate with the **LONDON RAIL ROAD** at **BIRMINGHAM**;—and **CAMBRIAN RAILWAY** at **GLOUCESTER**;—the particulars of which will be explained by that Gentleman, who is now in this Town, and will attend such Meeting.

JOHN GOUGH, Jun.
PARDOE, HOOMAN, & PARDOE
J. MORTON
JOSEPH NEWCOMB
WATSON, SON, & BADLAND
G. & H. TALBOT & SONS
JOHN GOUGH & SONS
THOS. HALLEN.

In compliance with the above highly respectable Requisition, I hereby appoint a Meeting, for the purpose therein mentioned, to be held at the Guildhall, in the said Borough, on FRIDAY Next, the 22d inst. at Eleven o'Clock in the Forenoon.

Kidderminster, Nov. 19th, 1833.

S. BEDDOES,

HIGH BAILIFF.

THOMAS PENNELL, PRINTER, HIGH-STREET, KIDDERMINSTER.

DUDLEY AND BIRMINGHAM

JUNCTION RAILWAY,

COMBINING THE BROAD AND NARROW GAUGES IN CONTINUATION OF THE OXFORD, WORCESTER, & WOLVERHAMPTON LINE.

Capital £200,000, in £8,000 Shares of £25. each.

DEPOSIT £2. 10s. PER SHARE.

LONDON
AND
DOVOR
RAILWAY

THE Committee of the House of Commons, upon the South Eastern Railway Bill, having resolved "that a Railway from London to Dovor is desirable," and the "Kent Railway Company" being prepared to shew a line over the Greenwich Railway, by Dartford, Gravesend, Strood, Rochester, Chatham, Sittingbourn, Faversham, Canterbury, Sandwich and Deal to Dovor, with branches to Maidstone, Sheerness, and Ramsgate; the Inhabitants of Rochester, Chatham, Strood, and their Vicinities are respectfully requested to meet at the Bull Inn, Rochester, on Tuesday next, the THIRD day of MAY, at TWELVE o'Clock, to take the subject into consideration, and adopt the necessary measures for the protection and promotion of the Interests of this Neighbourhood.

The Engineeer and Secretary of the Company will be in attendance, to exhibit the plan and sections, and to afford any information that may be required.

HENRY PRENTIS,
*Solicitor to the Kent Railway
Company for the Rochester District*

Rochester,
April 28th, 1836.

WILDASH, PRINTER AND STATIONER, ROCHESTER.

THE GRAZIERS,
AND THE
Norfolk and Eastern
Counties Railway.

IN consequence of the proceedings which took place at the Public Meeting held at the Norfolk Hotel, on Saturday, November 28th, 1846, the GRAZIERS of Norfolk are requested to attend a MEETING on

Saturday, December 19th,

At the NORFOLK HOTEL, for the purpose of appointing a Committee to watch over the interests of the Graziers of the County, and of conferring with the Directors of the two Railways on the arrangements which were proposed at the late Meeting. JAMES NEAVE.

LEFT
Nothing changes...
Over 150 years later the route to the Channel Tunnel provoked similar necessary measures for the protection of interests.
The correct title of the company was the South Eastern Railway though London and Dover even appeared on some early 'official publications'.
Handbill, 1836, 342 x 210mm.
Courtesy Michael Brooks

ABOVE
Other vested interests.
Newspaper notice, 1846.
Norfolk Chronicle.
Actual size

BELOW
This line neither began at Manchester nor ended at Milford. It ran for 51 ½ miles between Llanidloss and Pencader in mid-Wales.
Prospectus, 1859.
420 x 534mm folding to 267 x 105mm

RIGHT
I.K. Brunel's first route, subsequently modified, for the Oxford, Worcester and Wolverhampton Railway.
Prospectus, 1844.
416 x 522mm folding to 261 x 104mm

Manchester and Milford Railway
COMPANY.
CAPITAL, £555,000, IN 55,500 SHARES, OF £10 EACH.
DEPOSIT £1 PER SHARE.
SHAREHOLDER'S LIABILITY LIMITED TO THE AMOUNT OF HIS DEPOSIT UNTIL THE ACT IS OBTAINED.

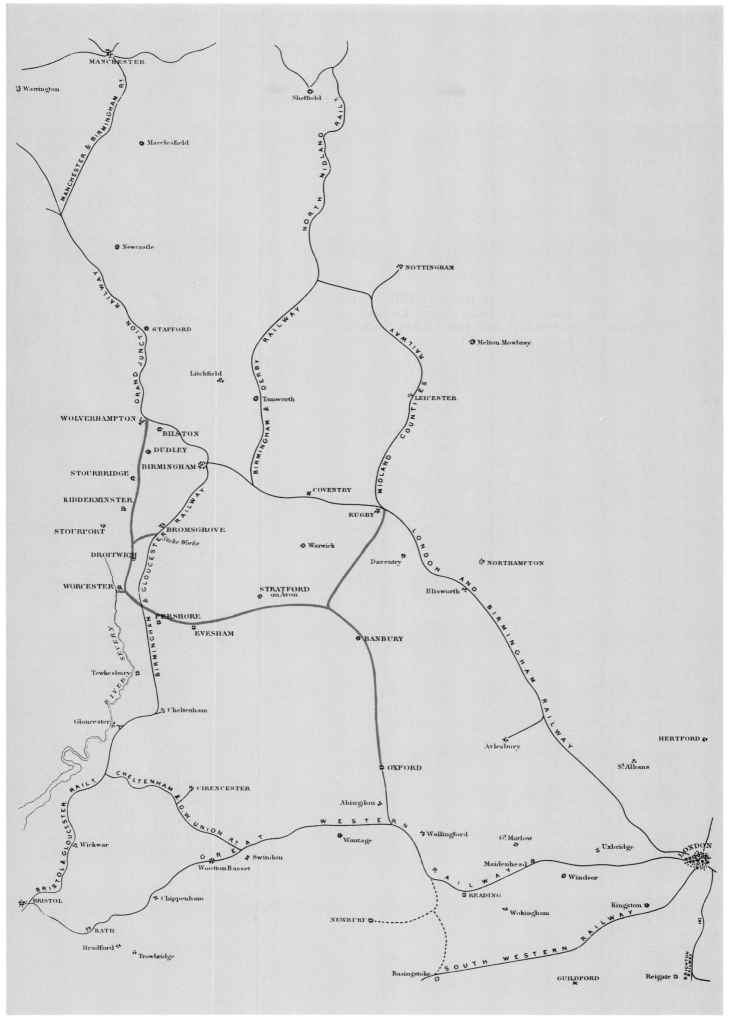

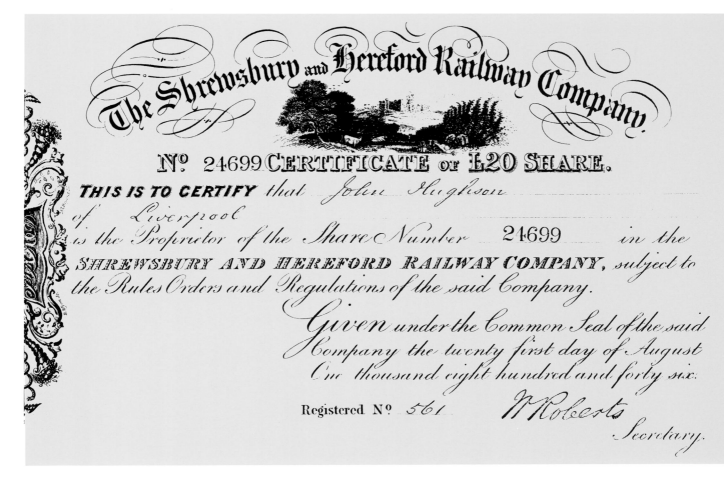

The Shrewsbury and Hereford Railway Company.

No. 24699 CERTIFICATE OF £20 SHARE.

THIS IS TO CERTIFY that *John Hughson* of *Liverpool* is the Proprietor of the Share Number 24699 in the *SHREWSBURY AND HEREFORD RAILWAY COMPANY*, subject to the Rules Orders and Regulations of the said Company.

Given under the Common Seal of the said Company the twenty first day of August One thousand eight hundred and forty six.

Registered No. 561

W Roberts
Secretary.

Railway finance was the first major example of popular support by the small investor. If pension scheme managers had been in existence it is doubtful that they would have taken a risk on this new form of transport. The true nature of this risk peaked in the mid-1840s when cheap money and signs of profitability by the early companies led to foolhardy speculation: 'Railway Mania'.

ABOVE
The Shrewsbury and Hereford Railway survived to eventually become jointly owned by the Great Western and the London and North Western railways.
Share certificate, 160 x 247mm, 1846.

ABOVE RIGHT
Mr. Prideaux was fortunate to have ten shillings (50p)

returned from his £20 investment in one that failed. Share certificate, 132 x 225mm, 1846.

BELOW LEFT
Nervous dealing, even in established companies, was a sign of the times.
Transfer certificate, 300 x 190mm folding to 150 x 190mm, 1847.

BELOW RIGHT
Tighter money: the principal sum of this 5% 5 year mortgage was finally repaid 7 years later.
Mortgage deed, 405 x 250mm folding to 155 x 250mm, 1857.

BELOW
Promoters depositing plans at the Board of Trade.
Engraving, 160 x 110mm, 1845.

Reg. No.

London and North Western Railway Company.

£20. Shares

Of the late London & Birmingham Railway Company.

TRANSFER CERTIFICATE.

In pursuance of the Provisions of the Act of Incorporation of the London and North Western Railway Company, (date 16th July, 1846.)

I do hereby Certify, THAT

Deeds of Conveyance numbered from 1734 to of Six

£20. Shares of the said Company, bearing the following numbers

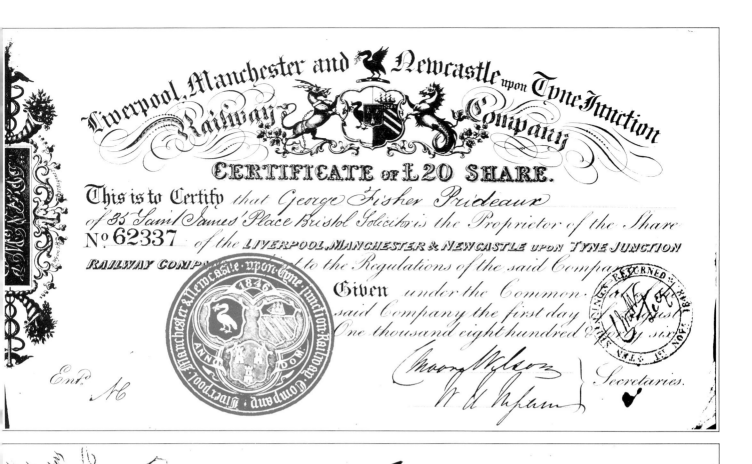

Liverpool, Manchester and Newcastle upon Tyne Junction Railway Company

CERTIFICATE of £20 SHARE.

This is to Certify that *George Fisher Prideaux* of *35 Saint James' Place Bristol Solicitor* is the Proprietor of the Share Nº 62337 of the LIVERPOOL, MANCHESTER & NEWCASTLE UPON TYNE JUNCTION RAILWAY COMPANY subject to the Regulations of the said Company.

Given under the Common Seal of the said Company the first day of August One thousand eight hundred & forty six

George Wilson
W. Wham } Secretaries.

Entd. NC

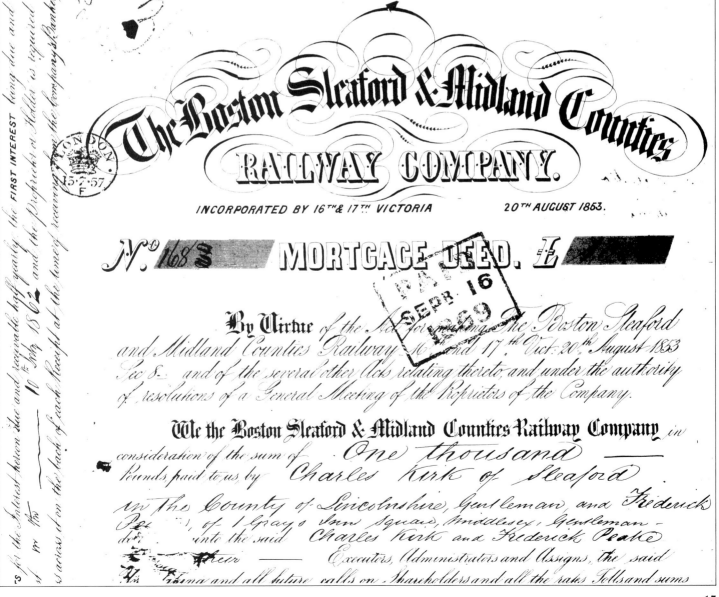

The Boston Sleaford & Midland Counties RAILWAY COMPANY.

INCORPORATED BY 16TH & 17TH VICTORIA **20TH AUGUST 1853.**

Nº 168 **MORTGAGE DEED.** £

By Virtue of the Act for making The Boston Sleaford and Midland Counties Railway 16 and 17th Vict. 20th August 1853 Sec 8 and of the several other Acts relating thereto, and under the authority of resolutions of a General Meeting of the Proprietors of the Company.

We the Boston Sleaford & Midland Counties Railway Company in consideration of the sum of *One thousand* Pounds paid to us by *Charles Kirk of Sleaford* in the County of Lincolnshire, Gentleman, and *Frederick Peake, of 1 Grays Inn Square, Middlesex, Gentleman* do into the said *Charles Kirk and Frederick Peake* their Executors, Administrators and Assigns, the said firma and all future calls on Shareholders and all the rates Tolls and sums

FIFTH CALL.

Chester and Birkenhead Railway Company.

INCORPORATED 1837.

Liverpool, _1 April_ 1839.

Mr. _Edw^d Segar_ has paid the *Fifth Call of Ten Pounds per Share,*

on _Twenty five_ Shares in the *Chester and Birkenhead Railway,* due on the

27th March, 1839.

£250

FOR THE NORTH AND SOUTH WALES BANK,

ABOVE and ABOVE RIGHT
Demands for more money seemed never ending before any
tangible evidence of its application appeared. Call of share
receipts, 1839 (above) and 1846.
Both actual size.

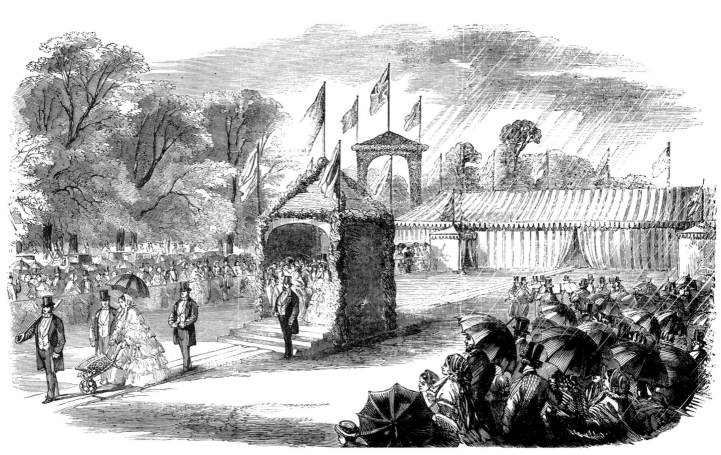

EIGHTH CALL, £2 per Share, on the £30 "unpaid-up" Shares.

No. *870*

Shs. *Thirteen*

Liverpool 27 March 18 48

Received for the use of the **Huddersfield and Manchester Railway and Canal Company** the Sum of *Twenty Sixpounds*

to be accounted for on Demand.

£ *26*

Int.

For

Liverpool Union Bank
H. Makin

It always rains on Sunday . . . and on festive occasions, but at least some action seemed imminent.

BELOW LEFT

Shoulder arms! The *de rigueur* spade and wheelbarrow about to be used for the ceremonial cutting of the first sod; Salisbury and Yeovil Railway.
Engraving, 146 x 238mm. *Illustrated London News,* 1856.

BELOW and RIGHT

The spade in use at Clutton for the commencement of the Bristol and North Somerset Railway. The detail drawing (right) accompanied the report in a supplement to the *Illustrated London News* in 1863
Engravings, below, 163 x 237mm, and right, actual size.

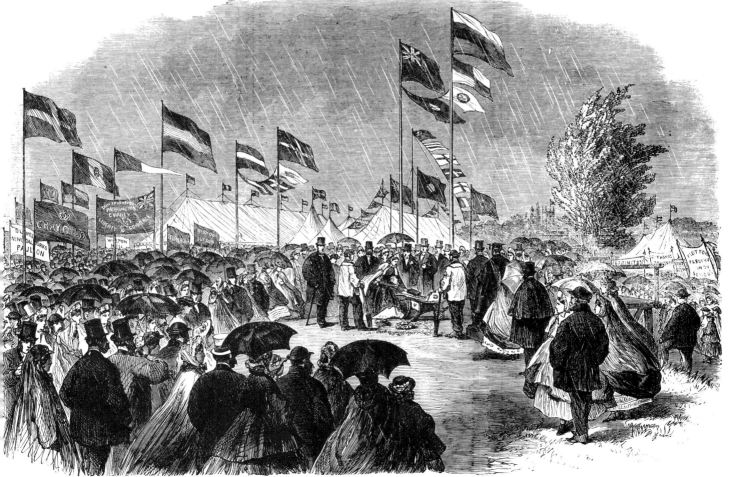

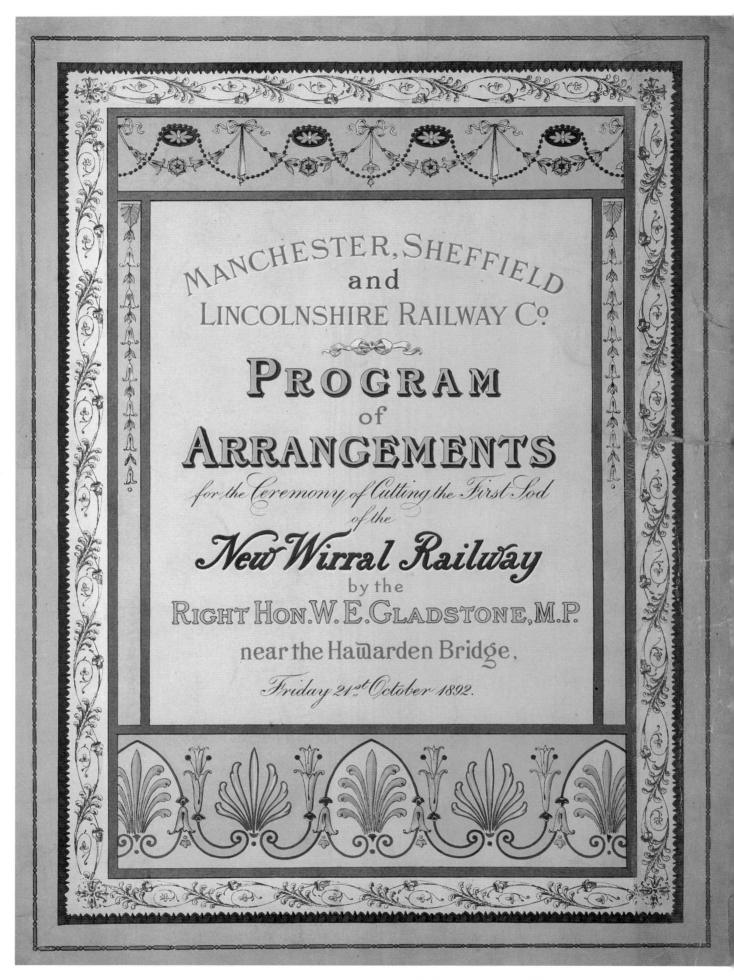

MANCHESTER, SHEFFIELD and LINCOLNSHIRE RAILWAY Cᵒ.

PROGRAM of ARRANGEMENTS

for the Ceremony of Cutting the First Sod

of the

New Wirral Railway

by the

RIGHT HON. W. E. GLADSTONE, M.P.

near the Hawarden Bridge,

Friday 21ˢᵗ October 1892.

Following a well established pattern
the Right Hon. W.E. Gladstone M.P. does the honours.
Folder, 313 x 230mm. 1892.
Courtesy Michael Brooks

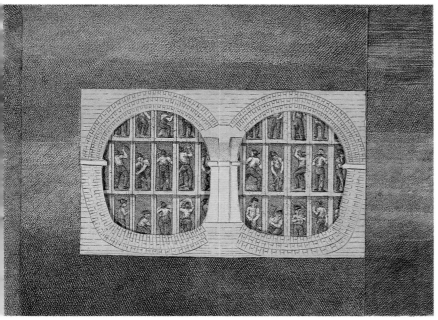

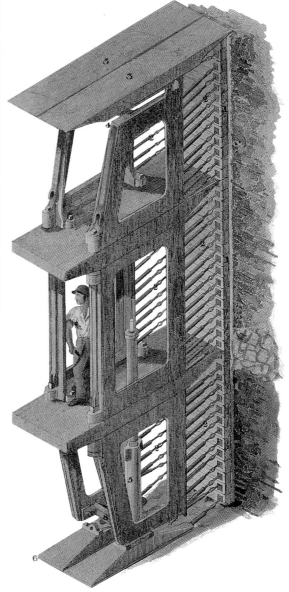

Work under way in the Thamas Tunnel between Rotherhithe and Wapping. Although initially conceived for the use of pedestrians and light road traffic, it was later to become part of the East London Railway in 1865. Designed by Sir Marc Isambard Brunel, it was begun in 1824 but suffered numerous setbacks before finally opening in 1843.

These illustrations are from *An explanation of the works of the tunnel under the Thames from Rotherhithe to Wapping,* produced as a progress report to the shareholders. The report describes:

'The dimensions of the excavation under the river are 38 feet wide by 22 feet 6 inches high; the whole area of which is constantly covered and supported by the iron shield in 12 divisions, which are advanced alternately and independently of each other; they have each three floors, or stages, forming a succession of scaffolding and cells for the bricklayers and miners during their operations.

The drawing above shows the work progressing within the iron shield. Arched brickwork is printed on a pierced overlay flap.

Etchings. Booklet size 212 x 260mm. 1838.

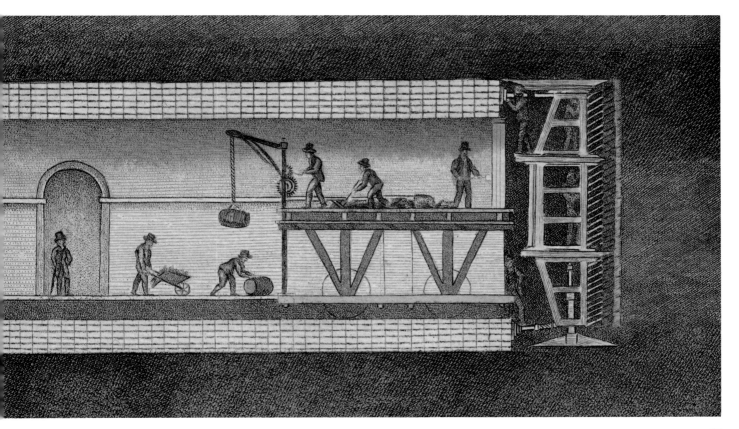

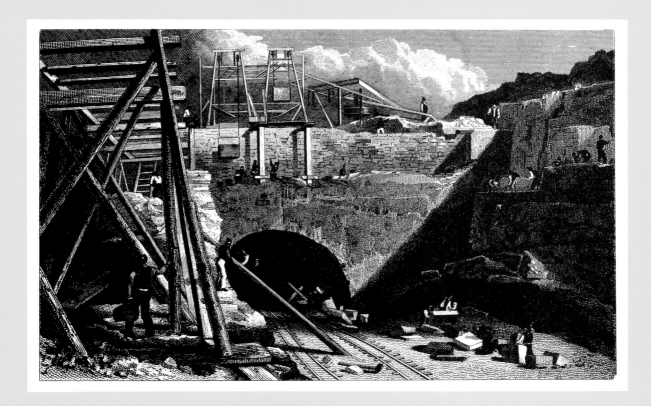

ABOVE

A somewhat idyllic engraving by John Davies of construction work in progress at the *Entrance to the tunnel of the Liverpool & Manchester Rail-Way, Edge Hill.*
Card, actual size, 1829.

BELOW

In contrast, the staff artist of the *Illustrated London News,* seems to convey atmosphere more vividly in reporting on the beginning of tunnelling at King's Cross, Metropolitan Railway.
137 x 236mm, 1861.

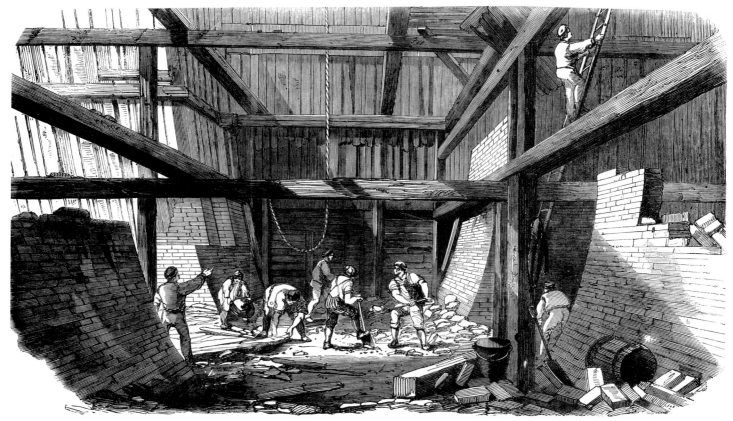

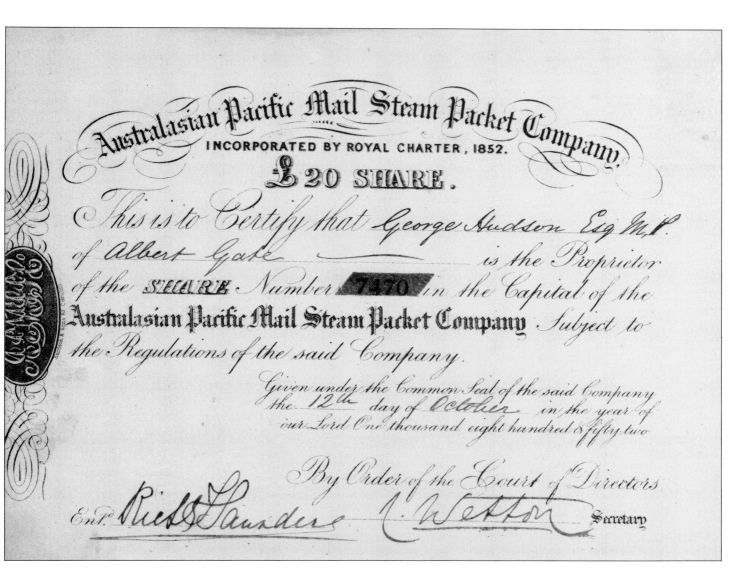

Diversification

ABOVE

'Railway King' George Hudson, despite the financial disasters of the 'Railway Mania', continued to spread his investments. Share certificate, 166 x 215mm, 1852.

BELOW

I.K. Brunel's engineering projects were not confined to railways. His famous *Great Eastern* proved to be a giant step forward in marine technology and design. Share certificate, 129 x 208mm, 1859.

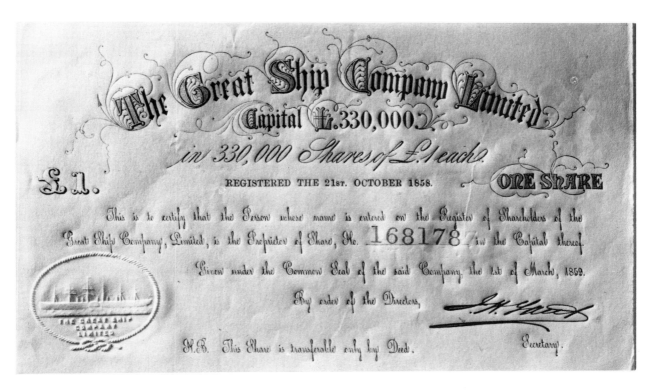

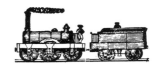

'*The admirers of railroads are in high glee; several new lines and branches have been opened during the week. The lovers of the convenient and picturesque may now be puffed, and rattled, and squeaked along from Nine Elms to Southampton in about three hours, without the nuisance of seeing anything of the country, or the possibility of hearing themselves speak. It is gratifying to know that coffins and stretchers are always ready at the different stations, and a new regulation is in course of completion, by which every passenger on all the lines, Eastern, Western, Midland, Birmingham, &c., &c., will be supplied with a label, to be suspended round his neck, so that when the crash comes, his bones, head &c., may all be carefully collected, and sent home to his expectant relations and friends, according to the address on the ticket.*'

Unknown staff reporter, *Kentish Observer,* 28 May 1840.

BELOW
One of the earliest branch lines.
Dinner ticket, actual size, 1839.

RIGHT
The last main line.
Programme, 310 x 233mm, 1899.

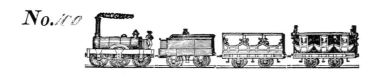

No. 110

OPENING

OF THE

AYLESBURY RAILWAY.

𝕯inner 𝕿icket,

W H I T E H A R T I N N,

Monday, June 10th, 1839.

10s. *Dinner on Table at 4 o'Clock.*

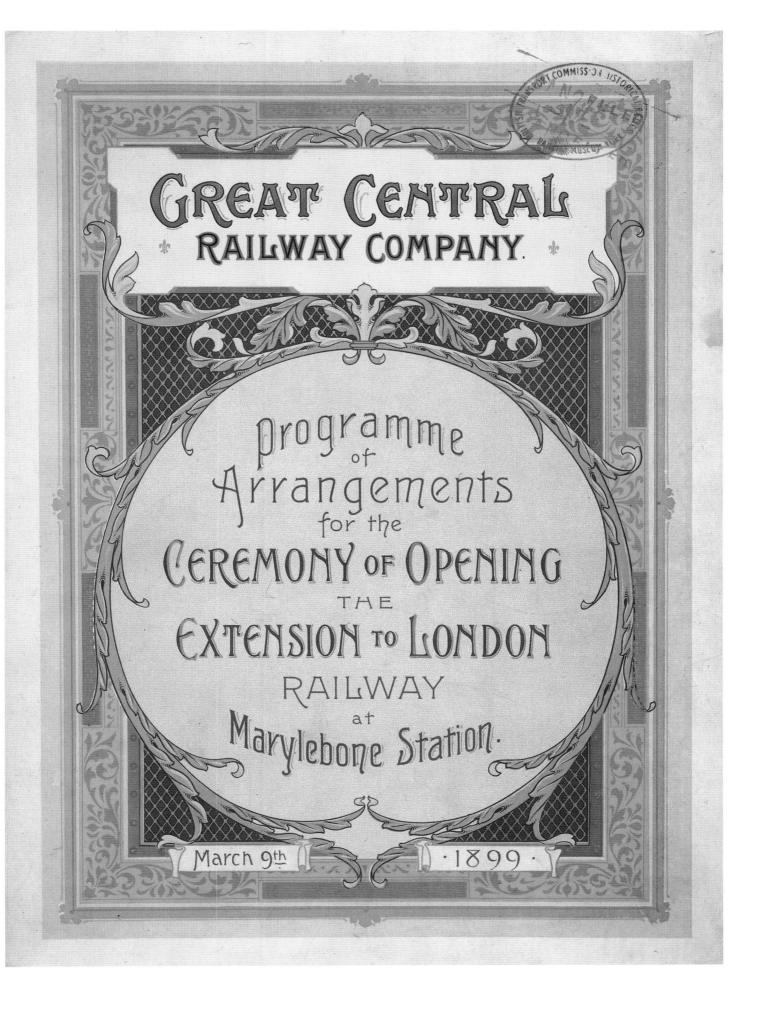

GREAT CENTRAL RAILWAY COMPANY.

Programme
of
Arrangements
for the
CEREMONY OF OPENING
THE
EXTENSION TO LONDON
RAILWAY
at
Marylebone Station.

March 9th · 1899 ·

NORFOLK RAILWAY.

OPENING OF THE LINE.

The Public are respectfully informed that this Railway will be opened in connexion with the CAMBRIDGE LINE, on

WEDNESDAY, 9th of JULY, 1845,

For Passenger Traffic & Light Goods, to & from LONDON, NORWICH, & YARMOUTH.

The TRAINS will run as follows:—

DOWN.	A.M.	A.M.	A.M.	A.M.	P.M.
	H. M.	H. M.	H. M.	H. M.	H. M.
From LONDON	—	—	8 0	11 30	5 0
„ ELY	—	7 30	11 5	1 50	7 50
„ NORWICH	8 30	10 45	2 15	4 30	11 0
Arriving at YARMOUTH......	9 15	11 30	3 0	5 15	11 45

UP.	A.M.	A.M.	P.M.	P.M.	P.M.
	H. M.	H. M.	H. M.	H. M.	H. M.
From YARMOUTH	5 30	9 30	3 15	6 30	8 30
„ NORWICH	6 45	11 0	4 30	8 0	9 15
„ From ELY	9 0	12 50	6 45	11 30	—
Arriving at LONDON	12 30	3 30	10 0	—	—

FARES FOR STOPPING TRAINS.

LONDON.	1st Class.	2d Class.	3d Class.
To NORWICH	£1 2 6	£0 16 0	£0 10 6
To YARMOUTH	1 6 0	0 18 6	0 11 9

FARES FOR QUICK TRAINS.

LONDON.	1st Class.	2d Class.	
To NORWICH	£1 7 0	£0 18 0	
To YARMOUTH	1 10 6	1 0 6	

Fish & Light Goods will be conveyed to **London** *by the* **6.30 pm. Up Train** *from* **Yarmouth,** *and arrive in* **London** *at* **3.30 a.m.**

TRAINS FOR HEAVY GOODS WILL BE PUT ON SHORTLY.

(By Order) RICHARD TILL,
 Secretary.

East Anglian openings:

ABOVE
Handbill, actual size, 1845.

RIGHT
Three Newspaper notices, all actual size, 1845, 1847 and 1849.

NORFOLK RAILWAY,
OPEN ON THE 9th OF JULY.

JAMES HUNT,
RAILWAY AGENT, COACH PROPRIETOR, AND POST MASTER,
BRANDON,

VERY respectfully announces to the Public and his numerous Friends in general, that he is appointed by the Norfolk Railway Company their Agent for collecting and delivery of all Parcels and Goods at Brandon.

The undermentioned Coaches will run to and from the Trains Daily (Sundays excepted.)

FROM HOLT.
THE NORFOLK REGULATOR

Leaves the Feathers Inn, Holt, at 7h. 30m. A.M., to join the FAST TRAIN at Brandon, and arrives in London at 3h. 30m. P.M., returning from Brandon after the arrival of the Fast Down Train from London at 11h. 30m. A.M., arriving at Holt 7h. 0m. P.M.

FROM WELLS AND FAKENHAM.
THE HERO

Leaves the Crown Inn, Wells, at 7h. 15m. A.M., and the Lion and Crown Inns, Fakenham, at 8h. 30m. A.M., to join the FAST TRAIN at Brandon, and arrive in London at 3h. 30m. P.M., returning from Brandon, after the arrival of the Fast Down Train, from London at 11h. 30m. A.M. arriving at Wells 7h. 0m. P.M.

A Branch Coach will be at the Station, Shoreditch, on the arrival of the Train to convey Passengers travelling by the above Coaches, to the White Horse, Fetter Lane, and Golden Cross, Charing Cross.

Places can be secured, and Parcels booked, at the following Offices, from London, viz., Golden Cross, Charing Cross, White Horse, Fetter Lane, Cross Keys, Wood Street, and at the Branch Office Station, Shoreditch.

Parcels delivered in London *Free of Porterage*, and all parcels over 18lbs weight only 1d. per lb., including delivery.

Post Horses, Flies, and Carriages, will be in readiness at the Brandon Station on the arrival of every Train.

Brandon, July 1st, 1845.

N.B.—*The HOPE COACHES will leave Lynn and Bury Twice a Day, on and after the 14th instant, to meet Trains at Brandon and Thetford.*

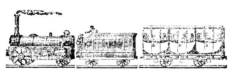

THE PUBLIC
Are informed that
THE RAILWAY
FROM
Wymondham to Dereham
WILL BE
Opened for Passenger Traffic
On MONDAY, NEXT,
The 15th day of February, 1847.

Further particulars may be had at all the Stations.

By Order,
RICHARD TILL, Secretary.

EASTERN UNION
RAILWAY.
Opening to the Victoria Station,
NORWICH,
Wednesday. Nov. 7th, 1849,

Instead of Thursday, the 8th, as advertised last week.

THE Friends of this Undertaking, desirous of testifying their appreciation of the great benefits which will result to the Traders and Inhabitants of Norwich by the completion of this important Line of Railway, have determined to celebrate that auspicious event by a

PUBLIC DINNER,
IN ST. ANDREW'S HALL,

To which, AS A DESERVED MARK OF RESPECT, they propose to invite the Chairman, Directors, and Officers of the Company.

The Mayor, Saml. Bignold, Esq.,
Will take the Chair.

Tickets 10s. 6d. each,

To be had at the Norfolk Hotel, or at the Office of Mr. Edgar Bond, Rampant Horse Street.

A previous inspection of the Line will take place, for which any Gentleman who purposes being at the Dinner will receive a Ticket to frank him and a Lady for the Trip.

Gentlemen disposed to contribute towards the expenses, are informed, that Subscriptions are received by Mr. James Hardy, St. Stephen's.

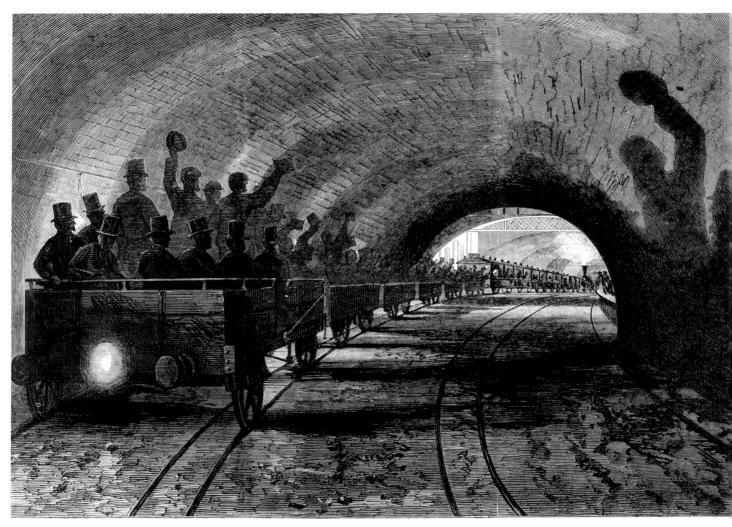

The Times said of the Metropolitan Railway: 'Even if it were accomplished it would certainly never pay.' It opened in 1863 and 100 years later the Underground was still expanding.

LONDON TRANSPORT SOUVENIR TICKET
OPENING OF THE
VICTORIA LINE
BY HER MAJESTY THE QUEEN
ON FRIDAY 7 MARCH 1969
Available for travel from Green Park to Oxford
Circus and return to Victoria on 7 March 1969

CAR No. 4 — LONDON TRANSPORT EXECUTIVE — CAR No. 4

Admit

W Fenton Esq.

to BRIXTON UNDERGROUND STATION *for the opening of*

THE BRIXTON EXTENSION OF THE VICTORIA LINE

by Her Royal Highness
PRINCESS ALEXANDRA

VICTORIA LINE 11 15 FRIDAY 23 JULY 1971 VICTORIA LINE

(Guests are asked to arrive between 10 40 and 11 00)

ABOVE
Train of shareholders and dignitaries at Portland Road Station on a tour of inspection prior to the official opening of the Metropolitan Railway. The stygian gloom is well conveyed despite the absence of smoke, though technical detail leaves something to be desired. Newspaper engraving, 170 x 236mm, 1863.

LEFT
Souvenir ticket for use in the then new automated machines.
Actual size. 1969.

BELOW LEFT
Car card and admission ticket.
102 x 127mm, 1971.

FACING PAGE ABOVE LEFT
Programme, 204 x 126mm, 1977.

FACING PAGE ABOVE RIGHT
Face and reverse sides of the all-line one day ticket issued to guests.
Actual size, 1979.

FACING PAGE BASE
Souvenir booklet for guests at the opening ceremony.
194 x 254mm, 1979.

OPENING

of the extension of the London Underground to

HEATHROW AIRPORT

by Her Majesty

THE QUEEN

Friday 16 December 1977

PROGRAMME

LONDON TRANSPORT EXECUTIVE

LONDON TRANSPORT SOUVENIR TICKET

OPENING OF THE

JUBILEE LINE

by His Royal Highness

THE PRINCE OF WALES

ON MONDAY 30 APRIL 1979

On the same day, this ticket is available
for unlimited travel by Underground trains
except as shown on the reverse

LONDON TRANSPORT

Issued subject to the Bye-laws and
conditions applicable to Passenger Tickets of
The London Transport Executive

0301

NOT TRANSFERABLE

This ticket is NOT available
to or from stations

KENSAL GREEN-WATFORD JUNCTION

The Jubilee Line

BRANDLING JUNCTION RAILWAY.

OPENING

OF THE

MARKET-PLACE LINE,

AT SOUTH SHIELDS.

The Inhabitants of South Shields, and the Public in general, are respectfully informed, that the Train will start from the NEW STATION on this Line, on

SATURDAY MORNING, Dec. 17, 1842,

At EIGHT o'Clock, and will continue to run thereon at such hours as will be stated in future Handbills.

FARES.

South Shields to Gateshead,　1st Class, 9d.; 2nd Class, 6d.
"　"　Wearmouth, 1st Class, 9d.; 2nd Class, 6d.

N.B. There will be a STATION at GREWCOCK'S CORNER to take up and set down Passengers.

Railway Office, Gateshead, December 14, 1842.

PRINTED BY WILLIAM DOUGLAS, OBSERVER OFFICE, HIGH-STREET, GATESHEAD.

ABOVE
Poster, 498 x 384mm, 1842.

BELOW
A Stockton and Darlington attempt to share through traffic

after opening a short line at South Church.
Notice, 254 x 380mm, 1842.

RIGHT
Newspaper notice, actual size, 1849.

THE

CHEAPEST AND EASIEST ROUTE

FROM

SCOTLAND

TO

THE SOUTH.

The Public are respectfully informed that a Communication is opened between Carlisle and London, with only Fourteen Miles of Road Travelling.

Passengers leaving Carlisle by the 8·30 a.m. Train, will proceed by the Newcastle and Carlisle and Brandling Junction Railways to Rainton, thence by Superior fast Four-horse Omnibuses through Durham to South Church, afterwards by Rail via Darlington and York, and arrive in London at Five o'clock the following Morning.

Manchester, Sheffield, and Lincolnshire Railway.
OPENING OF THE LINE
To Lincoln, Gainsborough, Market Rasen, Hull, Great Grimsby, &c.

THE Public are respectfully informed, that the portion of the Manchester, Sheffield, and Lincolnshire Line between Sheffield and Gainsborough, will be OPENED for passenger and merchandise traffic, on the 17th instant, thus forming a direct communication between the south-eastern and north-western parts of England, as well as between the ports of Liverpool, Hull, and Great Grimsby.

Times of Arrival and Departure at the following Places, until further Notice, viz. :—

UP TRAINS.—WEEK DAYS. / SUNDAYS.

FROM	1	2	3	4	5	6	7	S1	S2	S3	S4
	1,2,3 *Class	1,2,3 Class	1,2 Class	1,2,3 Class	1,2 Class	1,2, Class.	1,2,3 Class	1,2,3 Class	1,2,3 Class	1,2,3 Class	1,2,3 Class
	a.m.	a.m.	a.m.	a.m.	a.m.	p.m.	p.m.	a.m.	a.m.	p.m.	p.m.
Lime-street Station, Liverpool	9 0	..	10 40	2 0	4 30	..	6 45
MANCHESTER	..	6 0	10 30	11 30	2 0	3 45	6 0	..	8 20	2 0	6 0
SHEFFIELD	6 15	8 5	12 14	1 25	4 5	5 36	7 55	8 10	10 25	4 5	7 55
WORKSOP	6 54	8 44	12 48	..	4 44	6 10	—	8 49	11 4	4 44	—
RETFORD	7 12	9 2	1 6	..	5 2	6 28		9 7	11 22	5 2	
GAINSBOROUGH	7 34	9 24	1 25	..	5 24	6 47		9 29	11 44	5 24	
Lincoln	8 18	10 8	2 40	7 38		..	12 30	6 8	
Boston	9 43	11 33	4 15	9 3		..	2 3	7 33	
Peterborough	11 37	12 50	5 39	10 48		..	3 37	..	
Norwich	4 50	—	10 40	8 35	..	
Cambridge	1 58	..	7 42	1 45		..	6 5	..	
Ely	1 13	..	6 55	12 8		..	5 24	...	
Huntingdon	1 0	..	6 50	
St. Ives	1 20	..	7 3	
London, E. Counties	4 20	..	11 0	4 15		..	9 40	..	
London, L. & N. West	9 50	
BRIGG	8 20	10 10	2 4	..	6 10	7 26		10 15	12 30	6 10	
GREAT GRIMSBY	9 27	11 33	2 48	..	7 11	8 13		..	1 25	7 10	
HULL Arrival	9 35	11 20	3 10	..	7 20	8 32		11 25	1 40	7 20	

DOWN TRAINS.—WEEK DAYS. / SUNDAYS.

FROM	1	2	3	4	5	6	7	8	S1	S2	S3	S4
	1,2 Class.	1,2,3 Class.	1,2 Class.	1,2,3 Class.	1,2 Class.	1,2 Class.	1,2,3 Class.	1,2,3 Class.	1,2,3 Class.	1,2,3 Class.	1,2,3 Class.	1,2,3 Class.
	a.m.	a.m.	a.m.	p.m.	p.m.	p.m.	p.m.	p.m.	a.m.	a.m.	p.m.	p.m.
HULL	..	6 0	9 10	..	12 45	3 15	..	5 45	..	8 15	3 15	5 45
GREAT GRIMSBY	..	6 15	9 19	..	12 48	3 15	..	5 40	..	8 38	..	5 40
BRIGG	..	7 12	10 18	..	1 57	4 23	..	6 57	..	9 32	4 27	6 57
London L & N West	7 15	..	11 0	7 30	..
Lond. E. Counties	6 0	..	11 30	7 0	..
St. Ives	10 14
Huntingdon	10 35	..	2 40
Ely	10 20	..	2 25	10 35	..
Cambridge	9 34	..	1 48	9 50	..
Norwich	7 40	..	11 0	6 30	..
Peterborough	7 20	12 25	..	4 0	12 40	..
Boston	..	6 0	8 44	1 45	..	5 40	..	8 5	2 10	..
Lincoln	..	7 14	10 9	3 15	..	6 58	.	9 30	3 35	..
GAINSBOROUGH	..	7 56	10 55	..	2 39	5 0	..	7 41	..	10 16	5 11	7 39
RETFORD	..	8 19	11 17	..	3 4	5 22	..	8 4	..	10 39	5 34	8 4
WORKSOP	..	8 38	11 35	..	3 22	5 40	..	8 22	..	10 57	5 52	8 22
SHEFFIELD	8 30	9 24	12 16	2 40	4 9	6 21	7 0	8 59	8 0	11 44	6 39	8 59
MANCHESTER	10 25	11 19	1 51	4 35	6 4	7 56	8 55	..	9 55	1 39	8 34	..
Liverpool, Lime-st Station	12 30	12 30	3 15	6 5	7 50	9 50

Fares between Manchester and Hull.

	1st. Class.	2nd. Class.	3rd. Class.
Express	20s. 8d.	16s. 0d.	
Ordinary	18s. 6d.	14s. 6d.	9s. 3d.

* The classes above specified refer to the train of the Manchester, Sheffield, and Lincolnshire Railway only. For further particulars, see the Company's Time Bills.

By Order, C. W. EBORALL.

Traffic Manager's Office, Manchester, July 11th, 1849.

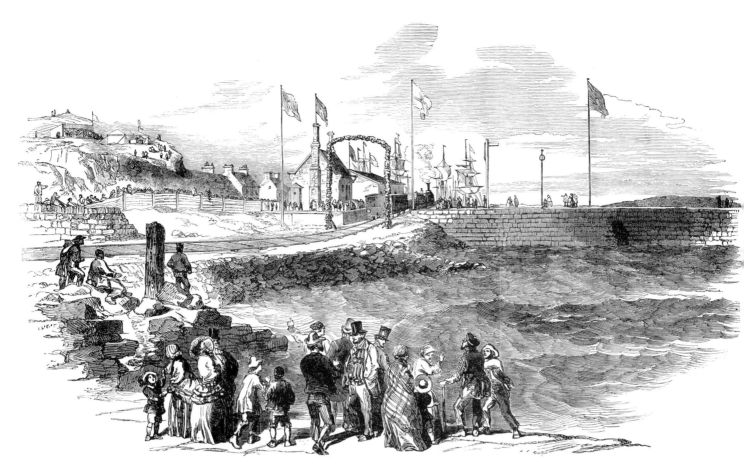

Around the land the scene followed a pattern.

ABOVE
Opening day of of the Morayshire Railway at the terminus at
Lossiemouth.
Engraving 145 x 234mm, 1852.

BELOW
The South Wales Railway opens at Carmarthen
Engraving, actual size, 1852.

FACING PAGE
Behind the scenes of the opening of the line.

ABOVE LEFT AND RIGHT
Circulars, 218 x 143mm, 1897 & 1898.

BELOW LEFT
Circular, 250 x 157mm, 1898.

BELOW RIGHT
Circular, 242 x 166mm, 1901.

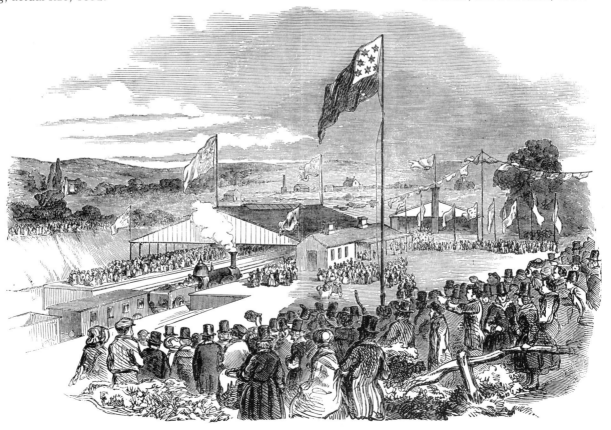

PRIVATE.—For use of Company's Servants only.

GREAT WESTERN RAILWAY.

(Circular No. 1096).

OFFICE OF SUPERINTENDENT OF THE LINE,
PADDINGTON STATION, *August 30th*, 1897.

OPENING

OF THE

BROMYARD & STEENS BRIDGE LINE.

(F. 46966).

On **Wednesday, September 1st, 1897,** the above Line will be opened for Traffic. The new Stations are named "**Rowden Mill**" and "**Fencote**," situated between Bromyard and Steens Bridge, the distances being as follows :—

STATION.	Distance from Bromyard.	Distance from Steens Bridge.
	MILES.	MILES.
Rowden Mill...	3	6
Fencote...	5	4

For particulars of Train Service see separate Time Bills. Through Fares and Rates will be supplied as required.

Parcels.—Parcels may be booked through to and from your Station and **Rowden Mill** and **Fencote** at the Clearing House Scale, and the way-bills must be abstracted as "local" traffic.

☞ Insert in alphabetical order the above-named Stations on your Local Stations Card.

Advise all concerned, and acknowledge receipt to your Divisional Superintendent.

T. I. ALLEN,
Superintendent of the Line.

Mr. _____

_____ *Station.*

WYMAN & SONS, Ltd., Printers, 63, Carter Lane, Doctors' Commons, E.C. (6932a)

PRIVATE.—For use of Company's Servants only.

GREAT WESTERN RAILWAY.

(Circular No. 1120).

OFFICE OF SUPERINTENDENT OF THE LINE,
PADDINGTON STATION, *April 1st*, 1898.

OPENING

OF THE

LAMBOURN VALLEY (LIGHT) RAILWAY.

On **Monday, April 4th, 1898,** the above Light Railway, which is a Branch from Newbury, will be opened for Traffic. The Stations are **Speen, Stockcross and Bagnor, Boxford, Welford Park, West Shefford, East Garston, Eastbury, and Lambourn,** and the distances from Newbury are as follows :—

STATION.	Distance from Newbury.	STATION.	Distance from Newbury.
	MILES.		MILES.
Speen	2	West Shefford ...	8
Stockcross & Bagnor	3	East Garston ...	10
Boxford	5	Eastbury ...	11
Welford Park ...	6	Lambourn... ...	12

The Line will be worked by the Lambourn Valley Company. For particulars of Train Service see separate Time Bill.

Parcels.—Parcels may be booked through to and from your Station and the above-named Stations on the Lambourn Valley (Light) Railway *via* Newbury at the Railway Clearing House Scale according to distance to Newbury **plus an additional charge of 4d. per parcel,** and the way-bills must be abstracted on local Abstracts Nos. 2597 or 2598 after the total of the "local" Traffic.

There will be Horse and Carriage accommodation at Lambourn and for Horses only at West Shefford.

☞ As the Accounts for this Railway will be dealt with through "Private Settlement" insert the above Stations at the end of your Local Stations Card, thus :—

Boxford
Eastbury
East Garston
Lambourn } Lambourn Valley (Light) Railway *via* Newbury.
Speen
Stockcross & Bagnor
Welford Park
West Shefford

Advise all concerned, and acknowledge receipt to your Divisional Superintendent by First Train.

T. I. ALLEN,
Superintendent of the Line.

Mr. _____

_____ *Station.*

WYMAN & SONS, Ltd., Printers, 63, Carter Lane, Doctors' Commons, E.C. [8988a]

PRIVATE.—For use of Company's Servants only.

GREAT WESTERN RAILWAY.

(Circular No. 1110.)

OFFICE OF SUPERINTENDENT OF THE LINE,
PADDINGTON STATION, *January 13th*, 1898.

OPENING OF THE
SOUTH HAMS (YEALMPTON) LINE.

(F. 47260.)

On **Monday, January 17th, 1898,** the above Line will be opened for Traffic. The new Stations are Plymstock, Billacombe, Brixton Road, Steer Point, and Yealmpton, the distances from Mutley being as follows :—

STATIONS.	Mutley & Stati'ns west thereof. To be added to Mutley distance.	Stations east of Mutley. To be added to Mutley distance.
	Miles.	Miles.
PLYMSTOCK	3	1
BILLACOMBE	4	2
BRIXTON ROAD	5	3
STEER POINT	7	4
YEALMPTON	9	6

The New Line runs from Mutley to Yealmpton via Plymstock as per sketch.

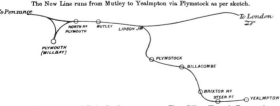

For particulars of Train Service see separate Time Bills. Through Fares and Rates will be supplied as required.

Parcels.—Parcels may be booked through to and from your Station and **Plymstock, Billacombe, Brixton Road, Steer Point, and Yealmpton** at the Clearing House Scale, and the way-bills must be abstracted as "local" traffic.

Erase Plymstock from Circular 1006, and treat Plymstock Traffic as Local to G. W. R.

☞ Insert in alphabetical order the above-named Stations on your Local Stations Card.

Advise all concerned, and acknowledge receipt to your Divisional Superintendent.

T. I. ALLEN,
Superintendent of the Line.

Mr. _____

_____ *Station.*

WYMAN & SONS, Ltd., Printers, 63, Carter Lane, Doctors' Commons, E.C. (8077a)

PRIVATE AND NOT FOR PUBLICATION.—(For use of the Company's Servants only.)

GREAT WESTERN RAILWAY.

(Circular No. 1294.)

OFFICE OF SUPERINTENDENT OF THE LINE,
PADDINGTON STATION,
April 1st, 1901.

OPENING
OF
CHEADLE (STAFFORDSHIRE) RAILWAY.

(F. 66489.)

The above Railway, which joins the North Staffordshire Railway at Cresswell, was opened for **PASSENGER TRAIN TRAFFIC (EXCEPT HORSES AND CARRIAGES)** on the 1st January, 1901.

The Stations on the Cheadle (Staffs.) Railway and distances are as follows :—

Station.	Distance from Cresswell.
	Miles.
TOTMONSLOW	2
CHEADLE (Staffs.)	4

Parcels, Milk, Dogs (and other small animals that can be conveyed in the Guard's Van), Perambulators, Bicycles, Excess Luggage, Corpses, and Returned Empties may be booked through to Totmonslow and Cheadle, via Market Drayton, N. S. Rly., and Cresswell, at the charge to Cresswell **PLUS** the following amounts :—

Parcels	2d. each up to 56 lbs., 2d. extra for each additional 56 lbs. or part thereof.
Milk	1½d. per Churn, minimum 2d., Owners Risk, including carriage of Returned Empty Churns.
Dogs and Small Animals that can be conveyed in Guard's Van	1d. each.
Perambulators and Bicycles ...	2d. each.
Excess Luggage	1d. per 14 lbs.
Returned Empties	Packages up to 14 lbs., 1d.
	,, 15 lbs. to 28 lbs., 2d.
	,, 29 ,, ,, 56 ,, 3d.
Corpses	Adults, 7s. 6d. each.
	Children, 5s. ,,

Traffic must be abstracted as Railway Clearing House.

All previous Circulars and Instructions referring to these subjects are cancelled.

Receipt of this Circular to be acknowledged to your Divisional Superintendent by First Train.

T. I. ALLEN,
Superintendent of the Line.

T. I. Allen Esq

_____ *Station.*

WYMAN & SONS, Ltd., Printers, 63, Carter Lane, Doctors' Commons, E.C. (10498a)

OPENING

OF THE

MELBOURNE RAILWAY

MR. THOMAS COOK

(Formerly of Melbourne)

Respectfully intimates to his old Friends and Fellow Townspeople that, in connection with the visit of his

FIRST EXCURSION PARTY,

FROM LEICESTER,

ON THURSDAY, SEPTEMBER 10th, 1868,

(To arrive at about 4-0 p.m.,)

HE WILL GIVE AN

ADDRESS

IN THE ATHENÆUM,

TO INHABITANTS & VISITORS,

Briefly recapitulating some of the events of his EXCURSION and TOURIST LIFE, since leaving Melbourne nearly 40 years ago; and anticipatory of his approaching Trips to

ITALY, EGYPT & PALESTINE

FREE ADMISSION

AFTER TEA, AT HALF-PAST SEVEN O'CLOCK.

T. COOK, Printer, Granby Street, Leicester.

He seemed the impersonation of the moving, active spirit of the age; and though mechanical agencies had raised him to so high a reputation, it was not the successful engineer, but the thinking man before whom one bent as to a superior.
What faults he had (and who will pretend that he was without them) cease to be remembered, now that he is no more.
Take him for all in all, we shall not look upon his like again.'

Obituary to George Stephenson,
Derby and Chesterfield Reporter, 1848

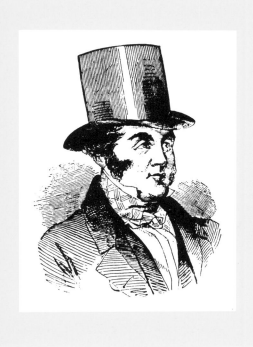

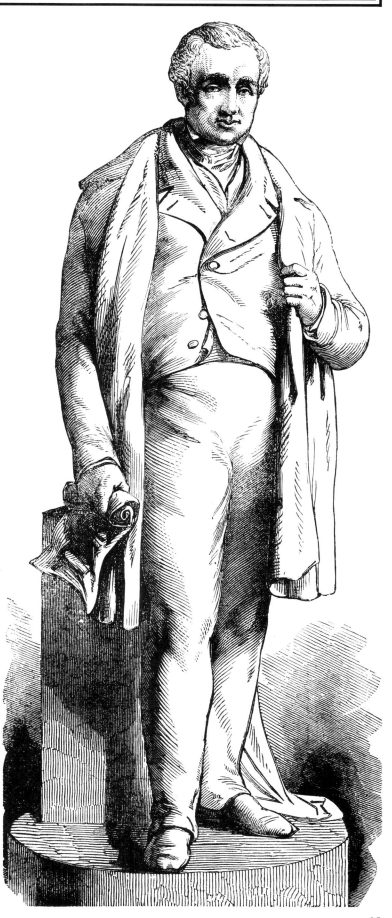

The engineer and the entrepreneur. Lifelong friends, the great Georges combined to provide the vision and then the reality of a national railway network.

ABOVE
George Hudson, financial enigma, as a young man. Engraving, actual size, 1845.

RIGHT
George Stephenson by E.H. Bailey RA. The statue erected in the Great Hall, Euston Station seen in a contemporary report; *Illustrated London News.* Engraving, 193 x 80mm, 1852.

LEFT
The prodigal son returns.
Notice, 355 x 254mm, 1868.

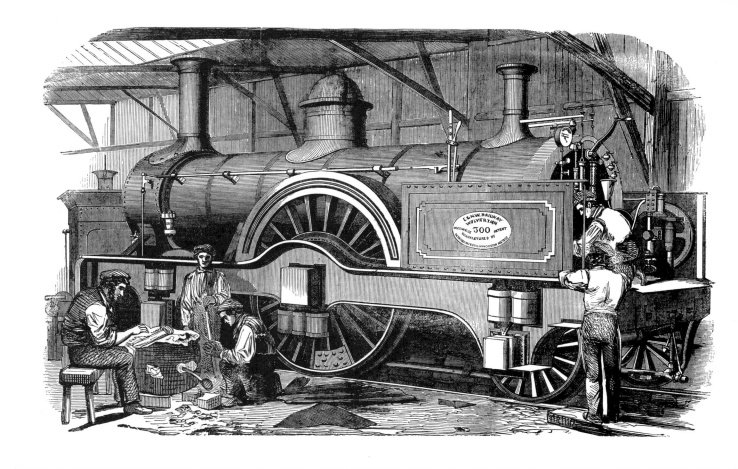

This Indenture

made the Day of

in the Year of the Reign of our Sovereign Lady VICTORIA, by the Grace of God of the United Kingdom of *Great Britain and Ireland*, QUEEN, Defender of the Faith, and in the Year of our LORD One Thousand BETWEEN

of the one Part, and THE NORTH EASTERN RAILWAY COMPANY of the other Part: WITNESSETH, That the said hath of his own Free Will, and with the Consent of his said put and bound himself Apprentice with the said NORTH EASTERN RAILWAY COMPANY, hereinafter called Masters, and with them after the manner of an Apprentice to remain and serve from the day of One Thousand for, during, and until the Term of Years thence next following to be fully complete and ended; DURING all which Term the said Apprentice his said Masters well and faithfully shall serve, their Secrets shall keep, their lawful Commands shall do, Fornication or Adultery he shall not commit, Hurt or Damage to his said Masters shall not do or consent to be done, but to the utmost of his power shall prevent it, and forthwith his said Masters thereof warn; Taverns or Ale houses he shall not haunt or frequent unless it be about his Masters' Business there to be done; at Dice, Cards, Tables, Bowls or any other unlawful Games he shall not play; the Goods of his said Masters shall not waste, nor them lend or them give to any person without his said Masters' Licence; Matrimony within the said term he shall not contract, nor from his Masters' service at any time absent himself, but as a true and faithful Apprentice shall order and behave himself towards his Masters as well in Words as in Deeds during the said term; and a true and just Account of all his said Masters' Goods, Chattels, and Money committed to his charge, or which shall come to his hands, faithfully he shall give at all times when thereunto required by his said Masters or their Assigns. AND the said for self, his Heirs, Executors, and Administrators doth covenant with the said Company, their Successors, or Assigns, that the said Apprentice will during the said term faithfully serve the said Company in manner aforesaid; and that the said will throughout the said term find and provide the said Apprentice with good and sufficient Meat, Clothing, Lodging, and Washing, and, in case of sickness, with Medicine and Medical Attendance; and the said Company for themselves, their Successors, or Assigns doth covenant, promise, and agree by these Presents, to and with the said and the said Apprentice, that they the said Company shall and will teach, learn, and instruct him, the said Apprentice, or cause him to be taught, learned, or instructed in the trade or business of a in their Permanent Way Department, at after the best manner that they may or can, with all Circumstances thereunto belonging; And also will pay or otherwise allow the said Apprentice during the said term the weekly wages following, namely: shillings weekly during the first year of the said term shillings weekly during the second year thereof, shillings weekly during the third year thereof, shillings weekly during the fourth year thereof, shillings weekly during the fifth year thereof, and shillings weekly during the and last year of the said term; Provided always that in case the said Apprentice shall at any time or times during the said term be absent from his said work by reason of sickness, lameness, or from any other cause (unless such absence be caused through injury received in the Company's service, or through general holidays in the works), then and in such case the said Apprentice shall not be entitled to receive any wages for or in respect of such day or days during which he shall be so absent from his said work as aforesaid.

And for the due performance of all and singular the Covenants and Agreements aforesaid, each of the Parties aforesaid doth bind himself unto the other firmly by these Presents. In Witness whereof, the Parties above named to these present Indentures, interchangeably have set their Hands and Seals the Day and Year above written.

Signed, Sealed, and Delivered by the above-named

in the presence of

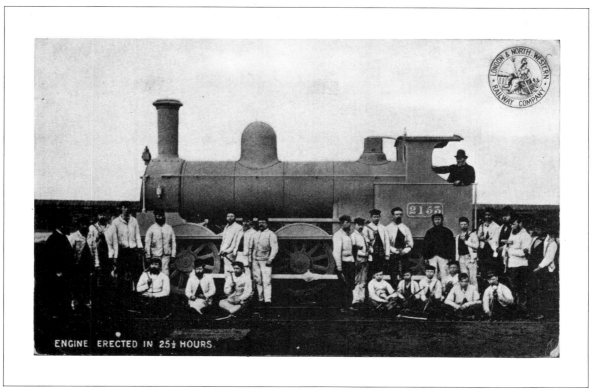

ENGINE ERECTED IN 25½ HOURS.

The engine builders.

ABOVE LEFT
Times don't change or is it the lunch break? Mr. McConnell's express passenger engine under construction at Wolverton works, London and North Western Railway.
Engraving, 150 x 235mm, 1852.

ABOVE RIGHT
A change of pace. At the turn of the century many companies indulged in spirited competition to build a locomotive in the shortest time. The London and North Western men at Crewe, (foreman on the footplate) don't appear to be over enthusiastic.
Postcard, actual size, 1905.

BELOW RIGHT
In contrast W. Heath Robinson saw the Great Western engine builders to be full of ingenuity and enthusiasm.
'Building the first locomotive' from Railway Ribaldry.
Actual size, 1935.

BELOW LEFT
. . . and to join this happy band an apprenticeship was necessary. A very forbidding prospect.
Apprenticeship indenture, North Eastern Railway, 344 x 420mm, 1900.

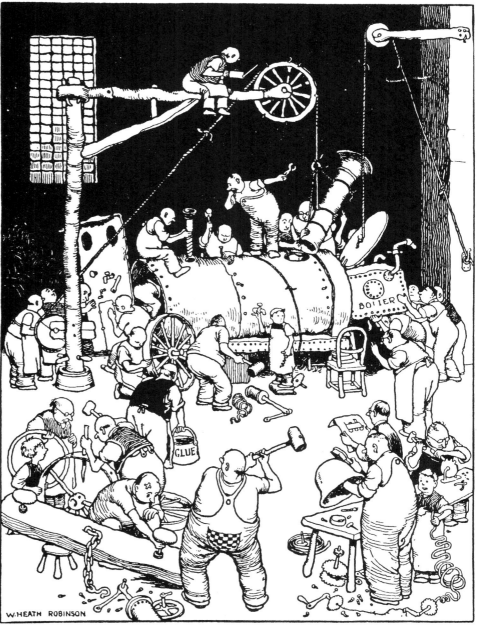

W. HEATH ROBINSON

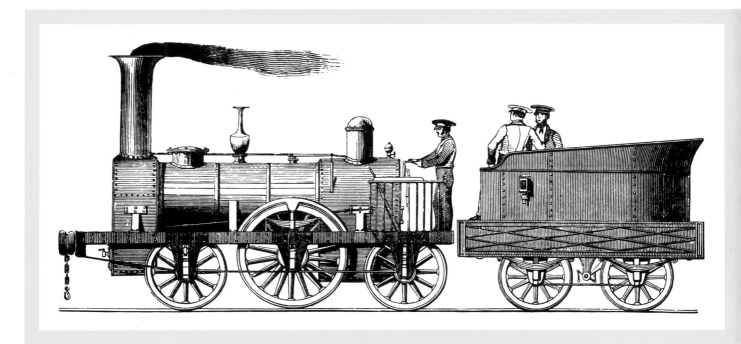

Early Enginemen.

ABOVE

Overstaffing on a Robert Stephenson standard passenger engine of 1836. Typefounder Caslon's catalogue included this stock block 18 years later. Note the different type sizes for engine and tender.
Actual size, 1854.

BELOW

Also from the same *'Series of Modern Railway Designs'* an equally clean driver is more actively engaged.
208 x 152mm, 1854.

RIGHT

The reality of life (and death) on the footplate
Card, 317 x 215mm, 1840.

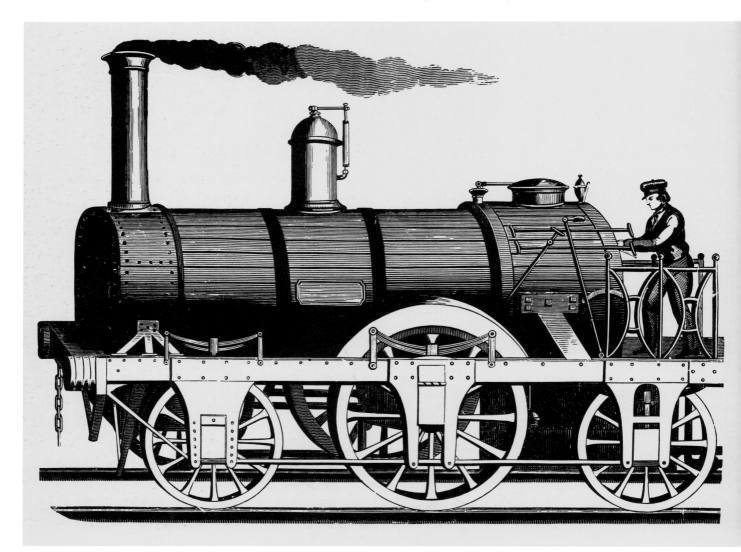

AN EPITAPH

ON

OSWALD GARDNER,

Locomotive Engineman,

WHO UNFORTUNATELY LOST HIS LIFE NEAR THE STOKESFIELD STATION,

NEWCASTLE AND CARLISLE RAILWAY

FROM THE CONNECTING ROD OF THE ENGINE BREAKING

ON SATURDAY, AUGUST 14th, 1840.

HE WAS TWENTY-SEVEN YEARS OF AGE, AND WAS HIGHLY ESTEEMED FOR HIS
MANY AMIABLE QUALITIES BY HIS FELLOW-WORKMEN, AND HIS DEATH WILL BE
LONG LAMENTED BY ALL WHO HAD THE PLEASURE OF HIS ACQUAINTANCE. THESE
LINES WERE COMPOSED BY AN UNKNOWN FRIEND, AND LEFT AT THE BLAYDON
STATION; AND AS A MEMENTO OF THE WORTHINESS OF THE DECEASED, HAVE BEEN
PRINTED, WITH SOME EMENDATIONS, AT THE EXPENSE OF HIS FELLOW-WORKMEN

My *Engine* now is cold and still,
No water does my *boiler* fill ;
My *coke* affords its flame no more
My days of usefulness are o'er
My *wheels* deny their noted speed ;
No more my guiding hand they heed.
My *whistle*, too, has lost its tone.
Its shrill and thrilling sounds are gone.
My *valves* are now thrown open wide.
My *flanges* all refuse to guide.
My *clacks*, also, though once so strong.
Refuse their aid in the busy throng.
No more I feel each urging breath,
My *steam* is now condens'd in death.
Life's *railway's* o'er, each *station's* past.
In death I'm stopp'd and rest at last.
Farewell, dear friends, and cease to weep !
In CHRIST I'm SAFE, in HIM I sleep.

COULTAS, PRINTER, YORK.

Eastern Counties
RAILWAY.

LIST OF
ENGINE-DRIVERS & FIREMEN
Who Resigned their Situations on the 12th of August, 1850.

ENGINE-DRIVERS.

William Young	Joseph Okell	George Mayne	James Challinor
Joseph Kinnerley	James Dawes	Thomas Reynolds	William Gordon
John Greener	Edward McKew	Henry Brownhill	Robert Minns
John Reay	George Brown	William Lindsley	James Pegg
James Jones	George Claridge	John Wilton	James George
Edward Reay	George Burling	John Reese, sen.	Benjamin Giles
William Cook	Charles Williamson	William Rowell	George Hincliffe
Thomas Thornton	Robert Stewart	Joseph Stevenson	George Mitchell
James Monks	John Green	Charles Watkins	John Scott
George Brown	Edward Mark	Henry Harris	John Thorpe
William Hewitt	George Jenkins	Anthony Cooper	George Blackbird
Philip Tatley	Samuel Barrow	Alfred Polton	George Crumbie
Walter Dawson	Robert Hines	Charles Clark	Thomas Slater
William Woodhouse	James Nelson	Michael Bird	John Annon
James Bartram	Joseph Tutton	Thomas Terrill	George Deacon
Robert Cree	Vincent Grundy	Joseph Slater	Thomas Gadd
Samuel Jackson	John Terrill	George Fletcher	John Young
William Howard	James Steel	Thomas Davison	Robert Edson
David Grundy	James Hargreaves	William Ayres	William Grant
James Jenkins	Edward Holness	Thomas Pameley	Peter Ashley
Alexander Hindmarsh	Robert Fawcett	William Brown	John Thomas Hope
Robert Hallows	Joseph Pamley	William Livesey	William Dempsey
William Rowell	John Fawcett		

FIREMEN.

Jonathan Oxley	James Lambourn	James Horn	William Dugard
Charles Warren	Richard Watkins	George Baker	Edward Wooden
Daniel Lambert	William Webster	James Dickenson	William Stearn
John Braithwaite	Jonathan Gibson	William Christian	William Gregory
Daniel Holden	James Dearman	John Reese, Jun.	John H. Beetson
James Raistrick	Thomas McCue	James Head	William Leonard
Edward Knevitt	Thomas Gordon	Richard Lindle	Edward Horsley
Edward Lushey	William Jolly	James Boothroyd	Thomas Roxby
William West	Joseph Watkins	Henry Cranwell	Benjamin Thompson
Joseph Pegg	Thomas Wilson	John Knight	John Wayne
Daniel Armstrong	John Garner	Richard Smart	Edgar Dawson
Thomas Carter	Thomas Murphy	James Keetch	William Bailey
Charles Devall	William Cowen	George Orbine	George Drake
Henry Shrimpton	James Bull	Samuel Saul	John Crumbie
Oswald Hogarth	Thomas Manooch	Thomas Clarke	Andrew Thompson
John Gandy	Henry Dawson	Thomas Hallows	George Lindsley
Joseph Cranmer	William Bird	Henry Harrell	John Betts
John Golding	James Gregory	Godfrey Lennett	John Lish
George Cornwell	Henry Deadman	John Mays	George Brewster
Richard Stanton	Charles Ellis	William Claridge	John Dickenson
William Wilson	James Burrows	John Pestle	Thomas Harrell
Christopher Tatley	James Higlie	William Overton	

NOTICE
TO THE PUBLIC.

IN CONSEQUENCE OF THE

STRIKE OF ENGINEMEN

ON THE

Stockton & Darlington & North Eastern Railway,

THEIR PLACES BEING FILLED

By Inexperienced Men,

THE PUBLIC ARE

CAUTIONED AGAINST TRAVELLING.

Three moves towards ending a strike.

LEFT
The simple company initiative: a black list.
Notice, actual size, 1850.
Courtesy Ephemera Society

ABOVE
A union plea for support.
Notice, 205 x 285mm, 1859.

RIGHT
The iron hand of government (as wielded by the directors of the Great Western Railway).
Card, actual size, 1919.

RAILWAY STRIKE, 1919.

The Prime Minister wishes it to be known that the Government are determined to see the Strike through and to use all its resources to this end.

Will the General Manager advise his Chief Officers accordingly, and instruct them to do everything in their power to carry on and break the Strike.

September 28th, 1919.

WE too often hear of railway accidents and unintentional neglect of duty arising from the carelessness and incapacity of railway officials, both of the higher and the lower grades ; but we seldom hear of any acts of gross brutality, or even of incivility, on their part. When accidents occur, affecting both rich and poor, the world is duly informed of them ; but railway officers respect the rich, or those supposed to be so, and are only brutal or uncivil to the poor, who make no complaints sufficiently loud to reach the ear of newspaper readers. We cannot but take the opportunity of the melancholy death of Colonel Gordon of calling the attention of railway directors and the public to the systematic contempt with which railway officials, from directors down to porters, regard the feelings, the comfort, and the health of those whom necessity forces to travel in third-class carriages. On many of the great Continental lines, the second-class carriages are quite equal in their appointments and fittings to first-class carriages in England; while their third-class carriages are more comfortable than our second. In France, Belgium, and Germany, the third-class passengers have cushions to sit upon and to lean against, and are thoroughly protected from the weather. In England a second-class passenger may get civil treatment; but a third-class passenger seldom obtains a taste of a commodity so cheap and yet so agreeable. But, on the Continent, railway servants not only treat third-class passengers as human beings, but bestow upon them quite as much courtesy as upon those who pay higher fares. The death of Colonel Gordon is no more remarkable in itself than many other cases that are never brought under notice, in which the sufferers are obscure individuals who have none to take their part, or say a word for them. It is the rank of the victim, as well as the melancholy catstrophe of his death, that so powerfully draws public attention to this particular case. We may be tolerably certain that, if Colonel Gordon had travelled in a first-class carriage, a drunken and offensive fellow-passenger would not have been obtruded upon him, and that the Inspector on duty would not have treated any complaint which he might have had to make, either with coarse incivility or brutal outrage. But, being only a third-class passenger, it was thought that the companionship of a man maddened by excess of drink was good enough for him, and that he might be rudely assaulted for daring to complain and to insist upon his right of being treated like a gentleman. We would impress upon railway managers and officials of all degrees the duty incumbent upon them of behaving with as much courtesy to one class of travellers as to another.. The servants of railway companies acting upon the premises, and in the business of their employers, used to be considered as police constables; and if the Stafford Inspector had acted, as he should have done, in that capacity, a valuable life might have been saved to society. Wealth-worship is bad enough in itself, even if it lead to nothing worse than sycophancy towards those who can pay both for respectful behaviour and accommodation. But when neither the one nor the other can be procured without a fee, which the poor cannot pay, it becomes still more repulsive, because it becomes inhuman.

EASTERN COUNTIES RAILWAY.

RULES AND REGULATIONS.

Each Servant of the Company before he shall be allowed to serve on the Line, shall sign these Regulations, and for disobedience to which, he will be punishable as for an offence against his employers and against the law.

SIGNALS.

HAND SIGNALS.

DAY.

1. The Signal *All Right is* shown by extending the Arm horizontally, so as to be distinctly seen by the Engine Driver.

LEFT
The editor of the *Illustrated London News* had a very low opinion of railway staff.
Actual size, 1854.

BELOW
An appendix to the London, Chatham and Dover Railway rules recommends restraint with troublesome passengers.
Actual size, 1898.

ABOVE
The modest rule book of the Eastern Counties Railway.
52pp, 152 x 100mm, 1849.

FACING PAGE ABOVE
By 1917 the London, Brighton and South Coast Railway's rules and regulations occupied 400pp with appendices of over 100pp.
Page size 163 x 103mm.

FACING PAGE BELOW
Staff accident prevention was and still is a major railway problem. This booklet, by the London and North Eastern Railway, oddly uses Great Western Railway photographs.
Actual size, undated, c.1926.

Violation of Bye-laws, &c.	In cases of violation of the Company's Rules, Bye-Laws, &c., and where such violation does not affect the safety of the public or the property of the Company, the mildest means for preventing it must be adopted. When there is danger to the public, or the Company's property sustains, or is likely to sustain, damage, steps are to be immediately taken for stopping the same, but **no violence** is to be used for enforcing this Rule, unless all other means fail.
Detention of offenders.	The power of detention is to be exercised with the greatest caution, and never where the address is given, and there is no good and sufficient reason to doubt its correctness, or adequate security is offered for appearance to answer a charge. When it shall be necessary to detain any Person, such detention shall not continue for a longer period than is absolutely necessary, but he shall be conveyed before a Magistrate with as little delay as possible.
Discretion to be used.	As it is the **intent** which constitutes the offence, caution and discretion must be used in treating different cases, as it frequently occurs that Passengers travel beyond the distance for which they have paid their fare unintentionally, or even against their wish and to their inconvenience. In such cases they may be allowed to return to the Station to which they originally booked without paying additional fare, provided they return by the very next Train, and do not in the interval leave the Company's premises.
Tickets not to be issued after Train arrives.	No Ticket may be issued to any Person applying for one after the arrival of a Train at a Station, unless it shall have arrived before the time specified on the Time Bills.
No Passenger to be admitted to Booking Office after arrival of Train.	After a Train arrives, no one may be admitted into the Booking Office ; and no Ticket may be issued to any one who may get out of the Train without the sanction of the Officer in charge, nor until the Ticket which entitled him to travel to that Station has been collected and found correct.

Uniform— Wearing and care of.

4. (*a*) Every servant receiving uniform must, when on duty, appear in it clean and neat, with the number and badge (where supplied) complete ; and if any article provided by the Company be damaged by improper use, it must be made good by the servant using it.

Company's property not to be appropriated.

(*b*) Servants are not allowed to appropriate to their own use any article, the property of the Company.

Conduct of servants.

5. All servants must be prompt, civil, and obliging. They must afford every proper facility for the business to be performed, be careful to give correct information, and, when asked, give their names or numbers without hesitation.

Public safety of first importance.

6. The safety of the public must, under all circumstances, be the chief care of the servants of the Company.

Security for faithful service.

7. All persons holding situations of trust will be required to find security for their faithful services, the amount and conditions of which security will be stated upon appointment.

Pension or other Funds.

8. A copy of the Company's Pension Act, 1899, with the Rules made thereunder is sent to every servant of the Company, and every servant of the First Class under the age of 24 must, and every servant of the First Class over the age of 24, or servant of the Second or Third Class may, become a Contributing Member of the Fund. Every servant shall join any Fund, Schemes, or Society the Company may establish for the benefit of its Staff if the Rules thereof so require.

Refreshment rooms —entering without special permission forbidden.

9. No servant when on duty or in uniform is allowed to enter a Station Refreshment-room, or any other Refreshment-room under the control of the Company, except by permission of the Station-master or person in charge of the Station.

10. No servant of the Company is allowed to solicit gratuities from passengers or other persons.

Gratuities not to be solicited.

11. No servant of the Company is allowed to trade, either directly or indirectly, for himself or others.

Trading forbidden.

12. (*a*) A servant who is guilty of misconduct, *i.e.*, dishonesty, serious neglect of duty, disobedience to the orders of superiors, any act of insubordination, or drunkenness whilst on duty, will render himself liable to dismissal. Such dismissal may be either immediate or after suspension during investigation of the charge of misconduct.

Misconduct punishable.

(*b*) A servant may be suspended at any time whilst any charge against him is being investigated, and if such charge be substantiated, he may be dismissed or reduced in pay or grade.

Suspension from duty.

(*c*) All pay will be stopped when a servant is absent from duty (unless such absence is permitted under the Company's Rules and Regulations in force for the time being without stoppage of pay) whether on account of sickness, leave of absence, or suspension from duty whilst any charge brought against the servant is being investigated. In any case of suspension which is followed by dismissal, the Company's liability to pay the servant's wages will cease from the date of the commencement of the suspension. In any case of suspension which is followed by reduction in pay or grade, the Company's liability to pay the servant's wages at the rate in force previous to such reduction will cease from the date of the commencement of the suspension.

Stoppage of pay during absence.

13. No servant is allowed to leave the Company's service without giving the notice required by the terms of his engagement.

Leaving service— notice requisite.

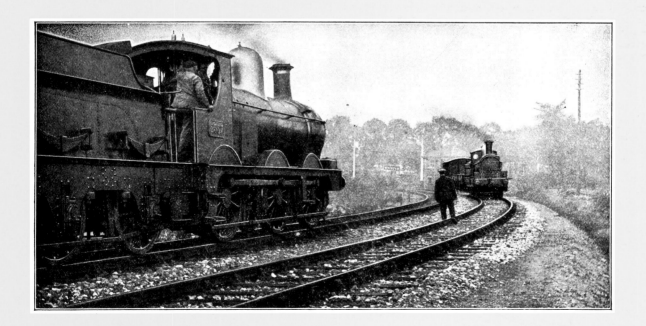

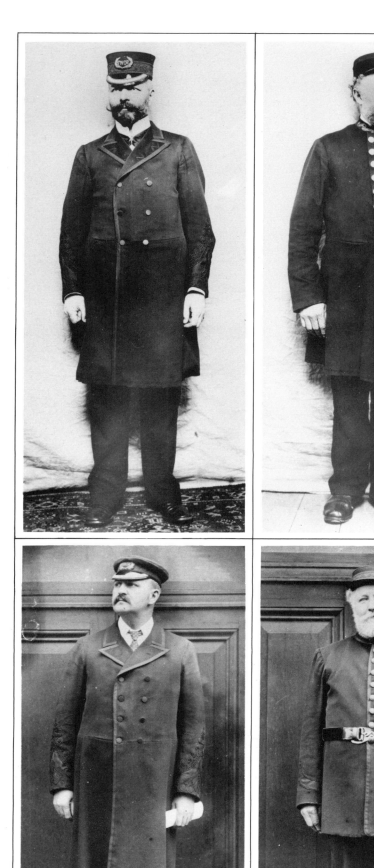
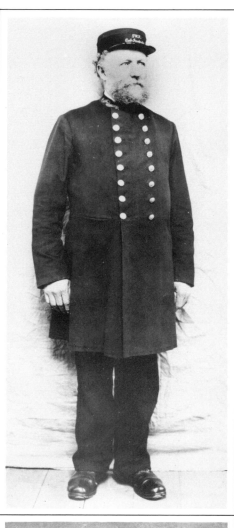
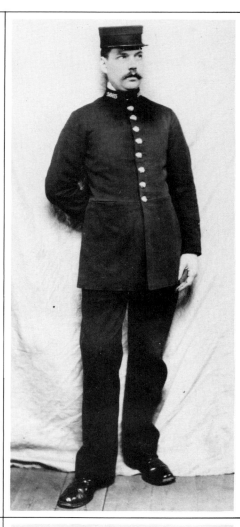
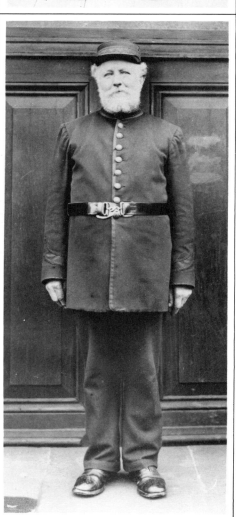
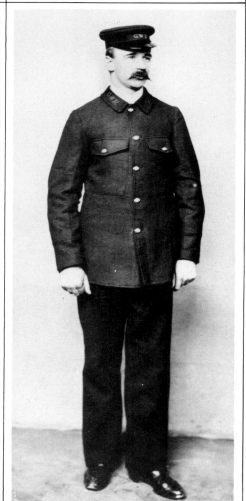

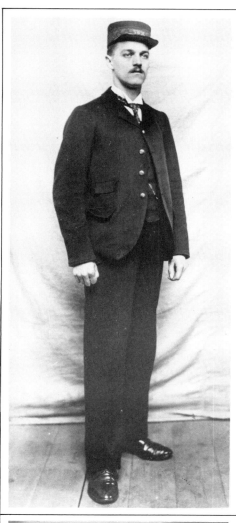

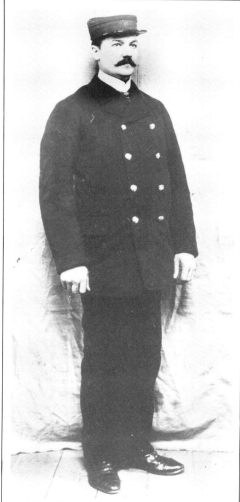

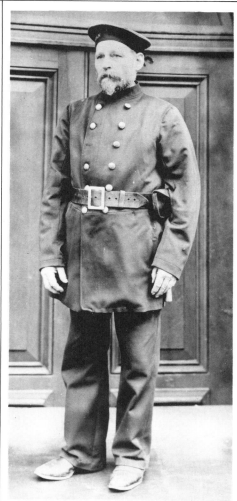

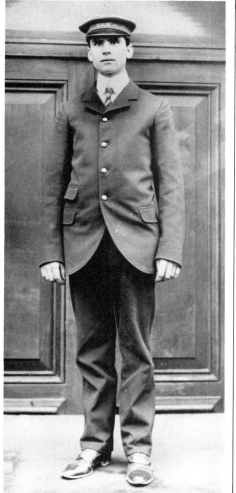

MEMORANDUM OF SUGGESTED CHANGE IN STYLE AND MATERIAL OF UNIFORM CLOTHING AND REVISION OF THE CAP AND CLOTHING CONTRACTS, WITH STANDARD LIST OF CLOTHING, AUTHORISED BY THE DIRECTORS TO BE ISSUED TO THE STAFF OF THE GREAT WESTERN RAILWAY.

To the directors of the Great Western Railway the beginning of a new century seemed an appropriate time to create a new image, and at the same time save a little money. By a redesign, incorporating longer-lasting materials, the overall cost of staff uniforms could be reduced from £43,730 to £38,730. The memorandum not only showed photographs of the old and proposed new styles but gave a comprehensive description, numbers involved, costs and life expectancy. (See overleaf). This selection begs the question: is change always for the best? All the recommendations were adopted in 1902.

FROM LEFT TO RIGHT (Old style at the top, new below):
First class stationmaster, cab inspector, signalman, office messenger, parcels carman (no change), fireman (no change).
Page size 319 x 200mm, 1900.

15. Rates of Pay.

DRIVERS.

1st and 2nd years	12/- per day.
3rd and 4th years	13/- ,, ,,
5th, 6th, and 7th years	14/- ,, ,,	
8th year and onwards	15/- ,, ,,	

These rates include the War Wage.

FIREMEN.

1st and 2nd years	9/6 per day.
3rd and 4th years	10/6 ,, ,,
5th year and onwards	11/- ,, ,,	

These rates include the War Wage.

Signalmen.

No.....2,600

Clothing now supplied.	Annual cost
Cap yearly.............................	1 . 4
Overcoat every 2 years at 23/6..........	11 . 9
Tunic every 2 years at 19/9.............	9 . 11
Cloth trousers every 6 months at 11/3...£1 . 2 . 6	
Cloth vest sleeved every year........... 7 . 0	
	£2 . 12 . 6

Description.

Cap, Overcoat, Tunic and trousers, same as supplied to Sergeants, with the exceptions that the number is put on the collar in brass instead of worsted, and there are no buttons on the cuffs.

Vest. Dark blue cloth, linen sleeves, G. W. R. buttons.

Clothing to be supplied	Annual cost
Cap yearly.............................	
Overcoat every 2 years at 21/-..........	10 . 6
Serge Jacket every 12 months at 10/2....	10 . 2
Serge trousers every 6 months at 6/8....	13 . 4
Serge vest sleeved yearly............... 6 . 0	
	£2 . 0 . 0

Description.

Cap. Dark blue cloth with overlapping crown, turn down rounded peak, one red pipe around crown, badge "G. W. R." in red worsted in front.

Overcoat Rough dark blue pea cloth, badge "G. W. R." in red worsted on each end of collar, G. W. R. buttons, vertical pockets.

Jacket. Dark blue serge, lined, small turn down collar, badge "G. W. R." in red worsted on each end of collar, pockets on right and left breasts with flaps and buttons, G. W. R. buttons.

Vest. Dark blue serge, linen sleeves, G. W. R. buttons.

Trousers Dark blue serge with red piping down the sides.

Saving (less cost of cap)...........£1,452.

LEFT
Detailed description of uniform changes for signalmen of the Great Western Railway (see pp 44 & 45).
Page size 319 x 200mm, 1900.

BELOW
The memorandum (pp 44 & 45) excluded enginemen who were not supplied with uniform. This description is from the poster/circular above right. Actual size, 1919.

ABOVE RIGHT
Conditions of service for enginemen.
Poster/circular, 556 x 756mm, 1919.

ABOVE
Details of wages from the same poster/circular.

23. Clothing.

It is agreed that the following clothing shall be supplied to Enginemen free of cost : —

2 suits of jean overalls	
1 serge jacket	Annually.
1 cap.	
1 reefer jacket, or	Every
1 overcoat	2 years.

This arrangement to commence with the next general issue of clothing.

PRIVATE FOR USE OF COMPANY'S SERVANTS ONLY.

GREAT WESTERN RAILWAY

REGULATIONS RESPECTING HOURS & WAGES OF DRIVERS & FIREMEN

(Operative on and from August 18th, 1919).
(ALL PREVIOUS REGULATIONS ARE HEREBY CANCELLED.)

Circular No. 4060.

1. Calculation of Time.

Time to be calculated at the rate of eight hours per day.

The total time for the week to be arrived at by adding the daily hours and fractions and payment for the week to be made to the nearest half of an hour.

In connection with the calculation of time in respect of payment for—
(a) Overtime
(b) Sunday Duty
(c) Night Duty

the excess payments for odd minutes for overtime, Sunday duty and night duty shall be cumulative to the end of the week, and the odd minutes then dealt with in the following manner—

(a) Periods of less than 15 minutes to be dropped.
(b) Periods of 15 minutes and up to 44 minutes ... ½ an hour
(c) Periods of 45 minutes and up to 60 minutes ... 1 hour

2. Overtime.

All time worked on week days in excess of the standard hours shall be paid for at the rate of time and a quarter, or, if between the hours of 10.0 p.m. and 4.0 a.m. at the rate of time and a half. (See Section 3 under the heading of "Night Duty.") For the purpose of computing overtime each day shall stand by itself.

Overtime rates shall not apply to any hours worked between midnight Saturday and midnight Sunday, nor from midnight Sunday to completion of turn on Sunday-Monday turns, but all time so worked shall be paid for at the Sunday rate, viz., time-and-a-half.

All week-day time worked in excess of 48 hours in any one week shall be paid for at overtime rates.

3. Night Duty.

All ordinary ten week duty worked between the following hours, viz.—

Sunday, midnight to 4.0 a.m. Monday (except on Sunday-Monday turns)
10.0 p.m. Monday, Tuesday, Wednesday, Thursday and Friday to 4.0 a.m.
Tuesday, Wednesday, Thursday, Friday and Saturday.
10.0 p.m. Saturday to midnight Saturday

shall be paid for at the rate of time and a half.

All OVERTIME worked between these hours shall be paid for at the inclusive rate of time and a half.

4. Sunday Duty.

All time worked between midnight Saturday and midnight Sunday shall be paid for at the rate of time and a half.

A turn commencing on Sunday and running into Monday shall be paid as for a Sunday turn at the rate of time and a half.

Hours worked on these days in excess of 8 standard days' work to be computed as part of the hours of work of any other day.

Neither overtime rate nor night duty rate applies to any time worked on Sundays or Sunday-Monday turns. All such time worked shall be paid for at the inclusive rate of time and a half.

5. Payment for Good Friday and for Christmas Day, when latter falls on a Week-day.

Turns of duty worked on Good Friday and Christmas Day (except when Christmas Day falls on a Sunday) are included in and form part of the Guaranteed Week's work.

All time worked on these days to be paid at the inclusive rate of time and a half, the extra allowance of half time on time worked to be paid for in addition to the payment for the Guaranteed Day.

6. Beginning and End of Week.

For wage computation purposes, a turn commencing at or after midnight Saturday will be the first turn for the week, and a turn commencing before midnight on the Saturday following will be the last turn for the week.

7. Engine Preparation and Disposal Payment.

Payment to be made from the booked time of starting from Shed to actual time of relieved of engine on arrival at the Shed, Coal Stage or other place appointed to be scheduled, with marginal times as given below.

BEFORE GOING OFF THE SHED WITH AN ENGINE

Minutes per turn
(a) For engines with a heating surface of more than 1,500 square feet ... 20
(b) For all other classes of steam engines ... 15
(c) Where engine is prepared by Shed Staff to include booking on, examining and ... 15

AFTER RELIEVED OF ENGINE ON ARRIVAL AT SHED

Minutes per turn
18 To include making out tickets and booking off duty. The driver seeing the engine to be responsible for putting out any oil or matters requiring attention, and for booking the same in the repair book where necessary.

8. Definition of a Turn, also Sunday Turns.

A turn is the period of employment between each appointed time of booking on and off duty.

A Sunday turn is one which begins not earlier than midnight Saturday and finishes not later than midnight Sunday.

NOTE. Turns subsequent to Sunday and extending into Monday to be paid under the conditions applicable to Sunday turns.

9. Guaranteed Day.

No man to be paid less than a standard day's pay for each time of signing on duty except as stated below.

(a) Men working a short day for their own convenience, or illness.
(b) Men coming late on duty through their own fault to receive payment for the actual hours worked.

10. Guaranteed Week.

The standard week's work to consist of 48 hours.

The standard week's wages exclusive of any payment for overtime or Sunday duty to be guaranteed to all employees who are available for duty throughout the week, but turns commencing on a Saturday and finishing on Sunday shall form part of the guaranteed week, and all turns commencing on a Sunday shall be excluded from, and be paid for independently of, the guaranteed week.

A turn commencing at midnight on Saturday night is to be treated as a Sunday turn of duty, and a turn commencing at midnight on Sunday night is to be treated as a week day turn of duty.

11. Rest.

The roster shall provide for a period of 12 hours rest being shewn in the case of all regular duties for men when at their home station. In all other cases a minimum of 9 hours shall be allowed from the time of signing off for one turn before signing on for the next turn of duty.

(a) The rest interval agreed on shall not be adhered to when it is necessary to call men out for emergencies, such as breakdowns, failures, fog, etc. This is not intended to vary the agreed arrangements in regard to the intervals of rest between train duties.

(b) The 12 hours' interval for rest may be reduced to 8 hours by mutual agreement in the case of men working in shifts of 8 hours when changing turns of duty at the week ends.

(c) The 9 hours' interval shall not necessarily be adhered to in respect of train men working race trains, excursion trains, or other similar special trains; in such cases it is agreed that an interval of 7 hours' rest only need be given where the outward working has not exceeded 7 hours. In such cases the men shall be released from work as soon as possible after completion of the return journey.

12. Meal Times.

To have continuous duty. Meals to be taken as opportunities arise. In the case of Drivers and Firemen working on shunting engines, where the working is continuous, it is realised that opportunity for a meal must be given, and although a definite interval cannot be reserved, an interval of 20 minutes shall be arranged between the third and fifth hours of duty.

13. Special Train Duties.

Special train duties to be eliminated as far as possible with a view to the number of drivers and firemen who are shewn as standing "spare" for such duties being reduced to the minimum.

In view of the fact that it is not possible to avoid special train duties for drivers and firemen who are not rostered for actual working, a system shall be instituted under which each man when booking off duty shall be given a form to shew at what hour after he has had 12 hours' rest, he shall hold himself in readiness for resuming work.

Week-days.

If he is not booked on for duty within 10 hours of the time shewn on the form provided on the time fallen on a week-day, he shall be given a day's pay of the ordinary rate.

14. Mileage.

(a) Where the mileage in any turn of duty exceeds 120 miles, payment to be made on the basis of 15 miles = 1 hour.

(b) Men whose day's work is on the mileage basis, if brought out earlier, or kept out later, for the purpose of piloting, shunting, or to perform work of any description other than mileage, not provided for in the 1 day's work on the mileage basis, are to be paid for such time worked, in addition to the day's mileage, in accordance with the regulations governing payment by time, less the usual diagrammed time for engine requirements.

(c) The allowances for night duty, overtime and Sunday duty, where payable, are to be paid on the hours worked, and in addition to the payments referred to in Clause 14, Section (a).

(d) In no circumstances will the time paid for be less than the actual time on duty.

15. Rates of Pay.

DRIVERS.

1st and 2nd years	12/- per day
3rd and 4th years	13/-
5th, 6th, and 7th years	14/-
8th year and onwards	15/-

These rates include the War Wage.

FIREMEN.

1st and 2nd years	9/6 per day
3rd and 4th years	10/6
5th year and onwards	11/-

These rates include the War Wage.

16. Firemen Driving.

Firemen employed temporarily as Engine Drivers to be paid the minimum rate of wages for Engine Drivers as per arrangement set out in Clause No. 18.

17. Unregistered Men.

Unregistered men may be used for engine turning, obtaining coal, or for any other work within the precincts of Engine Sheds and Locomotive Yards.

18. PROMOTION AND SENIORITY.

A Fireman when driving to be paid in accordance with the Driver's first year rate.

Promotion from Fireman to Driver to be by seniority, if qualified, when a vacancy arises.

Permanent promotion to be by seniority.

A Fireman after working 313 driving turns or shifts to be considered as entering upon his second year as a Driver when driving, and each 313 subsequent turns or shifts or driving duty will be treated as equivalent to one year's service as a Driver, and his pay regulated accordingly.

In the case of a Fireman who has worked 313 driving turns or shifts, and is not permanently appointed, he will be paid the maximum Fireman's rate when firing, unless he has completed 10 years' service as a Fireman, including the first 313 turns or shifts of firing duty; in such case he will be paid the minimum Driver's rate or pay when firing.

If, through notice or circumstances, a permanently appointed Driver has to go back to firing, he shall be paid the first year's Driver's rate whilst so acting.

If, through notice or circumstances, a permanently appointed Fireman has to go back to acting, he shall be paid the first year's Fireman's rate whilst so acting.

19. Incapacity of Enginemen owing to Defective Eyesight.

20. Lodging Allowances.

(1) WHEN NOTIFIED OF DOUBLE HOME TURN BEFORE LEAVING PLACE OF RESIDENCE.

The allowance to be 1½d. per hour, or portion thereof, for the whole of the time from booking on duty at the home station to booking off duty at the home station. Minimum 3s. 6d.

Where the Company provide lodging accommodation, a reduction of 1/- per day or night to be made

(2) MEN BOOKED OFF TO TAKE A SECOND REST.

After being once booked off, a man shall be worked back to his own station, but if in unforeseen circumstances it is necessary to book a man off again, the allowance shall be at the rate of 2d. per hour from the time of signing off duty for the second rest to signing off duty at the home station.

Where the Company provide lodging accommodation, a reduction of 1/- per day or night to be made

(3) WHEN NOT NOTIFIED OF DOUBLE HOME TURN BEFORE LEAVING PLACE OF RESIDENCE.

The allowance to be 2d. per hour, or portion thereof, for the whole of the time from booking on duty at the home station to booking off duty at the home station. Minimum 4s.

Where the Company provide lodging accommodation, a reduction of 1/- per day or night to be made

(4) ALLOWANCE FOR FOOD PROVIDED BUT NOT REQUIRED.

In the case of a man ordered to work a double home turn, who packs food accordingly, but is advised after leaving his home that he will not be required to take rest away from home, the sum of 1/- shall be allowed.

(5) MEN TEMPORARILY TRANSFERRED FROM HOME STATION TO ANOTHER STATION.

Lodging allowances for men temporarily transferred from their home station to another station to be 3s. 6d. per day and night.

Where the Company provide lodging accommodation a reduction of 1/- per day or night to be made.

21. Removal Allowances.

An expense allowance of £1 1s. to be paid for permanent removal without an advance of wages. This sum is in addition to any lodging allowance on double home work.

A further allowance to be given to married men removing their families, furniture, &c., as follows—

Distance between Points of Removal	Allowance
150 miles and under	1 day's pay
151 to 300	2
301 and upwards	3

These allowances will not apply to men removing at their own request

22. Men Residing in London.

Men residing in London to be allowed 3s. 6d. per week in addition to their ordinary pay.

23. Clothing.

It is agreed that the following clothing shall be supplied to Enginemen free of cost—

2 suits of jean overalls		
1 serge jacket	}	Annually
1 cap		
1 reefer jacket, or	}	Every
1 overcoat		2 years

This arrangement to commence with the next general issue of clothing.

24. Holidays.

After 12 months' service one week's holiday (6 weekdays) with pay shall be given to men who have been regularly employed for not less than 12 months.

25. Termination of Engagement.

The engagement of men to be terminated by one week's notice on either side.

26. Interpretation of Clauses.

The interpretation of Clauses to be according to schedule No. 1.

27. Existing Conditions of Service.

The instructions contained in this Circular must operate in all cases, and where they are not in accordance with present practice, such practice must be discontinued.

G. J. CHURCHWARD.

LONDON & NORTH WESTERN RAILWAY

INSURANCE SOCIETY

Several instances having occurred of men being injured while on duty, and having no claim upon the Insurance Society for an allowance owing to their not having signed the Declaration Form, no permanently appointed men will in future be permitted to commence work until they have signed the proper form declaring themselves Members of the Society.

Temporary or Extra Men employed for a longer period than a week, and not exceeding one month, will be allowed the option of joining the Society, the Rules of which, as well as the forms for admittance, can be obtained from the Station Master or Foreman; but all such men whose term of engagement extends beyond **one month**, will be required to become Members, after the expiration of that period.

BY ORDER.

EUSTON STATION,
1st May, 1873.

McCorquodale & Co. Printers, 6, Cardington Street, London, N.W.

Staff insurance and pensions.

ABOVE

London and North Western Railway.
Leaflet, 310 x 245mm, 1873.

Courtesy Michael Brooks

RIGHT

Great Western Railway
Leaflet, 255 x 203mm, 1925.

Great Western Railway.

GENERAL MANAGER'S OFFICE,
PADDINGTON STATION,
LONDON, W.2.

December 29th, 1925.

WIDOWS' ORPHANS' AND OLD AGE
CONTRIBUTORY PENSIONS ACT, 1925.

Under the provisions of this Act, which comes into force on the 4th January 1926, the members of the staff who are covered by the Company's Certificate of Exception from Compulsory Health Insurance, would be compulsorily insurable for Old Age Pensions and for Widows' and Orphans' Pensions in the absence of a further Certificate of Exception.

The persons covered by the Certificate of Exception from Health Insurance are those members of the Salaried Staff whose salaries do not exceed £250 per annum, and who are members of either the Great Western Railway Superannuation Scheme or the Railway Clearing System Superannuation Fund.

Having regard to the pension benefits secured by the Great Western Railway Superannuation Scheme and the Railway Clearing System Superannuation Fund, the Minister of Health has issued a Certificate of Exception from the Act as regards the provisions thereof for Old Age Pensions in respect of the members of the staff excepted from Health Insurance. In accordance, however, with the wishes of the overwhelming majority of the members of the Great Western Railway Salaried Staff Widows' and Orphans' Pension Society the Directors did not apply for a certificate of exception in respect of Widows' and Orphans' pension benefit as regards members of the Society and contributions under the Act in respect of Widows' and Orphans' Pensions will therefore be payable in respect of all members of the staff covered by the Certificate of Exception from Health Insurance.

The weekly contributions so payable are as follows :—

Employee	Company	Total Payment.
3½d.	3½d.	7d.

and the employee's proportion will be deducted four-weekly through the pay-bill. The total payment will not be made by means of stamps, as in the case of Health Insurance, but by payment direct by the Company to the Ministry of Health, consequently no cards will be issued to the staff affected, but a record will be kept by the Company for identification purposes.

To be followed by, (**NEVER ACTED**) an entirely New Farce, entitled The

RAILWAY BELLE.

		(Station Master, &c.)	Mr. GARDEN,
	Mr. Crabshaw,	(a Waiter)	Mr. JAMES ROGERS,
John Quick,			Mr. CHARLES SELBY,
	Mr. Samuel Greenhorne,		Mr. R. ROMER,
	Mr. Fallows,	(a Railway Porter)	Mr. PAGE,
	Lungs,		Mrs. STOKER,
Mrs. Fallows,			Miss C LELACHEUR,
Miss Mary Fallows,			Miss WYNDHAM.
Miss Julia Spruce,	—	(the Railway Belle)	—

After which will be tried (for the 19th 20th 21st 22nd 23rd and 24th times) a Point of Law, arising out of the New Beer Bill, in the shape of a Farce, by WILLIAM BROUGH, Esq., entitled

A

BONA FIDE TRAVELLERS.

	Batts,	(Landlord of the Goat's Head)	Mr. R. ROMER,
Joe,		(Potboy of the same)	Mr. KEELEY
	Cornelius O'Gripper,	Simkins, (Mary Ann's Young Man)	Mr. PAUL BEDFORD,
	Mimms,	(that keeps company with Jane)	Mr. HASTINGS,
	Boiter,	(a Military Gentleman attached to Susan)	Mr. LE BARR,
Fierce Customer,	Mr. CONRAN,	A Thirsty Soul,	Mr. WAYE,
1st Policeman,	Mr. C. J. SMITH,	2nd Policeman,	Mr. ALDRIDGE, Mr. SANDERS,
Jemima,	(Housemaid at the Goat's Head)		Mrs. KEELEY,
	Mary Ann,	(from No. 7 Round the Corner)	Miss LAIDLAW,
Jane,		(from the Greengrocers')	Mrs. GARDEN,
	Susan,	(from over the Way)	Miss THOMPSON,
Mild Customer,	Miss LOUISE,	Miss Biffin, (a small Customer)	Miss STOKER

SCENE:—

BAR PARLOUR of the GOAT'S HEAD.

TIME.—1854, FROM 3 to 5 P.M.

To conclude with (13th 14th 15th 16th 17th & 18th Times) the laughable Farce by Messrs AUGUSTUS MAYHEW and SUTHERLAND EDWARDS, called

THE FIFTH OF NOVEMBER.

	Wheeler,	Mr. GARDEN,
Sinjon,		Mr. JAMES ROGERS,
Alphonse,	(a Page) Mr. R. ROMER,	Gardener, Mr. PAGE,
	Catherine Wheeler,	Miss CUTHBERT,
Susan,		Miss MARY KEELEY.

A NEW COMEDY
IS IN REHEARSAL.

MR. BEN. WEBSTER
AND
MADAME CELESTE
Will make their First Appearance this Season in the course of the Week.

Stage-Manager, Mr. LEIGH MURRAY.

First Price.—Boxes, 4s. Pit, 2s. Gallery, 1s. Stalls, 3s.
Doors open at half-past 6, to commence at 7 o'clock. [Second Price at 9 o'clock.

W. S. Johnson, Nassau Steam Press," 60, St, Martin's Lane, Charing Cross

WHO comes on duty day by day,
His train on rail to take away
Of passengers or goods as may?
The Engine Driver.

Who first of all looks round to know
If all is in repair below
And everything will safely go?
The Engine Driver.

Who at the station joins his train,
And tries with all his might and main
The speed he knows he should obtain?
The Engine Driver.

Who is it looks with eyes so keen
At night to see lamps red or green
And keep from dangers unforeseen?
The Engine Driver.

Who is it keeps the steam up so,
To make the train go fast or slow,
And save fuel, as you may know?
The Fireman.

Who is it asks the guard if he
Can make the train quite punctual be,
And meet at junction, say, "Mugby"?
The Passenger.

Who gets the "tip" at the far end
When time is made up of no end,
With two-and-six for self to spend?
The Guard.

.T. HOUGHTON WRIGHT.

Popular pictures of railway people.

LEFT
On stage...with comic relief.
Theatre bill, 508 x 253mm, 1854.

ABOVE
In verse...with sentimental irony.
Railway Magazine, actual size, 1898.

RIGHT
In song...with sartorial elegance.
Music cover, 360 x 256mm. c.1910.
Courtesy Michael Brooks

This song may be sung in public without fee or license except at Theatres and Music Halls, which rights are reserved For Pantomime Permissions apply to FRANCIS, DAY & HUNTER.

" Oh! Blow the Scenery on the Railway!"

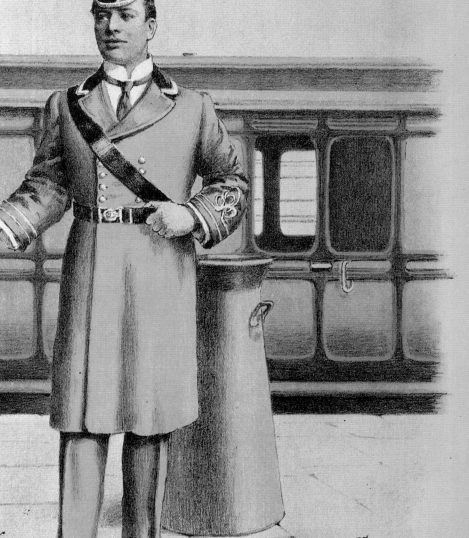

WRITTEN & COMPOSED BY

FRED W. LEIGH & GEORGE ARTHURS.

Copyright.

Price 2/- net.

SUNG BY GEORGE LASHWOOD.

FRANCIS, DAY & HUNTER 142, CHARING CROSS ROAD LONDON, W.C.

NEW YORK: T. B. HARMS & FRANCIS, DAY & HUNTER, INC. 1431-3 BROADWAY.

Publishers of Smallwood's Celebrated Pianoforte Tutor, Smallwood's 55 Melodious Exercises etc.

TELEPHONE Nº 5425 GERRARD.

TELEGRAPHIC & CABLE ADDRESS ARPEGGIO LONDON.

Copyright, MCMX , in the United States of America by Francis, Day & Hunter.

Printed by H. G. BANKS.

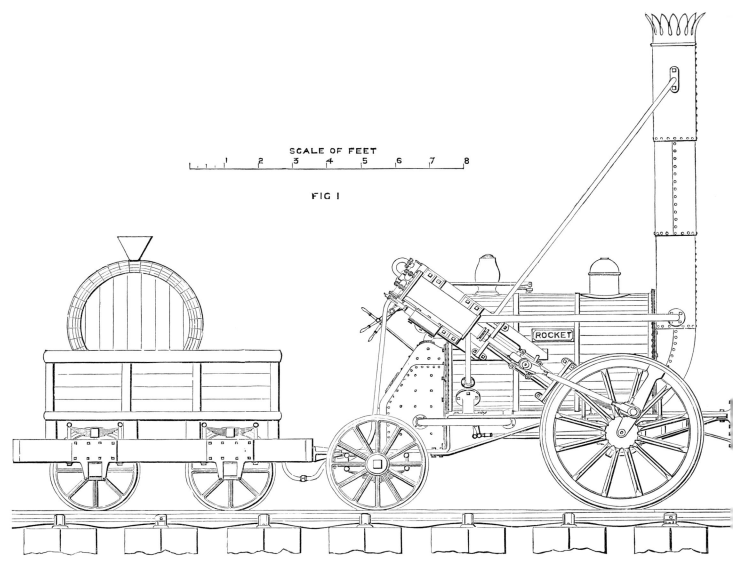

SCALE OF FEET

1 2 3 4 5 6 7 8

FIG I

Almost everyone can conjure up a mental picture of George Stephenson's 'Rocket'. But is it accurate? Bearing in mind the amount of rebuilding carried out during its working life *The Engineer,* between 1870 and 1885, set out to establish the authenticity of what it described as 'the exhibit at South Kensington'.
Here are four contributions to the discussion; publication dates in italics.

ABOVE LEFT

The Engineer's chosen version of the locomotive as it appeared in 1829.
Actual size, *1880.*

ABOVE RIGHT

Engraving from the *Mechanics Magazine* of 1829.
Actual size, *1876.*

BELOW RIGHT

How engineer James Nasmyth saw it the day before the opening of the Liverpool and Manchester Railway in 1830.
240 x 318mm. *1884.*

BELOW

Sketch by W. Stenson made near Leicester in 1832 in the presence of George and Robert Stephenson.
185 x 334mm, *1884.*

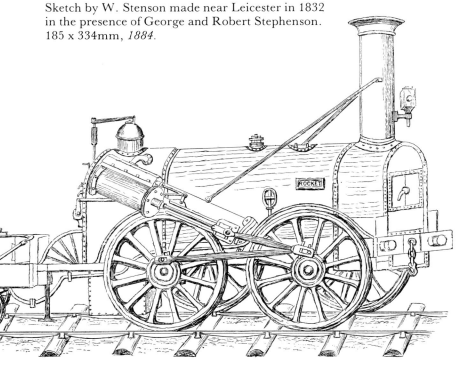

The locomotives

'I love, says Elihu Durritt, writing about the locomotive engine, to see one of those huge creatures, with sinews of brass and muscles of iron, strut forth from his stable and saluting the train of cars with a dozen sonerous puffs from his iron nostrils, fall back gently into his harness. There he stands, champering and foaming upon the iron track, his great heart a furnace of glowing coals, his lymphatic blood boiling within his veins, the strength of a thousand horses is nerving his sinews, he pants to be gone. He would drag St. Peter's across the desert of Sahara if he could be hitched on.'

Michael Reynolds, *Locomotive Engine Driving*, 1877.

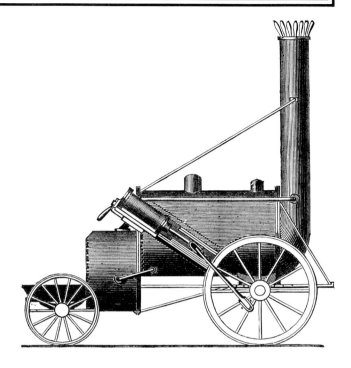

The ROCKET, 1830.

This Sketch of "The Rocket" I made at Liverpool on the 12 Sep.ʳ 1830 the day before the opening of the Liverpool and Manchester Railway while it remained stationary after some experimental trips in which George Stephenson acted as engine driver and his son Robert as stoker

James Nasmyth

Hot on the heels of the 'Rocket' were these little
engines built by Bury, Curtis and Kennedy. The
first appeared in 1830 to work on the Liverpool
and Manchester Railway. They were very
cheap, very light (about 12½ tons) and, for the
time, quite advanced in design; hence their
popularity.

END ELEVATION.

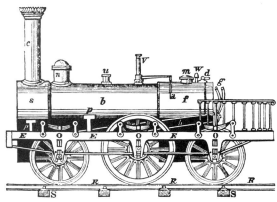

SIDE ELEVATION.

The letters refer to their respective parts in each view.

a. The spring guage connected with the end of the lever of the safety valve *v.*

b. The boiler, through the lower part of the transverse sectional area of which is passed longitudinally a great number of small brass tubes proceeding from the furnace chamber, which serve as hot air flues. See section.

c. The chimney, the top of which is covered with wire gauze.

d. The tap communicating with the steam whistle *w.*

f. The fire grate.

g. The working gear.

h, h. The rods connecting the working gear with the steam valves.

m. The man hole.

n. The steam vessel or head through which the steam passes from the boiler in its way to the cylinders; the tube from the valves reaches nearly to the top of this vessel, which prevents any water being shaken by the motion of the carriage into the valves, and finding its way into the cylinders.

o, o, o. The springs.

p, p. The supports.

s. The smoke box, whence the gases resulting from the combustion of the fuel ascend the chimney.

u. Case containing a safety valve which cannot be interfered with.

x. The door of the fire grate.

y. The throttle valve.

E. The frame work.

M. The wheels.

R. The rails.

s. The blocks or sleepers.

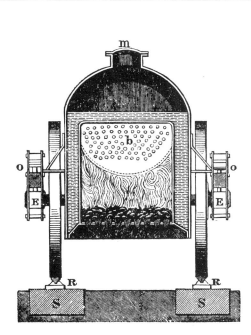

TRANSVERSE SECTION.

FACING PAGE, ABOVE LEFT

Nicknamed 'Old Coppernob' after its copper fire box cover, this engine ran on the Furness Railway from 1846 to 1900. It is now preserved.
Presentation plate issued with the *Railway Magazine.*
Actual size, 1907.

FACING PAGE, CENTRE LEFT

From *Osborne's London and Birmingham Railway Guide.*
Actual size, 1839.

FACING PAGE, BELOW LEFT

London and Birmingham Railway No. 1. One of fourteen plates from *A Rudimentary Treatise on locomotive engines.*
Actual size, 1859.

ABOVE

Osborne's Grand Junction Railway Guide offers the reader 'a correct idea of the engines at present in use'.
Actual size, 1838.

(3128),

PASSENGER

| TANK ENGINES. | | | ENGINES REQUIRING TENDE[RS] | | | |

"WOLF" CLASS.
15-in. CYLINDERS.
("STAR" CLASS. 16-in. CYLINDERS.)

Aeolus
Antelope
Apollo
Assagais
Atlas
Aurora
Bright Star
Comet
Creese
Djerid
Eagle
Eclipse
Fire-Ball
Fire-King
Gazelle
Giraffe
Hesperus
Javelin
Lance
Meridian
Meteor
North Star
Orion
Polar Star
Red Star
Rising Star
Rocket
Shooting Star
Snake
Stiletto
Sun
Sunbeam
Venus(No. 1.)
Viper
Vulcan
Wolf
Yataghan
Zebra

BOGIE CLASS.
17-in. CYLINDERS.

Brigand
Corsair
Euripides
Hesiod
Homer
Horace
Juvenal
Lucan
Lucretius
Ovid
Sappho
Seneca
Statius
Theocritus
Virgil
No. 1 (V. N.)
„ 2 „
„ 3 „
„ 4 „
„ 5 „
„ 6 „

METROPOLITAN TANK CLASS.
16-in. CYLINDERS.

N.B.—These are in course of alteration to TENDER Engines (May, 1869).

Bee
Bey
Camelia
Czar
Fleur-de-lis
Gnat
Kaiser
Khan
Locust
Mosquito
Rose
Shah
Shamrock
Thistle
Wasp

"PRIAM" CLASS.
16-in. CYLINDERS.

Achilles
Actæon
Arab
Argus
Arrow
Bellona
Castor
Centaur
Charon
Cyclops
Damon
Dart
Dog-Star
Electra
Elk
Erebus
Evening Star
Falcon
Fire-brand
Fire-Fly
Ganymede
Gorgon
Greyhound
Harpy
Hecate
Hector
Hydra
Ixion
Jupiter
Leopard
Lethe
Load Star
Lucifer
Lynx
Mars
Mazeppa
Medea
Medusa
Mentor
Mercury
Milo
Minos
Morning Star
Panther
Pegasus
Peri
Phœnix

Pluto
Priam
Prince
Proserpine
Queen
Royal Star
Saturn
Spitfire
Stag
Stentor
Sylph
Tiger
Venus (No. 2.)
Vesta
Vulture
Western Star
Wild-fire
Witch

METROPOLITAN TENDER CLASS.
16-in CYLINDERS.

Azalia
Hornet
Laurel
Lily
Mogul
Myrtle
Violet

"ALMA" CLASS.
18-in. CYLINDERS.

Alma
Amazon
Balaklava
Courier
Crimea
Dragon
Emperor
Estaffete
Eupatoria
Great Britain
Great Western
Hirondelle
Inkermann
Iron Duke
Kertch
Lightning
Lord of the Isles
Pasha
Perseus
Prometheus
Rougemont
Rover
Sebastopol
Sultan
Swallow
Tartar
Timour
Tornado
Warlock
Wizard

"ABBOT" CLASS.
17-in. CYLINDE[RS.]

Abbot
Antiquary
Cœur-de-Lion
Ivanhoe
Lalla Rookh
Pirate
Red Gauntlet
Robin Hood
Rob-Roy
Waverley

"VICTORIA" CLASS.
16-in. CYLINDE[RS.]

Abdul Medjid
Alexander
Brindley
Brunel
Fulton
Leopold
Locke
Napoleon
Oscar
Otho
Rennie
Smeaton
Stephenson
Telford
Trevethick
Victor Emanuel
Victoria
Watt

All Great Western Railway broad gauge locomotives carried names, many of which were chosen or sanctioned by I.K. Brunel. The intention to use classical sources led to some barrel scraping and misspelling; 'Lagoon' = 'Laocoön'. Presumably the enginemen on 'Nemesis' were oblivious to its meaning. After the Graeco-Roman origins had dried up there

RAILWAY

MOTIVE ENGINES.

GOODS

| TANK ENGINES. | ENGINES REQUIRING TENDERS. | | | | |

WTHORN
CLASS.
CYLINDERS.

ered from
Class.

on •
ide
nsop

is •
nce

orth
•
horn

Gray
g
ch
•
k

thon •
•
s

rt

"LEO"
CLASS.
15-in. CYLINDERS.

Aquarius
Aries
Buffalo
Cancer
Capricornus
Dromedary
Elephant
Etna
Gemini
Hecla
Leo
Libra
Pisces
Sagittarius
Scorpio
Stromboli
Taurus
Virgo

"SIR WATKIN"
CLASS.
17-in. CYLINDERS.

Bulkeley
Fowler
Miles
Saunders
Sir Watkin
Whetham

BANKING
CLASS.
17-in. CYLINDERS.

Avalanche
Bithon
Iago
Juno
Plato

VALE OF NEATH
CLASS.

No. 7	17½
„ 8	„
„ 9	„
„ 10	17
„ 11	„
„ 12	„
„ 16	17½
„ 17	„
„ 18	„
„ 19	„

"FURY"
CLASS.
16-in. CYLINDERS.

Ajax
Argo
Bacchus
Bellerophon
Bergion
Briareus
Brontes
Dreadnought
Fury
Goliah
Hercules
Jason
Premier
Sampson
Telica
Tityos
Vesuvius

VALE OF NEATH
CLASS.
18-in. CYLINDERS.

No. 13
„ 14
„ 15

"CÆSAR"
CLASS.
17-in. CYLINDERS.

Alligator
Amphion
Ariadne
Avon
Banshee
Behemoth
Boyne
Brutus
Cæsar
Caliban
Caliph
Cambyses
Cato
Ceres
Champion
Chronos
Cicero
Clyde
Coquette
Cossack
Creon
Cupid
Cyprus
Diana
Dido
Druid
Esk
Ethon
Europa
Flirt
Flora
Florence
Forth
Geryon
Giaour
Gladiator
Gyfeillon
Hades
Hebe
Hecuba
Hero
Humber
Iris
Janus
Lagoon
Leander
Leonidas

Liffey
Luna
Magi
Mammoth
Mersey
Metis
Midas
Minerva
Monarch
Nelson
Nemesis
Neptune
Nero
Nimrod
Nora Creina
Octavia
Olympus
Orpheus
Orson
Osiris
Pallas
Pandora
Panthea
Pearl
Pelops
Pioneer
Plutarch
Plutus
Plym
Psyche
Pyracmon
Regulus
Remus
Rhea
Rhondda
Romulus
Ruby
Salus
Severn
Severus
Shannon
Sibyl
Sirius
Sphinx
Steropes
Sylla
Talbot

Tamar
Tantalus
Tay
Thames
Theseus
Thunderer
Trafalgar
Tweed
Tyne
Typhon
Ulysses
Vesper
Vixen
Volcano
Warhawk
Warrior
Wear
Wellington
Wye
Xerxes
Zetes
Zina

"SWINDON"
CLASS.
17-in. CYLINDERS.

Bath
Birmingham
Bristol
Chester
Gloucester
Hereford
London
Newport
Oxford
Reading
Shrewsbury
Swindon
Windsor
Wolverhampton

seems little consistency in the rest other than curious spelling.
Blenk'e'nsop would have protested. Foreign engines taken
over, e.g. Vale of Neath Railway, did not have the pedigree for

anything other than a number.

Broadsheet, 380 x 506mm, 1869.

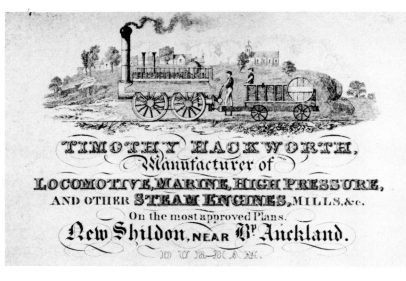

LEFT
Trade card, c.1830.
Courtesy N.R.M.

CENTRE
Receipt, actual size, 1876.

BELOW
Four cigarette cards, actual size, 1936.

RECEIPT FORM to be detached, filled up, signed, and sent to THE ACCOUNTANT addressed as at back.

Received this *4th* day of *Augt.* 187 *6*

from the GREAT NORTHERN RAILWAY COMPANY, an Order on MESSRS. SMITH,

PAYNE, AND SMITHS, for the sum of *Two thousand four*

hundred Pounds _____ Shillings

_____ Pence, for *one Express*

goods Engine with tender.

24 AUG 1876

Signature

£ 2400 - 0 - 0

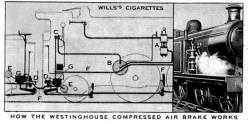

HOW THE WESTINGHOUSE COMPRESSED AIR BRAKE WORKS

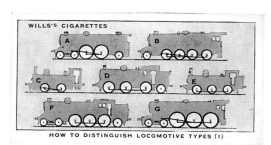

HOW TO DISTINGUISH LOCOMOTIVE TYPES (1)

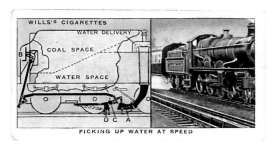

PICKING UP WATER AT SPEED

HOW TO DISTINGUISH LOCOMOTIVE TYPES (2)

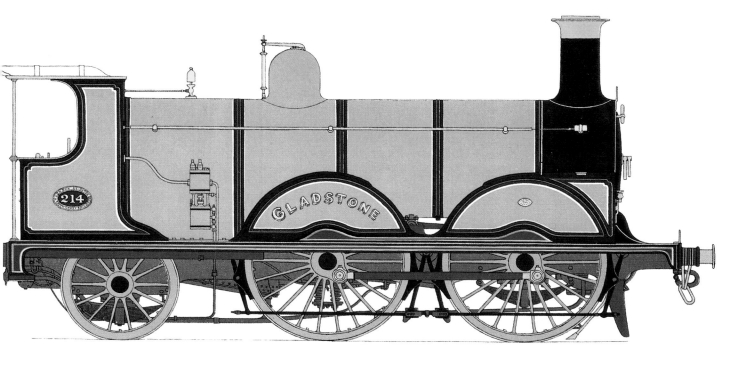

ABOVE
Colour print by the author.
Sheet size (with tender not
shown) 255 x 425mm, 1958.

CENTRE
Postcard produced after the
South Eastern and Chatham
Railway was absorbed into
the Southern Railway.
Actual size, 1923.

BELOW
Four cigarette cards, actual
size, 1936.
Courtesy Sylvia Calvert

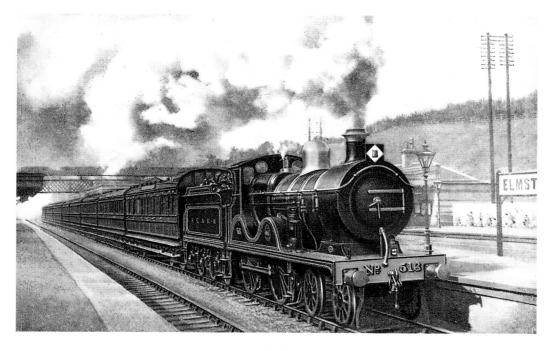

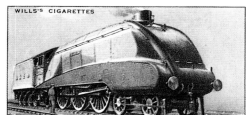

STREAMLINED EXPRESS LOCOMOTIVE "SILVER LINK," L.N.E.R.

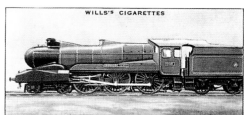

PARTIALLY STREAMLINED LOCOMOTIVE "MANORBIER CASTLE." G.W.R.

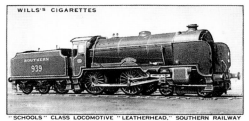

"SCHOOLS" CLASS LOCOMOTIVE "LEATHERHEAD," SOUTHERN RAILWAY

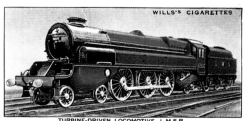

TURBINE-DRIVEN LOCOMOTIVE, L.M.S.R.

RIGHT

The logistics of supplying motive power for a catchment area that included Waterloo can be deduced from this one day roster sheet from Nine Elms locomotive department.
443 x 285mm, 1899.

Two of the engines on the list at that depot at that time:
CENTRE

No. 580, which was actually built at Nine Elms works.
Engraving from *The Engineer*, 122 x 265mm, 1893.

BELOW

No. 702, built by Dubs and Company of Glasgow and delivered only one month before the roster was made out.
Engraving from *The Engineer*, 101 x 262mm, 1899.

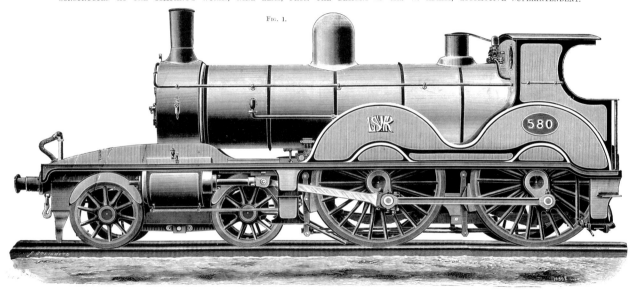

EXPRESS LOCOMOTIVE FOR THE LONDON AND SOUTH-WESTERN RAILWAY.
CONSTRUCTED AT THE COMPANY'S WORKS, NINE ELMS, FROM THE DESIGNS OF MR. W. ADAMS, LOCOMOTIVE SUPERINTENDENT.

FIG. 1.

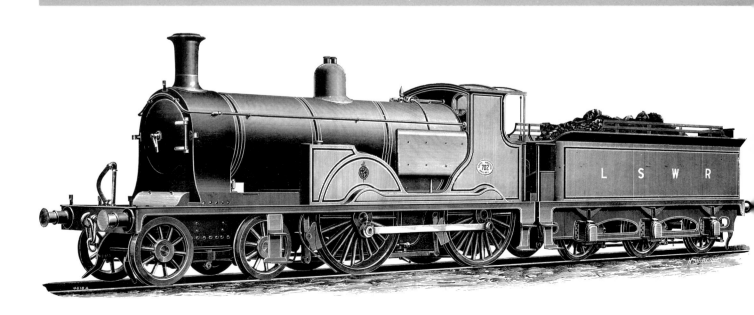

Copy
newsdned

LONDON & SOUTH WESTERN RAILWAY COMPANY.

(66)

LOCOMOTIVE DEPARTMENT, Nine Elms Station, Tuesday, the 18 day of July 1899

Time of leaving Coal Stage.	TO	ENGINE.	Road
12. 5 a.m.	N. E. G.	699	1
12. 15 „	„	516	6
12. 30 „	„	554	8
1. 0 „	„	505	
1. 30 „	„	692	10
2. 15 „	Clap.	328	
2. 30 „	„	193	
2. 30 „	„	543	10
2. 30 „	N. E. G.	166	6
2. 30 „	„	639	3
2. 45 „	W'loo.	177	
2. 50 „	W'don.	104	
3. 0 „	W'loo.	10	
3. 0 „	N. E. G.	611	8
3. 0 „	„	436	5
3. 5 „	„	436	5
3. 5 „	Clap.	379	
3. 15 „	N. E. G.	154	15
3. 30 „	„	627	5
3. 35 „	Clap.	180	
3. 40 „	N. E. G.	301	14
3. 45 „	Barnes	378	
3. 45 „	„	44	
3. 45 „	W'don.	130	
4. 0 „	N. E. G.	175	6
4. 0 „	„	275	
4. 0 „	„	274	
4. 0 „	„	263	
4. 10 „	„	264	
4. 15 „	W'don.	246	13
4. 15 „	W'loo.	24	4
4. 20 „	„	613	5
4. 20 „	„	248	15
4. 30 „	Clap.	221	
4. 30 „	„	426	
4. 35 „	„	225	
4. 35 „	N. E. G.	339	8
4. 40 „	Clap.	61	
4. 45 „	B'ford.	514	7
4. 45 „	Clap.	376	
4. 45 „	„	34	
4. 50 „	W'don.	675	10
5. 0 „	N. E. G.	404	2
5. 0 „	W'loo.	679	9
5. 0 „	„	686	8
5. 0 „	„	549	9
5. 10 „	„	496	7
5. 10 „	„	41	
5. 10 „	N. E. G.	640	1
5. 10 „	„	669	2
5. 15 „	B'sea.	474	
5. 15 „	W'loo.	58	
5. 20 „	W'don.	600	3
5. 30 „	W'loo.	245	
5. 30 „	„	605	7
5. 30 „	N. E. G.	301	2
5. 30 „	Clap.	124	
5. 30 „	„	22	
5. 35 „	N. E. G.	623	4
5. 40 „	Clap.	513	5
5. 40 „	W'loo.	526	5
5. 50 „	„	630	5
6. 0 „	Clap.	39	
6. 0 „	„	670	
6. 0 „	Shd.	88	
6. 0 „	Loco.	258	
6. 0 „	„	103	
6. 0 „	„	150	
6. 10 „	Clap.	65	
6. 10 „	W'loo.	113	1
6. 15 „	Kens.	45	
6. 20 „	N. E. G.	164	3
6. 20 „	W'don.	37	
6. 20 „	W'loo.	114	8
6. 20 „	„	362	
6. 40 „	N. E. G.	695	4
7. 0 „	W'loo.	720	14
7. 15 „	B'sea.	529.375	14
7. 25 „	W'loo.	529	14
7. 30 „	Coal Yd.	620	3
7. 30 „	Clap.	684	7
7. 45 „	„	596	4
8. 0 „	Hay Yd.	68	

Time of leaving Coal Stage.	TO	ENGINE.	Road
8. 10 a.m.	W'loo.	—	
8. 10 „	„	—	
8. 10 „	N. E. G.	684	10
8. 15 „	„	700	14
9. 0 „	„	308	9
10. 10 „	W'loo.	582	6
10. 10 „	„	—	
10. 25 „	„	703	14
10. 45 „	„	64	15
11. 15 „	„ (Fratton Engine.)		
12. 0 noon			
12. 0 „	N. E. G.	550	6
12.50 p.m.	W'loo.	—	
1. 0 „	„	524	
1. 0 „	„	503	15
1. 15 „	Ch'rtsy.	653	9
1. 15 „	W'loo.	588	7
1. 45 „	„	616	12
2. 0 „	„	242	14
2. 0 „	„	704	11
2. 15 „	„	652	12
2. 30 „	N. E. G.	650	2
2. 40 „	„	379	
2. 45 „	W'loo.	624	3
3. 0 „	Clap.	24	10
3. 0 „	„	—	
3. 0 „	Barnes	107	
3. 10 „	W'loo.	65	
3. 10 „	„	44	
3. 15 „	N. E. G.	622	2
3. 30 „	W'don.	670	
3. 45 „	Clap.	715	12
4. 0 „	„	630	8
4. 20 „	W'loo.	613	13
4. 35 „	N. E. G.	161	
5. 0 „	W'don.	—	
5. 30 „	N. E. G.	600	8
5. 50 „	„	306	9
6. 30 „	B'sea.	699	5
6. 40 „	N. E. G.	436	4
6. 45 „	„	206	5
7. 25 „	„ (Souton Engine.)	514	
7. 30 „	B'sea.	—	
8. 0 „	W'loo.	620	3
8. 5 „	N. E. G.	309	4
8. 25 „	„	29	11
8. 45 „	W'loo.	—	
9. 0 „	N. E. G.	695	1
9. 0 „	„	496	10
9. 0 „	W'loo.	325	1
9. 30 „	N. E. G.	368	10
9. 30 „	„	611	11
10. 0 „	„	646	1
10. 15 „	W'loo.	598	3
10. 30 „	N. E. G.	64	5
11. 25 „	„	635	1
11. 25 „	„	692	4
11. 30 „	„	689	11

BOAT TRAINS

Time		ENGINE.	
11. 0		626 spl	
11. 10		395	

Time of leaving Coal Stage.	TO	ENGINE.	Road
SPECIALS.			
2. 30 a	C	28	
4. 45	Norbiton	401	4
5. 20		577	5
6. 0		655	11
6. 10	C	290	14
6. 20	W	291	4
6. 50	Andover	573. 497 Coupled	12
7. 0	C	472	7
7. 45	W	709	4
7. 50	W	716	2
8. 0	W	623	6
8. 15	C	58	
9. 0	C	66	
9. 0	C	299	15
9. 0		481 in steam.	
9. 10	Andover	459. 688 coupled.	14,6
9. 30	W	714	9
10. 0		484	
10. 0		456	7
10. 35	Bton	635	14
11. 30	C	577	5
12. 10 p	W	610	5
1. 30	W	638	3
2. 15	C	228	
2. 0	W	707	3
3. 30	C	378	
5. 30	NCt	66	
5. 30		630	1
6. 50		644	
7. 45	C	702	13
9. 0	Steam	L'head Eng	
11-15 p	NEG	156.	10

MAIN LINE.	EARLY.	WASH OUT ENGINES. ALL DAY.	LATE.
712	524	671. 375. 241	75
705		368. 355. 261	611
710		29. 646. 600	315
713		694. 309. 514	
677		166. 150. 161	
		L'head Eng	

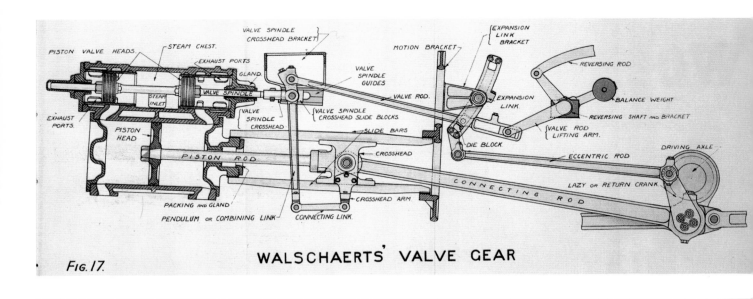

WALSCHAERTS' VALVE GEAR

FIG. 17.

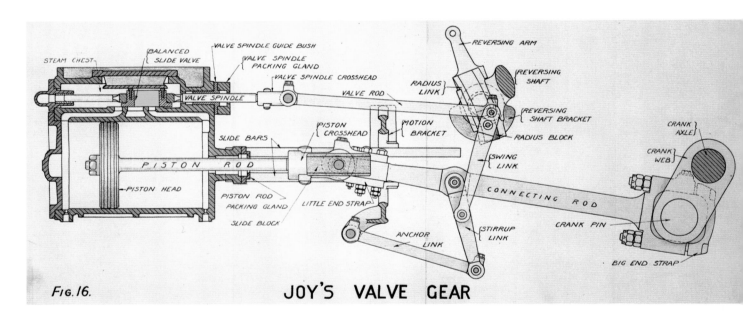

JOY'S VALVE GEAR

FIG. 16.

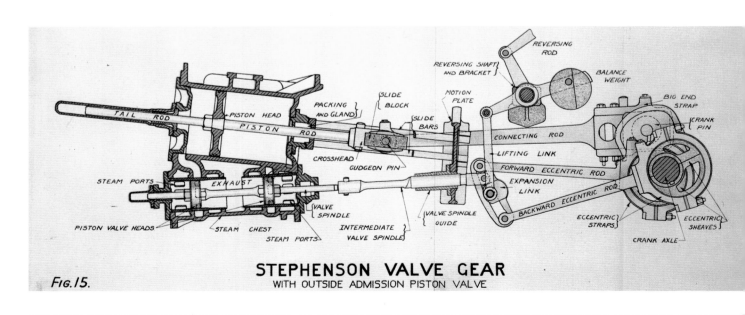

STEPHENSON VALVE GEAR
WITH OUTSIDE ADMISSION PISTON VALVE

FIG. 15.

LEFT

Three illustrations from *'Questions for Enginemen &c';* a constantly updated publication by the London Midland and Scottish Railway. Primarily for cleaners and firemen, its purpose was to 'facilitate their qualification for advancement'.
Page size 154 x 100mm.
Illustration (unfolded) 154 x 340mm, 1931.

RIGHT

The 14th version of the Great Western Railway's *Engine Book* for engine spotters.
185 x 123mm, 1938.

BELOW

Two of a series of four GPO stamp book covers.
Actual size, 1983.

GWR ENGINES

VARNON

1/°

NAMES, NUMBERS, TYPES & CLASSES

LNER Mallard
Third of four
illustrations by
Stanley Paine on
Railway Engines
Printed by
Harrison &
Sons Limited

4468

£1.25

Royal Mail Stamps
Ten at 12½p

SR/BR Clan Line
Fourth of four
illustrations by
Stanley Paine on
Railway Engines
Printed by
Harrison &
Sons Limited

35028

£1.25

Royal Mail Stamps
Ten at 12½p

The carriages

'A party of sixteen persons was ushered into a large courtyard, where, under cover, stood several carriages of a peculiar construction, one of which was prepared for our reception. It was a long bodied vehicle with seats placed across it back to back; the one we were in had six of these benches, and it was a sort of char-a-banc. The wheels were placed upon two iron bands, which formed the road, and to which they are fitted, being so constructed as to slide without any danger of hitching or becoming displaced, on the same principle as a thing sliding on a concave groove. The carriage was set in motion by a mere push and, having received this impetus, rolled with us down an inclined plane into a tunnel, which forms the entrance to the railroad.'

Fanny Kemble; on a trial run on the Liverpool and Manchester Railway, 26 August 1830.

Fanny Kemble probably referred to one of the first two carriages of this Liverpool and Manchester Railway train. The original Ackermann print; *Coaches etc. employed on the railway',* was reproduced by the London Midland and Scottish Railway during the centenary year of the opening of the Liverpool and Manchester Railway.
Print, actual size, 1930.

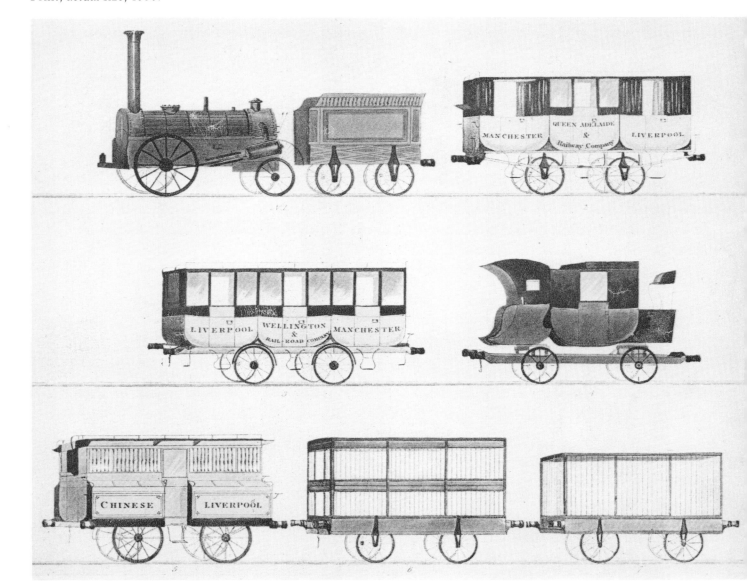

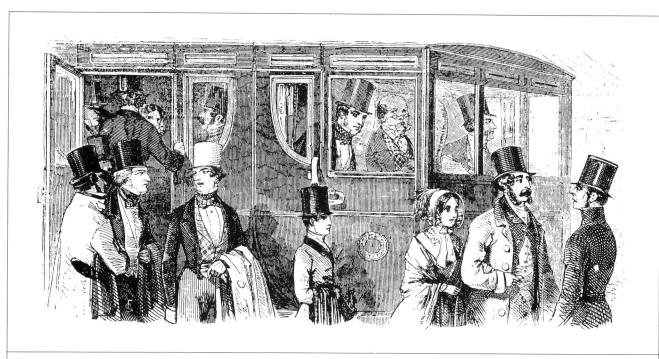

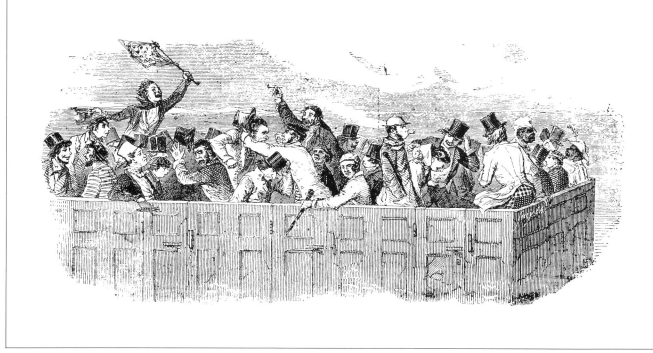

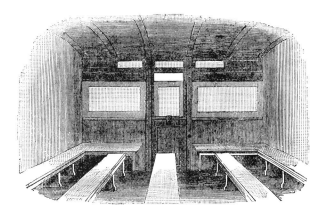

ABOVE
First and third class on the London and South
Western Railway on Derby Day.
Engravings, actual size, 1846.

BELOW
First and second class on the Eastern Counties
Railway.
Engravings, actual size, 1847.

Detail drawing of a standard first class compartment
designed by W. Adams for the North London Railway.
Issued as a supplement to *The Engineer*.
This section actual size from the print, 590 x 805mm,
1869.

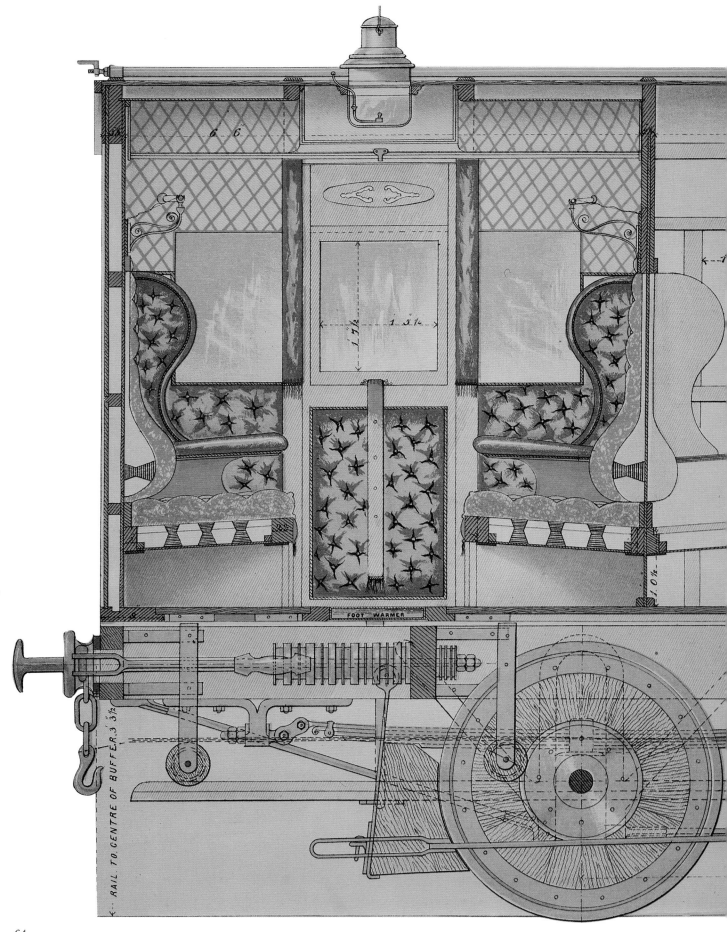

Until carriage heating was introduced travel in winter
left much to be desired. The only comfort came from
an ever-cooling footwarmer placed on the floor.
The position for this can be seen in the facing illustration.
Circular, actual size, 1878.

(Circular No. 307.)

GREAT WESTERN RAILWAY.

STORAGE OF FOOTWARMERS—SPRING, 1878.

Be good enough to have every Carriage (in Traffic, Carriage, Storing, and Shop Lines), Lamp Room, Footwarming Room, and other places on your Station thoroughly searched on Sunday, May 5th, at 8.0 a.m., for the purpose of collecting Footwarmers of *all* descriptions.

A correct account must be taken on a form to be ruled as under—

No. on Warmer.	Company's Initials.	No. on Warmer.	Company's Initials.	No. on Warmer.	Company's Initials.

The whole of the Warmers collected must be loaded in a Horse Box or, when the number is not large, in the Guards Break Vans of the Train, and booked through the Parcels to

Mr. SMITH,
Lamp Inspector,
Paddington.

A copy of the account of the Warmers so collected and forwarded must be sent to my Office the same day.

Any in Coaches in Trains that may be running at the time appointed for the collection must be dealt with by the Station where the Coaches terminate their journey.

It is important that this muster be correctly taken by reliable men, and each Station Master must personally attend to the matter, and certify the Return as a correct statement of the whole of the Warmers on hand.

The receipt of these instructions to be acknowledged to the Divisional Superintendent.

G. N. TYRRELL,
Superintendent of the Line.

Paddington,
May 1st, 1878.

Three stage coach bodies joined together and mounted on
four flanged wheels equalled one first class railway carriage.

RIGHT and CENTRE
Printer's stock blocks by Caslon.
Both actual size, 1854.

BELOW
Standard design for a first class railway carriage
by Brown, Marshall & Co, Birmingham.
Plate by Blackie & Co; *Railway Machinery*.
142 x 279mm, 1855.

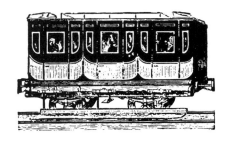

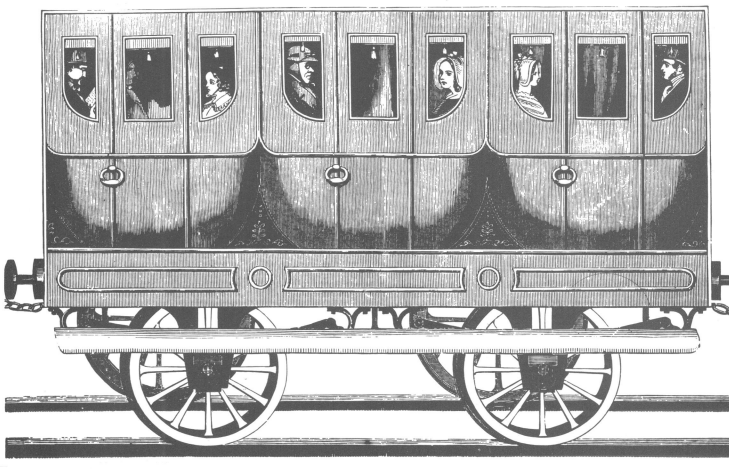

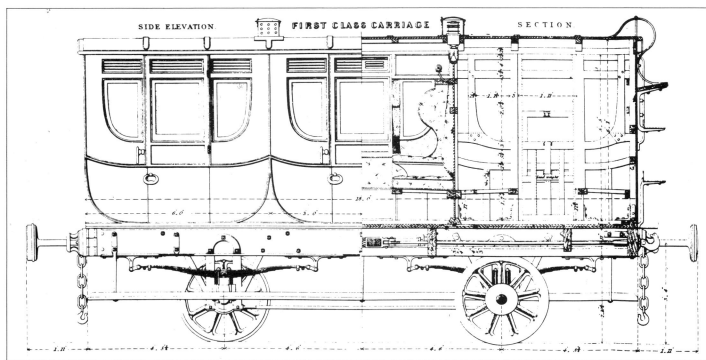

SIDE ELEVATION. FIRST CLASS CARRIAGE SECTION.

One of many curious inventions devised as a result of numerous accidents.
The basic principle outlined in the accompanying blurb claimed . . . 'in the
event of a frame breaking up in a collision, they will be projected or
squeezed upwards instead of being crushed' . . . They went on to recommend
one or two such vehicles being used at the front and rear of the train.
Leaflet, 285 x 222mm, c.1855.

BENNETT AND ROSHER'S

PATENT CYLINDRICAL COMPARTMENT

SAFETY + RAILWAY + CARRIAGE

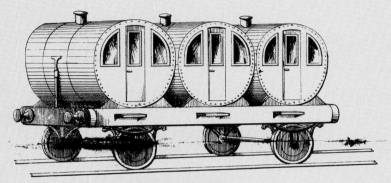

GENERAL VIEW.

FIG : 1.

FIG : 2.

x

After 1874 Pullman became a synonym for luxury.
The Midland Railway contracted with the Pullman
Palace Car Company of Detroit to import these
sumptuous vehicles designed by George Mortimer
Pullman. They were shipped in parts and
re-assembled at Derby.

BELOW
Drawing room car 'Victoria'.

RIGHT
Sleeping car 'Enterprise'.
Both actual size, supplement to *Engineering*, 1875.

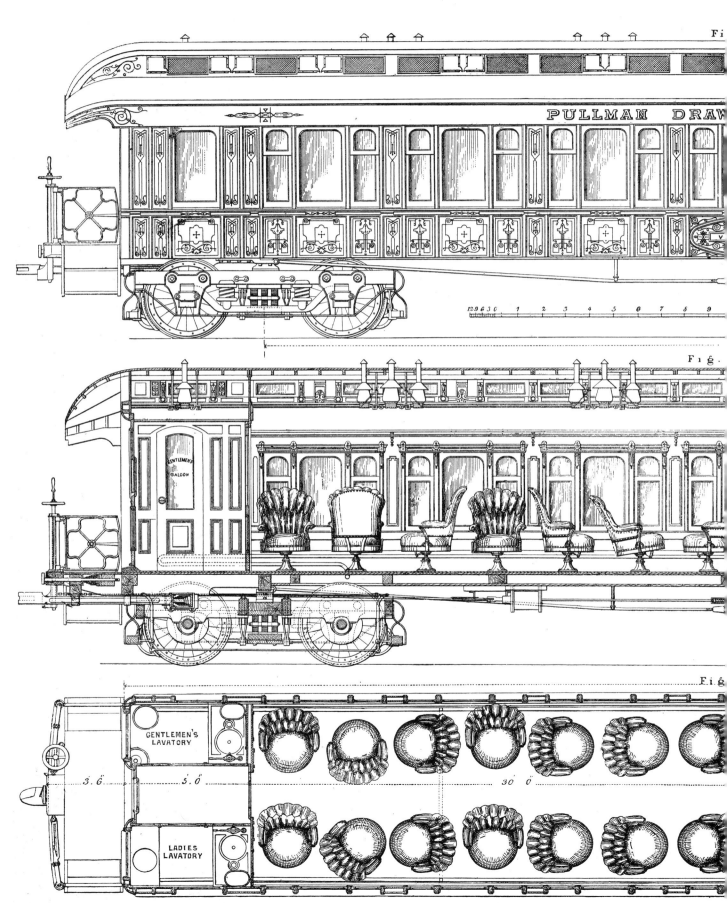

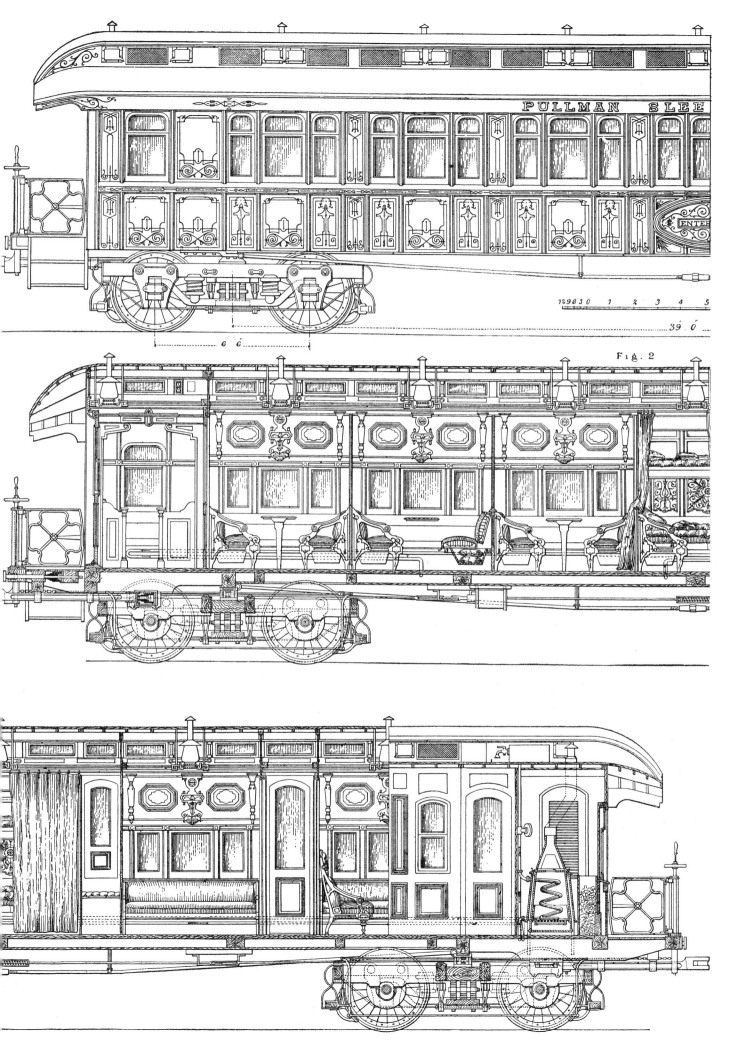

PULLMAN SLEE

ENTER

Fig. 2

Double page advertisement from *Railway News*.

ABOVE
Detail, actual size.

BELOW
The spread, half size, 1914.

Improved Balanced Blind Roller; Retains the Blind in any Position.

Seat Upholstered in Grey Hair Seating, with Leather Head Rest, Brass Parcel Racks, and Roof Ventilator.

W. S. LAYCO CK, LIMITED,

VICTORIA WORKS, MIL LHOUSES, SHEFFIELD.

Telegraphic Address: "INVENTION" SHEFFIELD. A B C Code, 5th Edition.

Manufacturers —of— ## Railway and Steam ship Patented Specialities.

Combination Automatic Coupler and Vestibule.

Sliding Door, fitted with Frictionless Ball Race Runner, Frameless Light and Window Lift.

Improved Balanced Blind Roller; Retains the Blind in any Position.

Seat Upholstered in Grey Hair Seating, with Leather Head Rest, Brass Parcel Racks, and Roof Ventilator.

BLIND ROLLERS OF EVERY DESCRIPTION, TORPEDO AND OTHER VEN
PUSHOVER AND OTHER REVERSIBLE SEATS, RATTAN, HORSE

SPECIAL ELASTIC JOURNAL PACKING FOR AXLE BOXES. The best lubricating material yet produced.

Patent System of Vapour Steam Heating.
Patent Storage Heaters.

For Warming Railway Carriages, Tram

Patent Self-Balancing Frameless Sash for Promenade Decks of Steamships or

LINCRUSTA DECORATION AND MILLBOARD PANELLING. SPEC

Pullman Type Vestibule, Centre Platform, Patent Combination Automatic

"Orite" Metal Bearing Brasses for Railway Carriages, Wagons, and Tramcars. Brass Castings of all kinds
Drop Forgings of every description in Steel and Iron. Upholstering Materials of every

FIRST PRIZE MEDALS:—CHICAGO, 1883; INVENTIONS EXHIBITION, 1885.
GRAND PRIX:—BUENOS AYRES RAILWAY EXHIBITION, 1910.

London Office :—**77a, QUEEN VICTORIA STREET, E.C.**

TILATORS, WINDOW LIFT, DUST AND DRAUGHT EXCLUDER, PATENT
HAIR, MOQUETTE, VELVET AND OTHER SEAT COVERINGS.

Composed of Curled Horse Hair and Wool. Always retains its elasticity in the box. SAVES 50% IN OIL.

Patent System of Direct Steam Heating.
Gold's Patent Electric Heaters.

ways, Steamships, Public Buildings, Etc.

other purposes, as supplied by us to many of the large Atlantic Liners.

IALLY ADAPTED FOR RAILWAY CARRIAGES AND STEAMSHIPS.

Coupler & Adjustable Side Buffers, interchangeable with Screw Coupling.

suitable for Railway, Ship, and general purposes, produced in first-class style by special Moulding Machinery.
description. Moquettes, Velvets, Moroccos. Buffalo Hides, Laces, Linings, Curled Hair.

Many of these Patents are now in use on all the principal Railways throughout the World.

Telegrams—"AUTOCOUPLE," LONDON.

Goods engine No. 401 seems an unlikely candidate for
either speed or comfort.
Whole page advertisement from *Railway News,* actual size, 1914.

PRIVATE AND NOT FOR PUBLICATION.—(For use of the Company's Servants only.)

GREAT WESTERN RAILWAY.

(Circular No. 1495.)

OFFICE OF SUPERINTENDENT OF THE LINE,
PADDINGTON STATION, APRIL, 1904.

F. 71/78300.

RAIL MOTOR SERVICE

BETWEEN

SOUTHALL & BRENTFORD.

On and from Sunday, May 1st next, the present Passenger Train Service (1st, 2nd, and 3rd class) between **SOUTHALL** and **BRENTFORD** will be superseded by a Rail Motor Service (**one class only**).

A single fare of Twopence will be charged between Brentford and Southall, and revised 1st, 2nd, and 3rd class fares between Brentford and Stations beyond Southall will be put into operation, enabling passengers to travel 1st, 2nd or 3rd class by ordinary Trains to and from Southall.

Parcels, etc., traffic will be conveyed by the Motor Trains, and rates will be the same as heretofore.

RAIL MOTOR SERVICE

BETWEEN

Westbourne Park & Southall

Via PARK ROYAL and HANWELL.

Rail Motor Cars, (one class only,) will run on week days, (commencing May 2nd), between **WESTBOURNE PARK** and **SOUTHALL** via Park Royal and Hanwell.

On Sundays, (commencing May 1st,) the Cars will run between **PADDINGTON** and **SOUTHALL** via Park Royal and Hanwell.

For particulars of the service see May Time Bills.

Advise all concerned, and acknowledge receipt to your Divisional Superintendent by First Train.

J. MORRIS, *Superintendent of the Line..*

Mr._____

_____*Station.*

WYMAN & SONS, Ltd., Printers, Fetter Lane, London, E.C. and Reading.—9344a.

The rail motor, or motor engine was a combined carriage and small locomotive; either an obvious combination (p71) or a camouflaged construction (above). Used on minor routes with limited traffic they were thought to be economic to run, though if the engine broke down the carriage was also a casualty.

LEFT
Circular, actual size, 1904.

ABOVE
The type of rail motor that probably worked on either of the services referred to on the circular opposite.
Plate presented with *The Locomotive Magazine;* 140 x 220mm, 1909.

RIGHT
Passengers beware! With sparks flying like this it is advisable not to lean out of the window. The driver's pose suggests that either the front window is dirty or he thinks he is still driving a steam locomotive. A remarkably sinister piece of graphic art.
Poster, 890 x 660mm, 1915.

BELOW
Seat reservation was included when purchasing a
first or second class ticket for travel on the
Liverpool and Manchester and many of the first
railways.
Leaflet, actual size, 1830.
Courtesy Liverpool Libraries.

RIGHT
Compartment ephemera.

Seat reservation label, London, Midland and
Scottish Railway, 98 x 100mm, 1938.

Notice, North Eastern Railway, actual size,
c.1905.

Travelling

BY THE

RAILWAY.

THE DIRECTORS of the LIVERPOOL and MANCHESTER RAILWAY beg leave
to inform the Public, that on and after MONDAY next the 4th of October, the Railway
Coaches will start from the Stations in Liverpool and Manchester respectively, at the follow-
ing hours :—

The FIRST CLASS COACHES, Fare 7s.
At Seven o'Clock.
Ten o'Clock.
One o'Clock.
Half-past Four o'Clock.

The SECOND CLASS COACHES, Fare 4s.
At Eight o'Clock.
Two o'clock.

On Sundays, the First Class Coaches will start at Seven o'Clock in the Morning, and
half-past Four in the Afternoon ; and the Second Class Coaches at half-past Six in the
Morning, and Four in the Afternoon.

Places may be booked at the Liverpool end, either at the Station in Crown-street, or at
the Company's Coach Office, in Dale-street ; and at the Manchester end at the Coach Office
in Liverpool-road, or at the Company's Coach Office in Market-street, corner of New Cannon-
street, where Plans of the Coaches constituting each Train will lie, in order that Passengers
may make choice of their respective Seats. Tickets for which will be given on payment of
the Fare.

A conveyance by Omnibusses twenty minutes before each of the above-mentioned hours
of departure of the First Class Coaches only, will proceed from the Company's Office, Dale-
street, to Crown-street, free of charge, for Sixty-eight Passengers and their Luggage, (the said
number, *first booked*, having the preference, on their claiming it at the time of booking) and
for the same number *from* Crown-street to Dale-street, on the arrival of the Coaches from
Manchester, a preference on the same terms being given to Passengers first booked at the
Company's Coach Offices, Manchester.

After the Festival week, during which it is impossible to ensure the desired accommoda-
tion, a conveyance to and from Crown-street will be provided for all the Passengers carried
by the First Class Coaches.

Parcels will be received at any of the Company's Coach Offices, and delivered with the
greatest regularity at the usual rates, and without any charge for booking or delivering.

No fee or gratuity is allowed to be taken by any Porter, Guard, Engine-man, or other
servant of the Company, and the Directors are determined to enforce this regulation by the
immediate dismissal of any person in their employ offending against it.

Railway Office, John-street, Liverpool, 30th September, 1830.

PRINTED BY BANCKS AND CO. EXCHANGE-STREET.

Window sticker, 'Smoking', London and South Western Railway, actual size, c.1900.

Window sticker, 'Hythe', Southern Railway, actual size, 1939.

Window sticker, 'Ladies only', London and South Western Railway, 64 x 243mm, c.1900.

LMS E.R.O. 19313
 O.P. 2

Seat
Reserved

PENALTY under Bye
Law 18 for
unauthorised removal of this label £5

NOTICE.

PASSENGERS ARE

REQUESTED

TO REFRAIN FROM

SPITTING.

(1763 B)

SMOKING.

HYTHE

(1763A)

LADIES ONLY.

[W. & S. Ltd.]

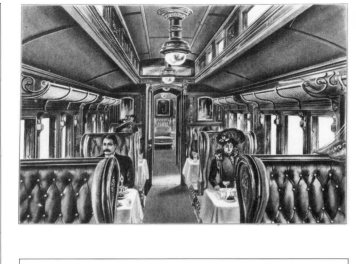

TRAVEL IN COMFORT

BY THE EXPRESS ROUTE BETWEEN —— LONDON (WATERLOO) AND —— THE SOUTH AND WEST OF ENGLAND

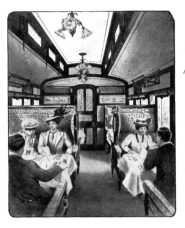

UP-TO-DATE
CORRIDOR
CARRIAGES
in the
principal
Services.

SEATS
RESERVED
FREE

'Phone
3365 Hop.

BREAKFAST,
LUNCHEON
AND DINING
SALOONS.

To which
passengers
travelling any
class have
access without
extra charge,
except cost of
meals.

TARIFF.

Breakfast, 2/6. Luncheon, 2/6.
Dinners, 4-course, 3/-; 5-course, 3/6.
Teas and other refreshments provided at moderate charges

For Time Tables and Week-End Programmes, also Illustrated Guides, &c.,
apply at the Company's Offices or to

Mr. HENRY HOLMES, Supt. of the Line,
WATERLOO STATION, LONDON, S.E.

H. A. WALKER, General Manager.

1019 $\frac{5276}{1912}$ — 20 —

ABOVE
London and South Western
Railway dining saloon from
'Weekends out of Town'.
Booklet, actual size, 1912.

ABOVE RIGHT
Midland Railway dining car
from *'Midland Railway of
England'*. Booklet distributed in
North America.
Page size 200 x 138mm,
c.1905.
Courtesy Michael Brooks

RIGHT
London Midland and Scottish
Railway dining car from
*'a Souvenir of a visit of members of
the International Hotel Alliance'*.
Booklet, actual size, 1926.

THE return from Manchester to London
will be made in the evening and it is
unfortunate that it will therefore not be
possible to see much of the English
countryside through which the LMS
runs for the greater part of the journey.
Nor will it be possible to examine such
matters of interest as the vast network of
lines in the great railway junction at
Crewe, the lofty viaducts and the sweeping
miles of the wide permanent way. But an
opportunity will be afforded of learning
at first hand to what perfection the
amenities of railway travel have been brought
on the LMS. The long vestibule coaches
with the dining saloons and special kitchen
cars have made the LMS trains as comfort-
able as a hotel and as well appointed. The
sleeping cars on the fast night expresses are
divided into individual little bedrooms, so
that each traveller can enjoy his night's repose
undisturbed and in privacy.

To the business man hurrying from city to
city "on his lawful occasions" such comfort

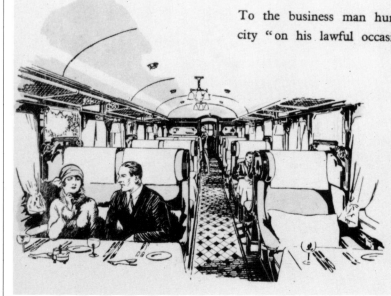

Whilst there was little basic change of style in
the three dining cars, left, this London and
North Eastern Railway buffet car was considered
to be very avant-garde at the time.
Somewhat more 'modern' than comfortable.
Leaflet, actual size, 1938.

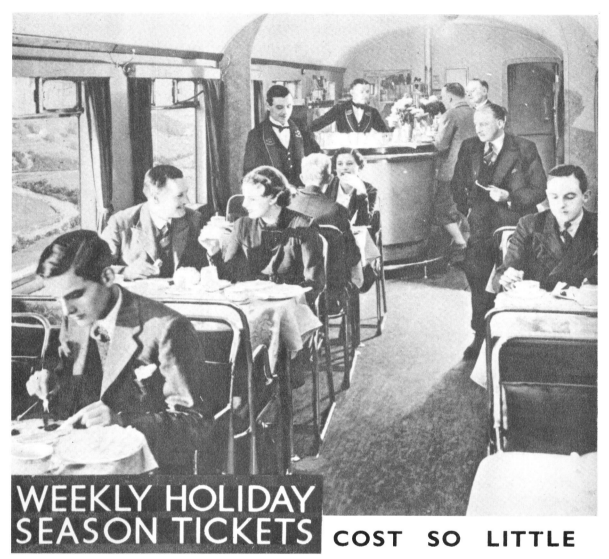

WEEKLY HOLIDAY SEASON TICKETS COST SO LITTLE

Any of the tickets mentioned in this
folder can be obtained for :—

10/6 THIRD CLASS OR **15/9** FIRST CLASS

CHILDREN UNDER 14 APPROXIMATELY HALF FARE

To take your dog with you for
the week, costs only 2/8 or
your bicycle 5/3

Travel as often as you like in the selected area

Issued any day of the week

How a carriage was built on the
London and North Eastern Railway in 1932.

BELOW
Visitors were presented with a hand assembled
booklet, 180 x 236mm,
and
a plan of the works showing the route they should take.
Whole plan; 455 x 655mm, detail shown; 200 x 250mm.

RIGHT
General view of the main workshop showing component parts
being prepared on the left and the assembly line on the right.

Stage 1: Fitting the floor framing and floorboards.

Stage 2: Erecting the body quarters, ends, compartment
partitions and cant-rails. Panelling is given two coats of varnish
and interior work begins.

Stage 3: The roof is framed and boarded. Vestibule laminated
buffing spring gear and lavatory roof tanks are installed.

Stage 4: Roof covering is completed; ventilators and passenger
communication are added. Electricians lay wires along
corridor and compartment screens. Work on the lavatory
begins.

Stage 5: Body platform doors are hung, electricians complete
the wiring and plumbers install the lavatory fittings connecting
them to the steam heated water system.

Stage 6: The body receives a third coat of preparing varnish
and internally photo frames, light fittings, switches and fuses
are fixed.

Stage 7: A first coat of hard drying varnish is applied, various
minor interior finishing is carried out and the seating is placed
in position.

The construction being completed, the carriage is ready to be
moved to the paint shop.

All pictures 155 x 205mm.

A Visit

to the

London & North Eastern Railway

Carriage & Wagon Works

York

GENERAL VIEW

STAGE 1

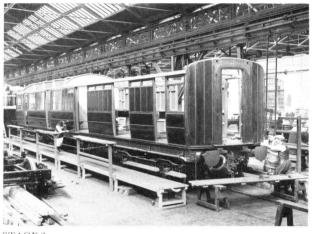

STAGE 2

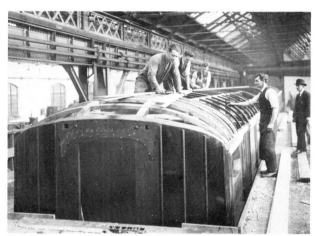

STAGE 3

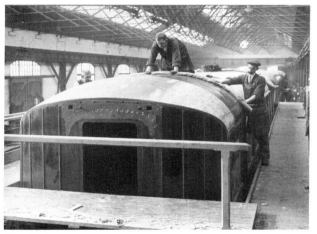

STAGE 4

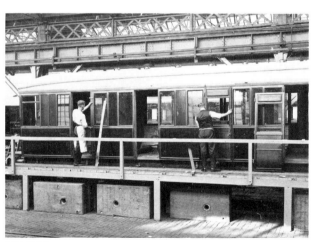

STAGE 5

STAGE 6

STAGE 7

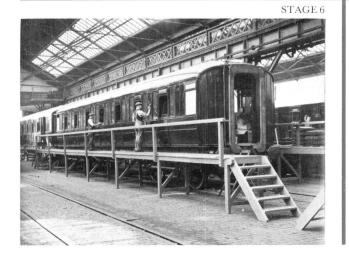

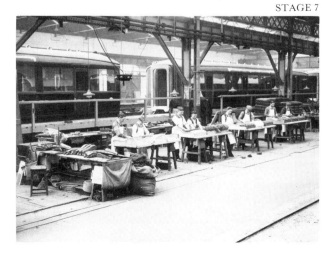

79

GREAT WESTERN RAILWAY.

COMMUNICATION WITH GUARD.

All Trains upon this Railway which run during any part of the journey a greater distance than 20 Miles without stopping, are provided with a means of communicating between the Passengers and the Servants of the Company in charge of the Train.

To call the attention of the Guard and Driver, Passengers must PULL DOWN THE CORD, which will be found outside the Carriage close to the Cornice, over the Window of the Carriage Door. There are Cords on both sides of the Train; but that on the RIGHT-HAND SIDE in the direction in which the Train is travelling IS THE ONE BY WHICH ALONE COMMUNICATION CAN BE MADE.

Passengers are earnestly requested to protect the Communication from improper and mischievous use, as it is very important that it should not be used without real and urgent necessity.
Under the provisions of the Regulation of Railways Act, 31 and 32 Victoria Cap. 119. any Passenger who makes use of the means of communication without reasonable and sufficient cause, is liable, for each offence, to a PENALTY NOT EXCEEDING FIVE POUNDS.

LUNCHEON AND TEA BASKETS.

Upon due notice being given to the Guard, BASKETS, with HOT or COLD LUNCHEON, or TEA, can be obtained at :—

PADDINGTON, SWINDON, GLOUCESTER, OXFORD, *LEAMINGTON,
BATH, TROWBRIDGE, NEWPORT, BIRMINGHAM, *WOLVERHAMPTON,
BRISTOL, TAUNTON, CARDIFF, SHREWSBURY, CHESTER,
EXETER, PLYMOUTH, NEATH, WORCESTER (Shrub Hill), HEREFORD (Barr's Court)

*HOT LUNCHEON BASKETS are not supplied at Leamington or Wolverhampton.
HOT LUNCHEON BASKETS are not supplied on Sunday.

CHARGES.—HOT OR COLD LUNCHEON BASKETS, 2/6 each, exclusive of Liquors. Small Bottle of Claret, 1/-.
Beer per Bottle, 6d. Other Liquors as per tariff exhibited in the Refreshment Rooms.
TEA BASKET for one person, 1/-, an Tea Basket for two persons, 1/6.

N.B.—It is requested that all fittings may be replaced, and the Basket handed to the Guard at the next Station after use.

PADDINGTON, August, 1897. J. L. WILKINSON, General Manager.

The first communication cord was introduced by the North Eastern Railway in 1869. Running outside, above the doors, for the full length of the train, it operated a whistle on the engine and a bell in the guard's van. In 1899 an improved system, using an interior mounted chain operating a valve on the continuous brake, was adopted by all companies.

ABOVE
Carriage notice, 190 x 250mm, 1897.
Courtesy Ephemera Society

LEFT
Carriage notice, 115 x 115mm, c.1892.

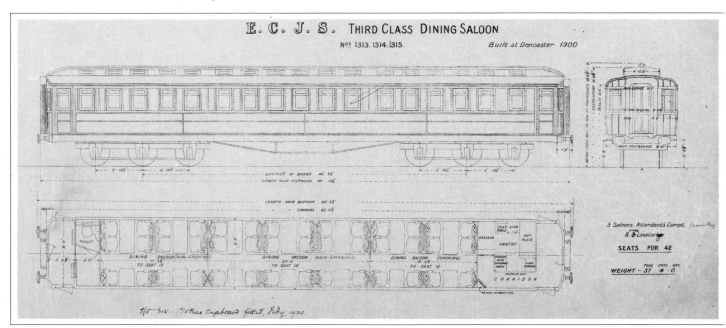

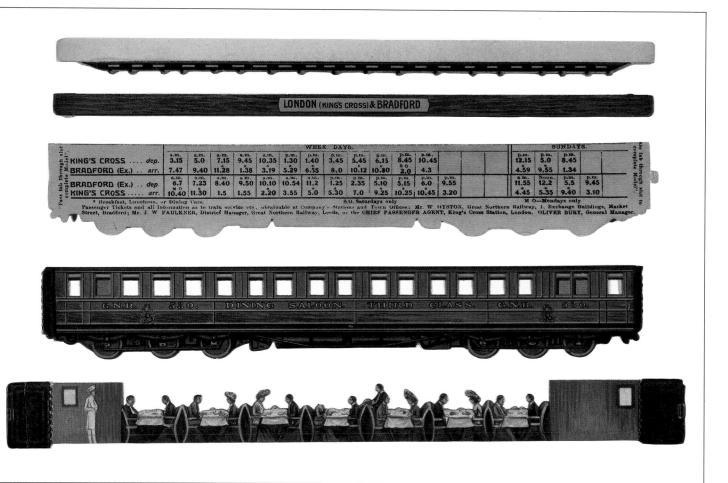

LONDON (KING'S CROSS) & BRADFORD

Pass tab through slot to complete Model.

	WEEK DAYS.														SUNDAYS.			
KING'S CROSS dep.	a.m. 3.15	a.m. 5.0	a.m. 7.15	a.m. 9.45	a.m. 10.35	1.30	p.m. 1.40	p.m. 3.45	p.m. 5.45	p.m. 6.15	p.m. 8.45	10.45			p.m. 12.15	p.m. 5.0	8.45	
BRADFORD (Ex.) .. arr.	7.47	9.40	11.28	1.38	3.19	5.29	6.55	8.0	10.12	10.30	S O 2.0	4.3			4.59	9.55	1.34	
BRADFORD (Ex.) .. dep.	a.m. 6.7	a.m. 7.23	8.40	9.50	10.10	10.54	11.2	p.m. 1.25	2.35	5.10	5.15	6.0	9.55		a.m. 11.55	Noon 12.2	p.m. 5.5	9.45
KING'S CROSS arr.	10.40	11.30	1.5	1.55	2.20	3.55	5.0	5.30	7.0	9.25	10.25	10.45	3.20		4.45	5.35	9.40	3.10

* Breakfast, Luncheon, or Dining Cars. S.O. Saturdays only M O—Mondays only

Passenger Tickets and all information as to train service etc., obtainable at Company's Stations and Town Offices: Mr. W. OYSTON, Great Northern Railway, 1, Exchange Buildings, Market Street, Bradford; Mr. J. W. FAULKNER, District Manager, Great Northern Railway, Leeds, or the CHIEF PASSENGER AGENT, King's Cross Station, London. OLIVER BURY, General Manager.

G.N.R. 530. DINING SALOON. THIRD CLASS. G.N.R. 530.

ABOVE

Advertising 'novelty' in the form of a card cut-out model of a Great Northern Railway dining car. Maximum width 234mm, 1901.
Courtesy Michael Brooks

FACING PAGE BELOW LEFT

Great Northern Railway drawing office diagram of the dining car on which the above model was based. 200 x 410mm, 1900.

LEFT

Exterior of a Great Northern, Piccadilly, and Brompton Railway train. Another 'novelty' in which the train emerged from a slot in the tunnel.
Actual size, c.1905.
Courtesy Michel Brooks

BELOW LEFT

The interior of a similar train on the Baker Street and Waterloo Railway. Postcard, actual size, c.1910.

Other rolling stock

'*To the ignorant or unintelligent mind, such a phrase as 'The Romance of Goods Traffic' seems
a mere contradiction in terms. The carrying of wares from place to place
seems as dull and unromantic a business as can well be imagined. But to the
discerning mind true romance underlies things that seem most commonplace.
Had but McAndrews, that dour Scotch engineer of Kiplings creation, been foreman
in a railway depot, instead of 'chief' in the engine room of a liner, we might have
had an epic of goods traffic, instead of machinery, which would mightily
astonish Mr. Jones and Mr. Brown.*'

Great Central Railway staff writer, *Per Rail,* 1913.

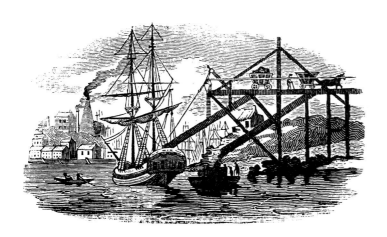

LEFT
Horse-drawn chaldron wagons on Tyneside.
Wood engraving by Thomas Bewick.
40 x 65mm, 1826.

BELOW
A similar wagon is the odd man out at the end of this printer'
(goods) train by Caslon.
Actual size, 1854.

FOOT OF BOTH PAGES
Mixed train of carriages and flat wagons on the Grand
Junction Railway used to decorate Drake's Railroad map.
Actual size, 1838.

RIGHT
Despite the wide variety of goods to be carried it was to be
many years before wagons were purpose built.
Poster, 660 x 483mm, 1838.
Courtesy National Railway Museum.

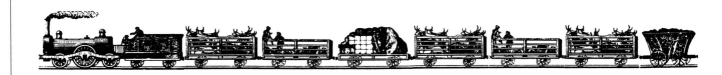

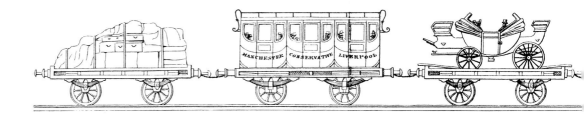

AN ACCOUNT OR LIST

OF THE SEVERAL

Rates, Tolls, and Duties,

EXCLUSIVE OF THE CHARGE FOR LOCOMOTIVE POWER AND CARRIAGES AND WAGGONS

WHICH THE

NORTH UNION RAILWAY COMPANY

Have directed to be taken for the Carriage or Conveyance upon or along the NORTH UNION RAILWAY, and over or along the Bridge and Viaduct across the River and Valley of Ribble, of Passengers, of Beasts, Cattle, and Animals, and of Articles, Matters, and Things, including small Parcels, (except such Passengers, Beasts, Cattle and Animals, Articles, Matters, and Things, including small Parcels as shall have previously passed or shall afterwards pass, upon or along the Bolton and Preston Railway, the amount whereof will be hereafter published,) viz :—

For every Person conveyed in or upon any Carriage, the sum of *One-penny farthing* per mile.

For every Horse, Mule, or Ass, or other Beast of draught or burthen ; and for every Cow or Neat Cattle, *One Penny* per mile.

For every Sheep, Lamb, Calf, Pig, or other small Animal, *One-eighth of a Penny* per mile.

For every Carriage of whatever description, not being a Carriage adapted and used for Travelling on a Railway, and not <u>weighing more than One Ton</u>, *Two Pence three farthings* per mile.

For every such Carriage weighing more than One Ton, *Four Pence* per mile.

For all Lime-stone, Coal, Slack, *One Penny* per Ton per mile.

For all Coals and Lime, all Dung, Compost, and all sorts of Manure, and all Materials for the repair of the public Roads and Highways, *One Penny-farthing* per Ton per mile.

For all Coke, Culm, Charcoal, Cinders, Stone, Sand, Clay ; Building, Pitching and Paving Stones ; Flags, Bricks, Tiles, and Slates, *One Penny-halfpenny* per Ton per mile.

For all Sugar, Corn, Grain, Flour, Dyewoods, Staves, Deals, Lead, Iron, and other Metals, *One Penny-halfpenny* per Ton per mile.

For all Cotton and other Wool, Hides, Drugs, Manufactured Goods, and all other Wares, Merchandize, Matters or Things, *One Penny-three-farthings* per Ton per mile.

RATES FOR SMALL PARCELS.

All Small Parcels, and all Parcels not exceeding 20lbs. or one cubic foot, *One Shilling.*
All Parcels not exceeding 40lbs. or four cubic feet, *One Shilling and Sixpence.*
Ditto ditto 60lbs. or six ditto, *Two Shillings.*
Ditto ditto 84lbs. or eight ditto, *Two Shillings and Sixpence.*
Ditto ditto 112lbs. or ten ditto, *Three Shillings.*
And all above 112lbs. to be charged *Three Shillings* per Cwt.

In all cases of Carriage or Conveyance upon or along the North Union Railway for a less distance than Four Miles, the charge will be for Four Miles, and in all cases of a Fraction of a Ton, the charge will be according to the number of Quarters of a Ton, and when there shall be a Fraction of a Quarter of a Ton, such Fraction will be charged as a Quarter of a Ton, and in all cases where there shall be a Fraction of a Mile, the charge will be according to the number of Quarters of a Mile, and where there shall be a Fraction of a Quarter of a Mile, such Fraction will be charged as and for a Quarter of a Mile.

Dated at Preston, the 6th Day of October, 1838.

(By Order)

JAMES CHAPMAN, Secretary of the Company.

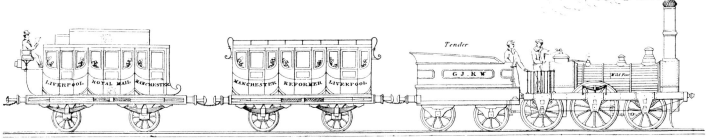

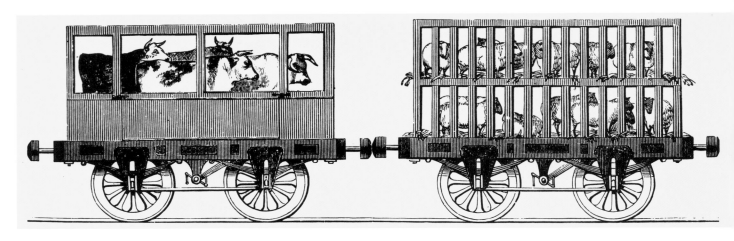

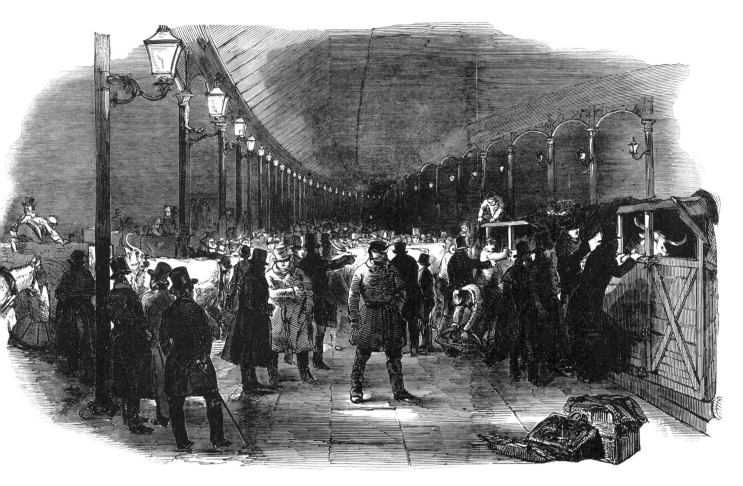

ABOVE LEFT
Cattle and sheep wagons offered by Caslon in their type catalogue at 6d each.
Actual size, 1854.

ABOVE
'Arrival of cattle at the railway terminus, Euston Square.' reported by the *Illustrated London News.*
147 x 230mm, 1849.

CENTRE LEFT
H.H. Henson's cattle wagon for the London and North Western Railway.
Plate from *Railway Machinery,* 132 x 210mm, 1855.

BELOW LEFT
The goods train as part of the overall transport scene.
Envelope cover, actual size, c.1843.

BELOW
Coal by rail, road and sea.
Letterhead, actual size, c.1870.

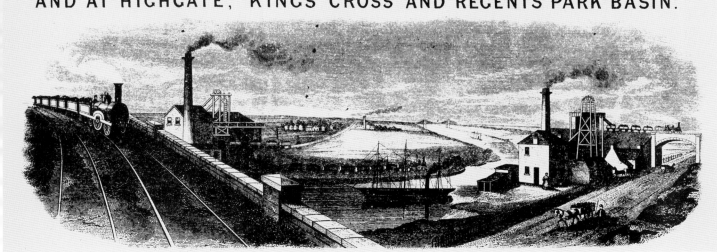

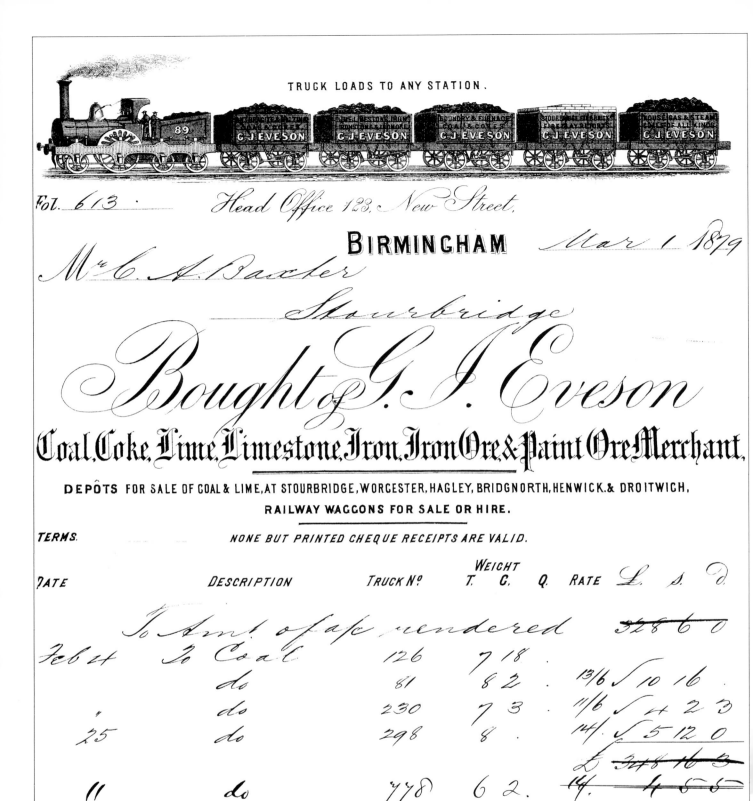

TRUCK LOADS TO ANY STATION.

C J EVESON · C J EVESON · C J EVESON · C J EVESON · C J EVESON

Fol. 613 · Head Office 123, New Street,

BIRMINGHAM Mar 1 1879

Mr C. A. Baxter

Stourbridge

Bought of G. J. Eveson

Coal, Coke, Lime, Limestone, Iron, Iron Ore, & Paint Ore Merchant,

DEPÔTS FOR SALE OF COAL & LIME, AT STOURBRIDGE, WORCESTER, HAGLEY, BRIDGNORTH, HENWICK. & DROITWICH,

RAILWAY WAGGONS FOR SALE OR HIRE.

TERMS. NONE BUT PRINTED CHEQUE RECEIPTS ARE VALID.

Date	Description	Truck Nº	Weight T. C. Q.			Rate	£. s. d.		
	To Amt of a/c rendered						328 6 0		
Feb 4	To Coal	126	7	18	.				
	do	81	8	2	.	13/6	5 10 16 .		
"	do	230	7	3	.	11/6	4 2 3		
25	do	298	8	.		14.	5 12 0		
						£	348 16 2		
11	do	778	6	2	.	14.	4 5 5		
							24 15 8		

923 (Pierced)

HENDERSON BROTHERS
NORTHAMPTON

Little basic change in wagon design within 80 years.

ABOVE
Letterhead, 260 x 216mm, 1879.

LEFT
Printers' stock block with facility for inserting appropriate name. From Stephenson Blake's catalogue. Actual size, 1959.

Every railway should have one.

RIGHT
Cupboard space under the seats and a highly original braking system. Advertisement, actual size, 1914.

H. F. CROHN & Co. (London), Ltd.

Eldon Street House,

ELDON STREET, LONDON, E.C.

Telegraphic Address:
LIGHTNESS, LONDON.

Telephone:
LONDON WALL 1922
(2 lines).

INSPECTION TROLLEYS, HAND-DRIVEN.

 ## MOTOR INSPECTION CARS

of all sizes and description, and for every consumption.

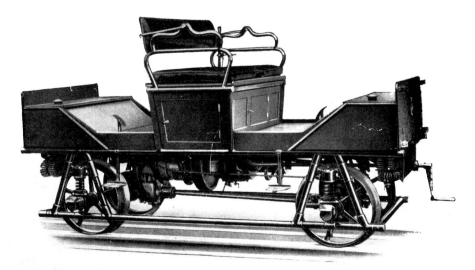

Please apply for Catalogues.

RAILWAY WAGON WORKS.

CHARLES ROBERTS,

Maker and Repairer of all kinds of

RAILWAY WAGONS.

Wagons Re-built with the old Iron Work, and Painted and Wrought
to any Style or Colour.

INGS ROAD, WAKEFIELD, YORKSHIRE.

LEFT
Probably the first advertisement by Charles
Roberts in the year he began trading.
White's Leeds Directory, actual size, 1856.

RIGHT
Roberts' railway engineering division was taken
over by Procor (UK) Limited in 1970 by which
time custom-building of freight rolling stock was
reaching a peak.
Poster, 1012 x 632mm, 1977.

HOUSEHOLD REMOVALS.

ESTIMATES FREE.

TAKING ALL RISK
HOUSEHOLD REMOVALS
LONDON BRIGHTON & SOUTH COAST RAILWAY
HUDSON.
L B & S C

ESTIMATES FREE.

Furniture Packed and conveyed in the same LOCK-UP-BOX VANS, throughout the entire system of Railways,
ENSURING SAFE DELIVERY.

FURNITURE WAREHOUSED.

DEPOSITORIES:
LONDON, NORWOOD, AND BRIGHTON.

WILLIAM HUDSON.

CHIEF OFFICES:
L. B. & S. C. RAILWAY, ST. THOMAS ST., LONDON BRIDGE, S.E.;
RAILWAY TERMINUS GATES, BRIGHTON;
WEST END
BRANCH OFFICE { 28, REGENT CIRCUS, } LONDON, W.
PICCADILLY,
AND
7, RUE DE LA PAIX, PARIS.

Door to door by the roll on-roll off system.

CENTRE LEFT
Printers' train by Austin, Wood, Browne.
Actual size, 1889.

BELOW LEFT
Advertisement, actual size, 1872.

BELOW
One of the dangers to wagon users following the
end of steam haulage.
Self adhesive label, 216 x 283mm, 1972.

DANGER
IT IS
STRICTLY FORBIDDEN
TO CLIMB ON TOP OF THIS
WAGON WHILST IN THE VICINITY OF
OVERHEAD
ELECTRIC WIRE

Procor (UK) Limited design, build, sell, hire, lease, maintain and repair all types of railway freight rolling stock.

PROCOR PROFILES

83 TON GLW LPG TANK WAGON

Designed by Procor (UK) Limited
Built by Norbrit Pickering Limited

Esso Petroleum Company Limited employs these wagons to convey Liquefied Petroleum Gases from their Refineries at Fawley and Milford Haven to distribution centres throughout the U.K. Each wagon averages 50,000 miles per year.

Air operated disc brakes
Speed: 60 m.p.h.
83 tons gross laden weight

50 TON G L W CAUSTIC SODA LIQUOR TANK WAGON

Designed by Procor (UK) Limited
Built at Horbury Wagon Works

I.C.I. Mond Division use these tank wagons to deliver caustic soda liquor in bulk to numerous customers in the textile, chemical and paper industries.

Air operated disc brakes
Speed: 60 m p h
50 tons gross laden weight

72 TON G L W PALLET VAN

Designed by Shellstar Ltd./Gloucester Railway Carriage & Wagon Co Ltd
Built by Procor (UK) Limited

In vehicles of this type Shellstar move 350,000 tons per year of bagged and palletised chemical fertiliser from their production plant at Ince, Cheshire to distribution depots throughout Britain.

Air operated clasp brakes
Speed: 60 m p h
72 tons gross laden weight

50 TON G L W PRESSURE FLOW PRESSURE DISCHARGE WAGON

Designed by Procor (UK) Limited
Built at Horbury Wagon Works

The Rugby Portland Cement Company Limited operate these wagons to carry cement in bulk from their works to distribution depots in various parts of the country.

Air operated disc brakes
Speed: 60 m p h
50 tons gross laden weight

**Procor (UK) Limited
Horbury Wagon Works
Horbury
Wakefield
West Yorkshire
WF4 5QH**

Telephone
Horbury 271881 (STD 0924)
Telex
556457 Procor G

CREATIVE CARTAGE BY PROCOR

HURST, NELSON & Co., Ltd.

BUILDERS OF RAILWAY CARRIAGES, WAGONS, ELECTRIC CARS AND EVERY OTHER
DESCRIPTION OF RAILWAY AND TRAMWAY ROLLING STOCK.

WAGONS LET ON SIMPLE HIRE.

MAKERS OF WHEELS AND AXLES, RAILWAY PLANT,
FORGINGS, SMITH WORK, IRON AND BRASS CASTINGS.

PRESSED STEEL WORK OF ALL KINDS, INCLUDING UNDERFRAMES AND BOGIES

THE GLASGOW ROLLING STOCK & PLANT WORKS

Telegraphic Address:
"NELSON, MOTHERWELL."

MOTHERWELL.

Branch Works { CHATSWORTH WAGON WORKS, Nr. CHESTERFIELD.
BRIDGEND WAGON WORKS, BRIDGEND, GLAMORGANSHIRE.
SᵂANSEA WAGON WORKS, SWANSEA.

Glasgow Office:
40, WEST NILE ST.

Cardiff Office:
GORDON CHAMBERS,
31, QUEEN STREET.

London Office:
14, LEADENHALL ST., E.C.

Please mention the " Great Western Railway Magazine " when writing to advertisers.

Fifty-five years of progress in advertising and wagon design. Private builders have always played a large part in supplying wagons for use on British railways. Oddly enough the British Rail booklet, right, shows privately-owned and constructed rolling stock.

ABOVE
Magazine advertisement, actual size, 1917.

RIGHT
12pp booklet, actual size, 1972.
Courtesy British Rail

CHOOSE YOUR WAGON

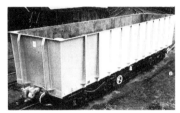
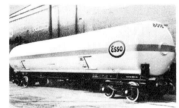

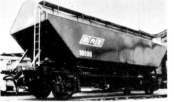
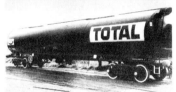

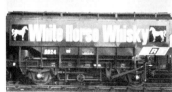

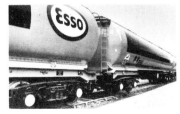

Rail Freight

91

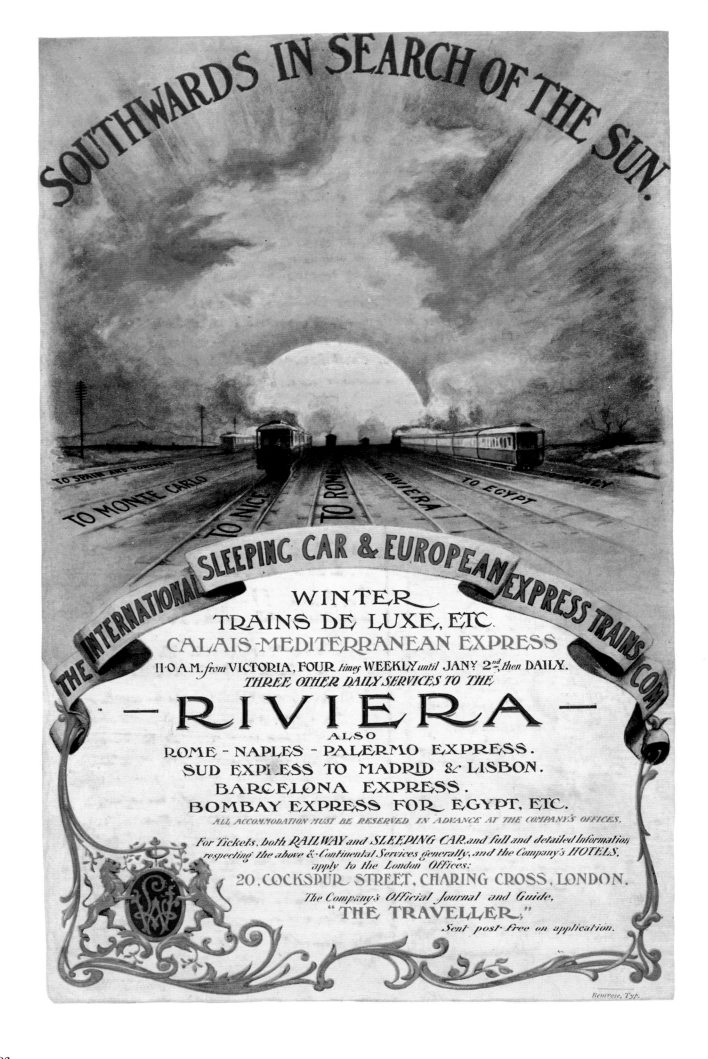

SOUTHWARDS IN SEARCH OF THE SUN.

TO SPAIN AND PORTUGAL

TO MONTE CARLO

TO NICE

TO ROME

RIVIERA

TO EGYPT

THE INTERNATIONAL SLEEPING CAR & EUROPEAN EXPRESS TRAINS COM.

WINTER
TRAINS DE LUXE, ETC.
CALAIS-MEDITERRANEAN EXPRESS
11·0 A.M. from VICTORIA, FOUR times WEEKLY until JAN.Y 2nd then DAILY.
THREE OTHER DAILY SERVICES TO THE

— RIVIERA —

ALSO
ROME - NAPLES - PALERMO EXPRESS.
SUD EXPRESS TO MADRID & LISBON.
BARCELONA EXPRESS.
BOMBAY EXPRESS FOR EGYPT, ETC.
ALL ACCOMMODATION MUST BE RESERVED IN ADVANCE AT THE COMPANY'S OFFICES.

For Tickets, both RAILWAY and SLEEPING CAR, and full and detailed Information
respecting the above & Continental Services generally, and the Company's HOTELS,
apply to the London Offices:
20, COCKSPUR STREET, CHARING CROSS, LONDON.
The Company's Official Journal and Guide,
"THE TRAVELLER,"
Sent post free on application.

Bemrose, Typ.

Additional services

'*There was no board of trade supervision then. The harbour at Newhaven was a mere creek, with only two or three feet of water upon the bar at low water, and it was impossible to use larger vessels. The fares being much cheaper than by the South Eastern route, the boats were crowded, and the miseries endured by the dock passengers were very great; they were often landed more like drowned rats than human beings.*'

Captain E. Blackmore on crossing the Channel by the Brighton and Continental Steam Packet Company, owned by the London, Brighton and South Coast Railway. 1850.

LEFT
How to find the sun; pointedly omitting the sea crossing needed to complete the journey.
Leaflet, actual size, 1902.
Courtesy Amoret Tanner

BELOW
A proposal by John Fowler C.E. for a steam railway ferry. Suggestions for a tunnel or bridge were also being considered at that time.
Illustrated London News, 202 x 241mm, 1870.

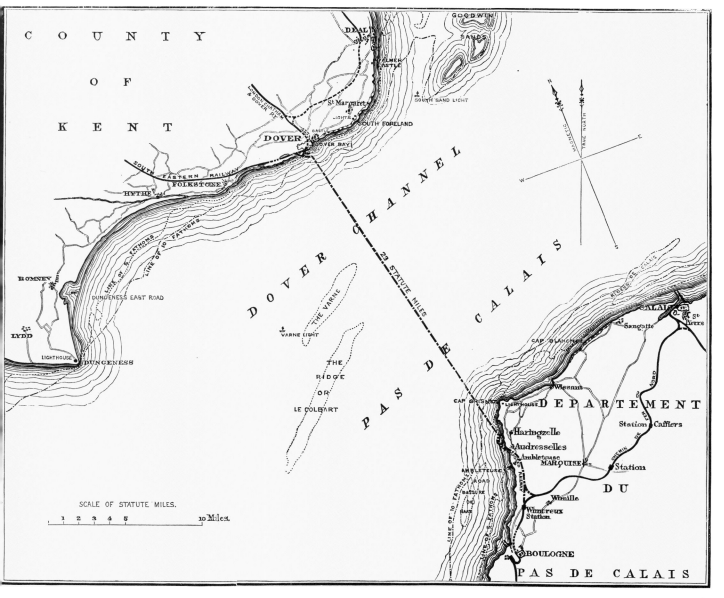

Side and end elevations of a proposed paddle steamer to operate the ferry crossing shown on p.93.
Below, 106 x 118mm, right above, 75 x 344mm, 1870.

RIGHT
The first catamaran rail ferry?
Booklet cover, actual size, 1881.

ABOVE
Timetable, actual size, 1851.

BELOW
London and South Western Railway mail packet *Normandy*.
Illustrated London News, 150 x 240mm, 1863.

THE
LONDON, CHATHAM, AND DOVER
RAILWAY COMPANY'S

NEW AND MAGNIFICENT TWIN STEAMSHIP

"CALAIS-DOUVRES,"

Specially appointed by the French Government for the conveyance of the Day Mails between

CALAIS AND DOVER,

Is now running Daily, except Sunday and Monday,

(Wind, Weather, and Tide permitting) leaving

DOVER for CALAIS at 9.30 a.m., in connection with the MAIL EXPRESS TRAINS leaving VICTORIA at 7.40 a.m., HOLBORN VIADUCT at 7.35 a.m., and LUDGATE HILL at 7.38 a.m., and returning from CALAIS at 1.20 p.m.

The " CALAIS-DOUVRES " has a Splendid Saloon above Deck, Handsome Ladies' Cabin, with Stewardess, Lavatories, and every convenience.

Private Cabins for parties and families. Saloon for Breakfasts and Luncheons ; and every kind of refreshment.

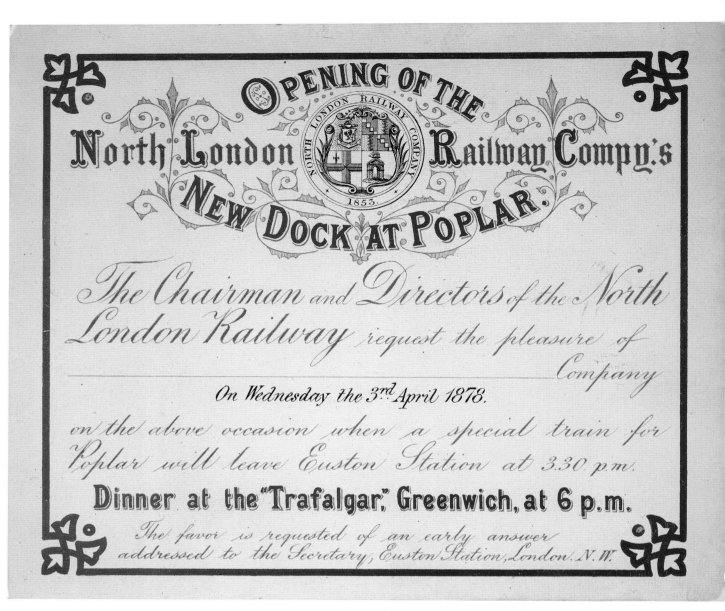

ABOVE
Invitation card, actual size, 1878. *Courtesy Michael Brooks.*

LEFT
Booklet cover, 168 x 108mm, c.1905. *Courtesy Amoret Tanner.*

FACING PAGE TOP LEFT
Folder, 237 x 160mm, 1939.

BELOW
Postcard, 87 x 140mm, c.1932. *Courtesy Michael Brooks.*

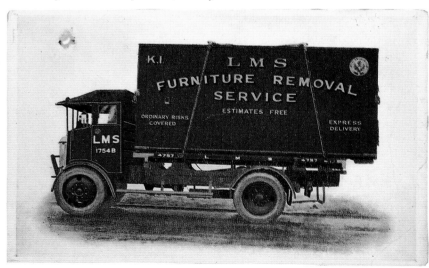

BELOW
The London and North Western Railway, like many others, owned a fleet of omnibuses. (see p.98).
Timetable detail, actual size, 1881.

ABOVE
With only 8 seats at 45/- return for London to the Isle of Wight, Railway Air Services were short-lived.
Folder, 202 x 150mm, 1935, *Courtesy Michael Brooks.*

OMNIBUSES
BETWEEN
EUSTON STATION & LUDGATE HILL.

| London and North Western Railway. | London, Chatham, & Dover Railway. |

A SERVICE OF OMNIBUSES HAS NOW BEEN ESTABLISHED BETWEEN
EUSTON STATION AND LUDGATE HILL

In order to facilitate the journey across London of Through Passengers between the LONDON AND NORTH WESTERN AND LONDON, CHATHAM, & DOVER COMPANIES' SYSTEMS, and also to accommodate Passengers going to or from either line and intermediate points on the route.

The route taken by the Omnibuses will be as under:—

EUSTON ROAD, JUDD STREET, LAMB'S CONDUIT STREET, RED LION STREET, HOLBORN, CHANCERY LANE, AND FLEET STREET.

THE OMNIBUSES WILL LEAVE EUSTON AND LUDGATE HILL AS FOLLOWS:—

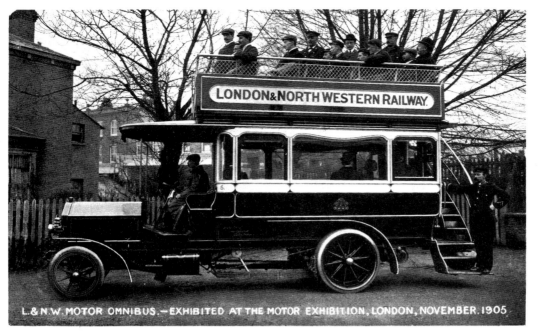

L.& N.W. MOTOR OMNIBUS.—EXHIBITED AT THE MOTOR EXHIBITION, LONDON, NOVEMBER, 1905.

LEFT
Postcard, actual size, 1905.

BELOW CENTRE
left
Milnes-Daimler Great
Western Railway omnibus
at Beaconsfield.
Postcard, 88 x 147mm,
c.1904.

right
Milnes-Daimler Great
Western Railway charabanc
at the same location.
Postcard, 88 x 147mm,
c.1905.

*Both courtesy Beaconsfield and District
Historical Society.*

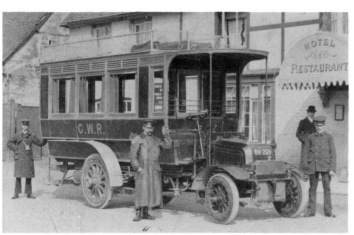

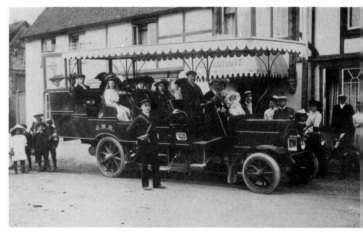

Make your transport worthy of your organisation !

Below: one of a large fleet of **AEC** Lorries
operated by the L.N.E. Rly. Co., Ltd.

AEC
LORRIES
(from 3½ to 8 Tons) and
PASSENGER VEHICLES
up to 60 Seats, comprise
the speediest and most
economical Passenger and
Commercial range. Ask
for details of the **AEC**
"MONARCH" short wheel-
base 4-tonner, for quick
handling on crowded
wharves and busy goods
yards.

AEC
385

THE ASSOCIATED EQUIPMENT Co.
Ltd., SOUTHALL, MIDDLESEX
Builders of London's Buses

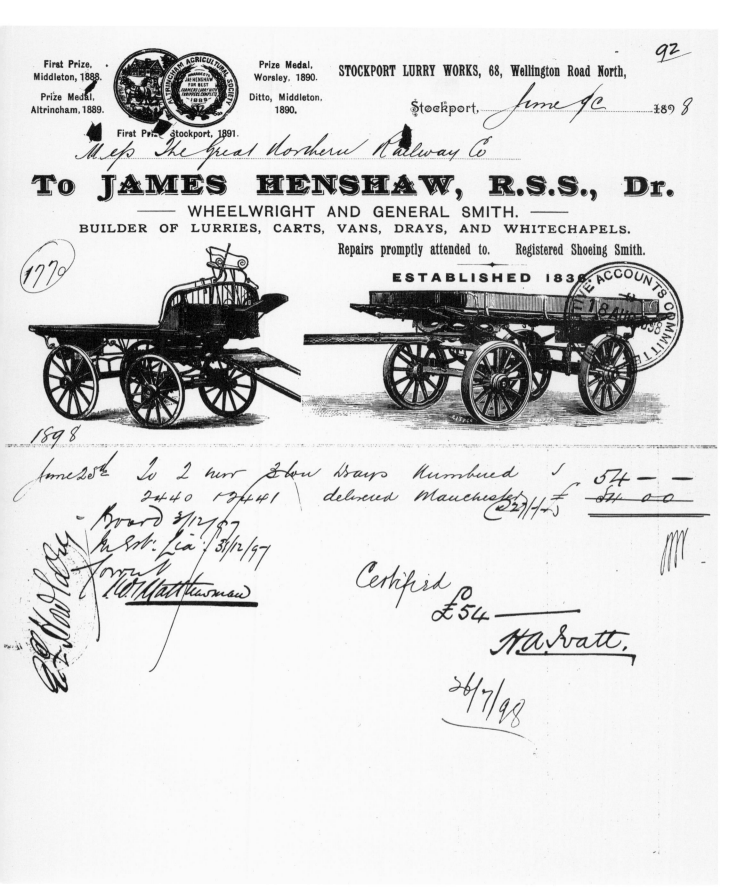

LEFT

A E C advertisement for insertion in London and North Eastern Railway publications. The same advertisement appeared in other companies' literature with appropriate amendments to the name on the vehicle and in the text. Actual size, 1930.

ABOVE

Invoice for 2 drays with payment approved by H A Ivatt, better known as locomotive superintendent of the Great Northern Railway.
255 x 206mm. 1898.

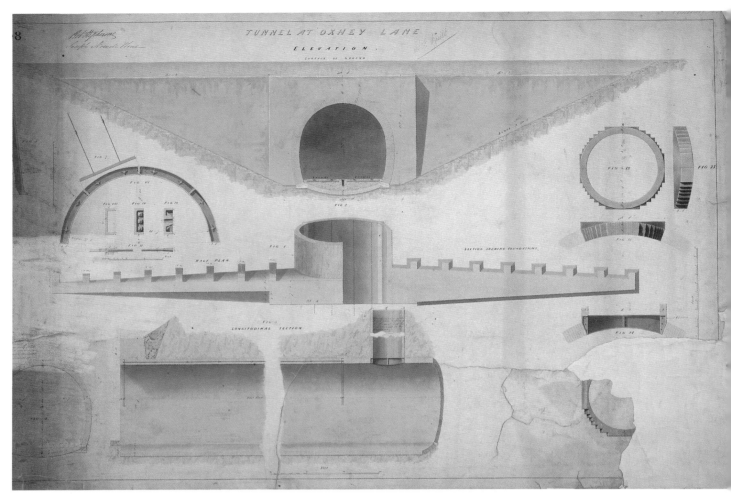

ABOVE
Robert Stephenson drawing for the tunnel at Oxhey Lane,
London and Birmingham Railway.
700 x 1090mm, 1835.

BELOW
'Entrance to Euston Square Station'.

CENTRE RIGHT
'Coventry Station'.

BELOW RIGHT
'Birmingham Station'.
Three engravings from Osborne's *London and Birmingham
Railway Guide,* page size, 160 x 95mm, 1841.

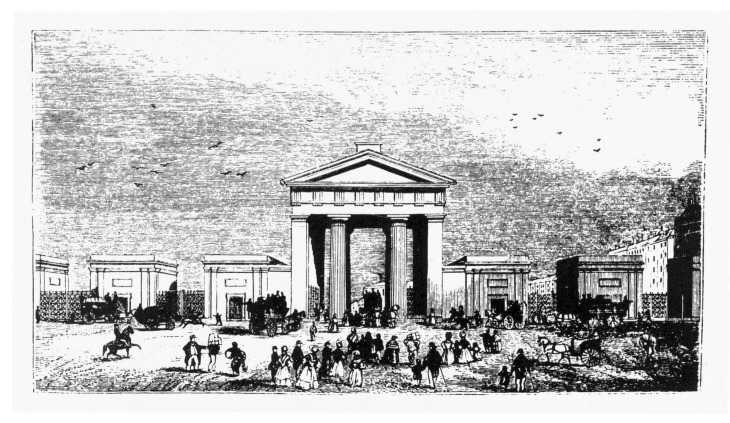

The buildings

'The grand facade, at Euston Grove, constitutes the London Terminus of this great national work; its centre consists of a stupendous Grecian Doric portico, perhaps the largest in the world, which faces an opening on the north side of Euston Square, and may be viewed from the City Road, from whence it has somewhat the appearance of the entrance gates to a Grecian city or temple.'

Osborne's *London and Birmingham Railway Guide*, 1841.

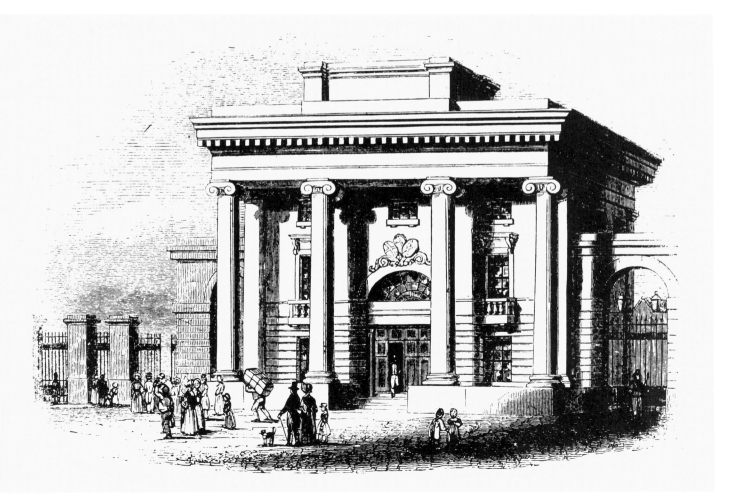

Viaducts around London

LEFT
Wharncliffe viaduct near Hanwell, Great Western Railway. The caption observed: 'The view from the top of the viaduct is extensive and beautiful; and from this spot a bird's-eye view may be obtained of Hanwell Lunatic Asylum'.
Actual size, 1839.

CENTRE LEFT
Hackney station and viaduct, North London Railway, with a watercress plantation in the foreground.
Actual size, 1851.

BELOW
North London Railway viaduct over the Great Northern Railway north of King's Cross with an early signalbox lower left.
Actual size, 1851.

RIGHT
London and Greenwich Railway viaduct near Bermondsey New Church.
Actual size, 1835.

BELOW RIGHT
The same viaduct in the distance in this view of the London and Croydon Railway near New Cross with trains, apparently, working in the wrong direction.
Actual size, c.1840.

All cuttings from unidentified sources

Before and after.

ABOVE
Thomas Bouch's Tay Bridge before the most tragic of all railway disasters. (see p.187)
Colour plate presented with *The Engineer.*
270 x 906mm, 1873.

RIGHT
William Arrol's new Tay Bridge; North British Railway.
Illustrated London News, 314 x 231mm, 1887.

LEFT
King's Cross police station in the process of demolition to make way for the new station.
105 x 143mm, 1850.

BELOW
Cubitt's terminus for the Great Northern Railway at King's Cross.
Illustrated London News, 145 x 235mm, 1852.

1. From the south east.
2. Inside the bridge.
3. From East Tayport.
4. From the north end.
5. Floating out the last span.
6. From the south west.
7. View through the piers.

SOUTH DURHAM AND LANCASHIRE UNION RAILWAY.

SPECIFICATION

RELATIVE TO THE ERECTION OF RAILWAY STATIONS.

ONE STOREY.

BRICKLAYER'S AND MASON'S WORK.

EXCAVATIONS.

Tracts for Foundations to be dug out to the various depths shown by the Plans, or to such further depth as may be necessary for securing a proper and solid foundation for the superstructure; and all the surplus earth or rubbish arising from the excavations, or otherwise, to be laid out as directed, either around the building or at a distance not exceeding 60 yards.

DRAINS.

The drains to be formed of 6 inch glazed earthenware pipes, well puddled with clay and neatly jointed in cement, having a declivity of 1 in 20. Water Closet Drains to have a declivity of 2 inches to the 10 feet.

CESSPOOLS.

The Cesspool for receiving the soil from the Drains to be 6 feet long, 4 feet 6 inches wide, and the bottom to be 4 feet below the level of drains; the sides and ends to be built with coursed rubble 14 inches thick, well puddled with clay on the outside of walls, and to be neatly jointed and pointed; and the bottom to be laid with self-faced flagstones jointed in Portland cement, with arrow-tongue and exit drain; the top to be laid with 5 inch rough flagstones closely jointed and pointed, and to have a rebated man-hole 2 feet square furnished with a malleable iron ring for access when required.

FOUNDATIONS.

The Foundations of 14 inch walls, together with those of Waiting Room, to be in two courses of stones averaging 6 feet superficial, and 6 inches thick and must form a scarcement of 6 inches on either side; those of 9 inches and 6 inches ditto to be constructed as shown by the sections, either of good rubble work or bricks, but in either case if with stone foundations, stones 6 inches thick and projecting 6 inches on either side of wall, and in every case to be neatly jointed and bedded in lime. A course of slates the breadth of the walls to be laid on the joint of the base course to prevent the rising of damp, and to be well bedded in cement on the upper and under surfaces. Each cast iron pillar to be set on two courses of stones 6 inches thick, the lower course 2 feet square. The upper ditto 14 inches square.

DOOR STEPS.

The steps to doors to be each in one stone and without nosings.

TOOLED WORK.

The base course round building; the jambs and heads of doors; the Sills, Jambs, Mullions, and Lintels of windows; the quoins, and the whole of the oriel window (which must be of parpind ashlar); together with panels over windows, chimney copes, and all other copes of walls; together with Weatherings and every other portion of masonry, as indicated by the yellow tint on the Plans, to be of polished stone work jointed so as to suit the brick courses. The panel over door to receive a date in projecting figures.

PAVEMENT.

The floor of urinal, platform, &c., where indicated by the blue tint, to be laid with tooled flagstones 2 inches thick, and in stones averaging 3' 6" × 2' 6" inches, neatly jointed and laid upon a bed of dry materials, such as lime scrap, dry stone shivers, &c., hard beat down and spread with a layer of pan ashes.

DWARF WALLS.

Courses of stones or bricks to be laid for supporting the joists (in the centre of each apartment).

FIRE-PLACES.

The fire-places in every situation to have cleansed flagstone hearths and back hearths. The Kitchen fire-place to have cleansed stone jambs 10 inches broad and 5 inches thick, with mantel and shelf 1½ inches thick and 10 inches broad, let well into the brickwork.

FLUES.

All flues must be carefully pargetted smooth throughout with a mixture of cow-dung and mortar. The fire-places in every apartment to have cleansed stone jambs, afterwards to receive wood finishings.

QUALITY OF STONE.

The stones for the building to be from some quarry approved of by the Company's Engineer, and to be all of the best quality, and of fair and uniform colour, and laid on their flat or natural beds. The chimney jambs and hearths to be of the best quality of freestone; and the pavement to be from a flag quarry approved by the Engineer, and of the best quality.

BRICKS.

The bricks to be red and must be of the best quality, hard burnt, and laid Flemish bond. The facing bricks to be very carefully selected, and must in every case be of uniform colour, otherwise they will be thrown out. All voids to have safety arches, and all external walls, with the exception of the back elevations of Platform, Waiting-room, Coal Cellar, and House Water Closet, to have joints neatly ruled in with fine white lime, after the walls are carried up to their proper heights, and care must be taken in every instance to keep the parpinds. The chimney heads to have a quarter-round moulding on the angles of gauged brick work, which must be very carefully and neatly executed, and no four courses must exceed 11 inches in the height. The walls in every situation to be beam filled and carefully pointed up below the sarking.

BRICKWORK OF COVERED PLATFORM.

The inside Brickwork of Covered Platform to be neatly ruled in on the joints with fine white lime. The back of Platform, Coal Cellar, and House Water Closet walls to be neatly drawn in mortar.

URINAL.

The urinal to be provided with a neat galvanized cast iron gutter to carry away the water, with perforated opening leading to the drain, and to have two divisions of slate or pavement rounded on the edge, to be 6 feet high and 2 feet deep.

KITCHEN AND SCULLERY SKIRTING.

The Kitchen and Scullery Skirting to be of Roman cement 6 inches high.

CONDITIONS.

The Contractor for the brick and mason work must furnish all and every necessary, whether in carriage, plant, scaffolding, materials,

LEFT

Sadly, Thomas Bouch will only be remembered for the Tay Bridge. This earlier simple specification did not make headlines. Folder, 377 x 235mm, c.1858.

ABOVE

Battle Station, South Eastern Railway. *Illustrated London News,* 90 x 230mm, 1852.

RIGHT

Blackwall terminus, London and Blackwall Railway. *Penny Magazine,* actual size, 1840.

BELOW

The 'Grand Central Railway Station' Birmingham, London and North Western Railway. The whole of the left wing was the Queen's Hotel. *Illustrated London News,* 136 x 226mm, 1854.

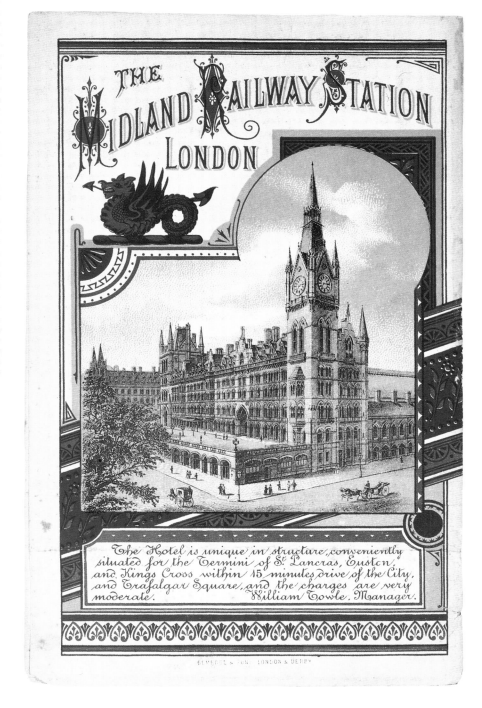

THE MIDLAND GRAND HOTEL,

TELEGRAPHIC ADDRESS—
"MIDOTEL, LONDON."

TELEPHONE, No. 7,502.

LONDON, N.W.

BREAKFAST.	PLAIN, with Swiss Honey, &c.	1/6
	With two Eggs	2/-
	„ Fish (except Soles and Salmon), Cold Meat, Chop, Ham and Eggs, &c.	2/6
	„ Soie or Salmon, Chicken and Tongue, two Chops, Kidney and Bacon, &c.	3/-
	„ Special Dishes, as per daily Bill of Fare	—
	Table d'hôte, 8.45 to 9.15 a.m.	3/-
LUNCHEON.	Soups, 1/- Cold Meat, with Bread and Butter ...	2/6
	Sandwich, 6d. Hot Joint, with plain Vegetables Cheese, Salad, &c., up to 3.30 p.m. ...	2/6
	Plate Hot Meat and Potatoes	2/-
DINNER.	THE MIDLAND TABLE D'HÔTE in the Coffee Room at 6.0 and 7.30 p.m. (except on Saturdays and Sundays, on which days it is served at 6.30 p.m. only), consisting of Soup, Fish, Relevés, Entrées, Roast, Entremets, Ices and Dessert, served at separate tables if desired	5/-
	(Open to Visitors not staying in the Hotel).	
	Dinners à la carte or at fixed prices from... ...	3/-
	Home Dinner, 6.30 to 8 p.m.	3/6
TEA	Charges similar as for Breakfasts.	
APARTMENTS.	BED ROOMS, for one person, from 3/6, and for two persons from 5/-, inclusive of ATTENDANCE AND GAS. SITTING ROOMS, with Bed and Dressing Rooms, at very moderate charges, according to position.	
PUBLIC ROOMS.	THE GRAND COFFEE ROOM is on the ground floor. The DRAWING, MUSIC and READING ROOMS are on the first floor; there are Billiard and Smoking Rooms on the ground and first floors. A special Coffee Room for Ladies and Families is opened on the first floor during the London Season. Hair Dressing Saloon for Ladies and Gentlemen on the ground floor. Electric Light.	
WEDDING BREAKFASTS AND PRIVATE DINNERS.	There are splendid SUITES OF APARTMENTS, and DINING ROOM suitable for Wedding Parties, and for public and private Dinners.	
CUISINE.	The arrangements combine the artistic refinements of the French Cuisine with the homely comforts of the best English Hotels.	
BATHS.	Sponge or Hip Bath, 6d.; in Bath Room, 1/6.	

LEFT
Rugby road bridge, *London and Birmingham Railway Guide,* 73 x 110mm, 1841.

CENTRE LEFT
Bookmark, actual size, c.1900.
Courtesy Amoret Tanner.

BELOW LEFT
Bridge at Tilt, Inverness and Perth Railway.
Actual size, 1863.

ABOVE AND RIGHT
Publicity folder for the U.S.A.
Cover actual size, 1886.
Courtesy Michael Brooks.

BELOW
Artist's impression of Manchester Piccadilly
Station before opening. Publicity booklet,
90 x 208mm, 1966.

The Chairman and Directors of The Great Northern Railway Company

in Account with

John Shaftoe & Thomas Barry
Contractors
York

New Hotel Leeds

1866
to
1869

To amount of Contract for the erection of New Hotel Wellington Street Leeds

£ s d

31,450 0 0

Board, 26 June 1866.

Additional Works

Alteration of Clerks Office Coffee Room Floor, Formation of additional Water closets Lavatories Urinals and Works consequent thereon

103 11 10

Formation of additional Rooms over Tea and Serving Room with Staircases to same as a Mezzanine Floor

70 11 10

Continued £ 31,624 3 8

Page _____ Certificate No. **20** Corn Exchange, Sheffield, *June 2? 1869*

I hereby certify that the Sum of **Three Thousand**
three hundred and forty one pounds two
shillings and ten pence is due 6 Messrs
of Shaftoe & Barry on account of for the balance (less
retention of 5 per cent) on their Contract
for the Hotel at Leeds for the Great Northern
Railway Company
£ 3341. 2 . 10 *M.H Hadfield* Architect.

The final chapter of the construction of the Great Northern
Railway Hotel at Wellington Street, Leeds.

Left, page 1 of the 4pp account. Additional costs raised this
figure to £32,406.12.10. A balance of £3,341.2.10. was due on
? March 1869 but the architect's certificate (above) was not
obtained until 23 June. This should have been the end but
further extras and arguments about the sum to be deducted
under a penalty clause for late completion dragged on until the
end of the year. Finally (right) the new general manager,
Henry Oakley, authorised payment on Christmas Eve. Action
was so immediate that (below) contractors Shaftoe and Barry
were able to send their final settlement receipt three days later.

Left 312 x 198mm; above 95 x 223mm; right (detail)
155 x 202mm; below 127 x 204mm. All 1869.

Deduct also amount
agreed upon as Penalties
for non completion of
Building to date 125-0-0 523-10-0
Total balance due to Shaftoe & Co £ 4,389 - 14 - 10

Certified & to be paid as
authorised by Hotel Comm &
by Board
 H Oakley
 24/12/69
MH— Dec 24/69

RECEIPT FORM to be detached, filled up, signed, and sent to THE ACCOUNTANT
addressed as at back.

Received this *27th* day of *December*
18**69** from the GREAT NORTHERN RAILWAY COMPANY, an Order on the UNION
BANK OF LONDON, for the sum of *Four Thousand Three Hundred*
and Eighty Nine Pounds *Fourteen* Shillings
Ten Pence, for *full settlement*
on a/c for Leeds Hotel

 31 DEC. 1869
 EXECUTIVE ACCOUNTS COMMITTEE
Signature, *Shaftoe / Barry*

£4389 : 14 : 10

BELOW
Eight of a set of postcards showing all the stations of the
Central London Railway. 83 x 138mm, c.1910.
Courtesy Amoret Tanner

FACING PAGE LEFT
Cornhill Magazine, 105 x 95mm, both 1861.

FACING PAGE RIGHT
Midland Railway booklet for the American market.
Cover, 202 x 138mm, c.1905.
Courtesy Michael Brooks.

Taking the train

*"It is good to travel', is a sentiment worthy of the most celebrated oracle in the world. Is it not so, ye commercial gentlemen, who, as 'principles and representatives', scour the country, and tarry awhile where business can be done? You will doubtless say, emphatically, with old **Du Bartass**.*

> *O thrice, thrice happy he, who shuns the cares*
> *Of city troubles.*

And you are right.'
Introduction, *The Illustrated Guide to the London and Dover Railway,* 1844.

A Mile an Hour

A Mile a Minute

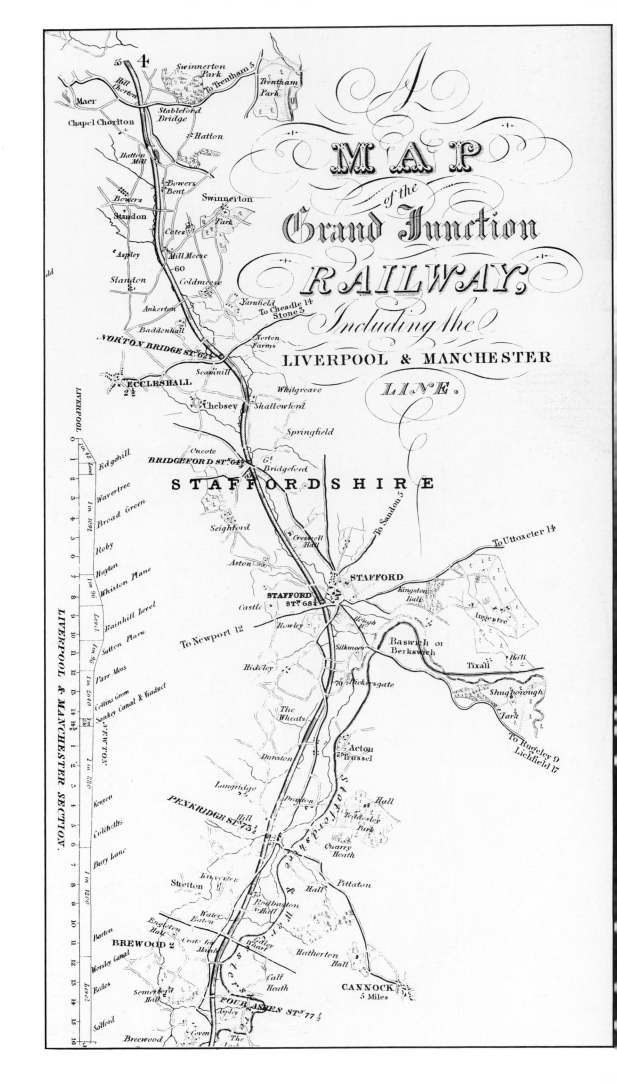

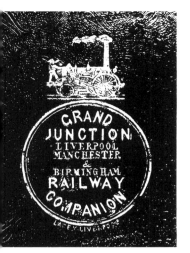

FACING PAGE and LEFT

Arthur Freeling's *Grand Junction Railway Companion* contained:
'An account of everything worthy of the attention of the traveller upon the line; including a complete description of every part of the railroad; of the noblemen or gentlemen's seats which may be seen from it, and of the towns and villages of importance in its neighbourhood.'
The gold blocked cover (left) offers yet another version of the *Rocket* (see p.51).
Both actual size, 1837.

BELOW

Many early railway maps were undated. At first glance the reference to excursions to the Crystal Palace might suggest a period soon after the Great Exhibition of 1851. However, the Metropolitan Railway (1863) and the District Railway (1868) are clearly shown. Then again, it was not unknown for railways under construction or proposed to be included as a *fait accompli* . . .
590 x 562mm.

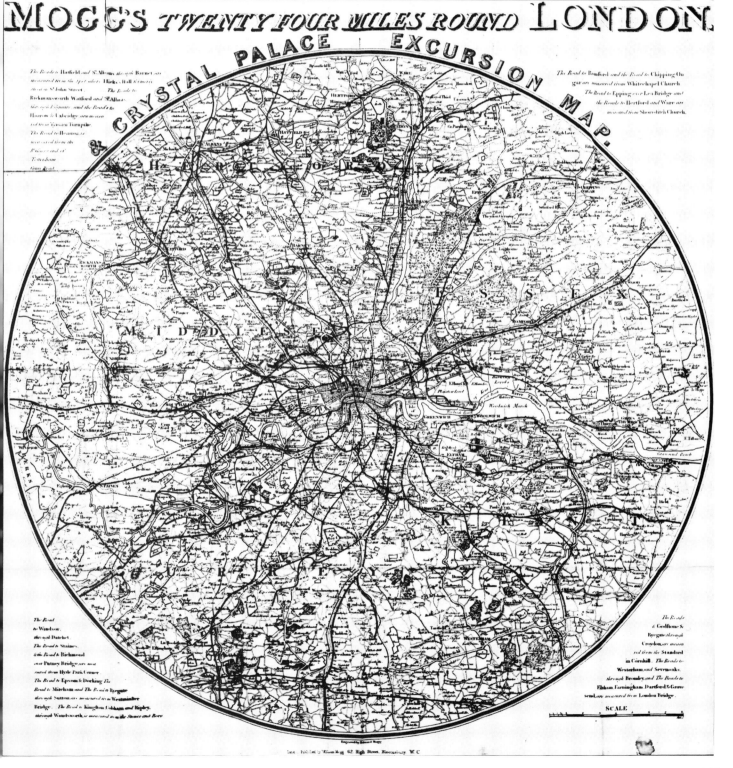

ABOVE
Folding map, cover, actual size, 1838.

BELOW
An appropriate accessory.
Pattern for a travelling bag issued free with
Beeton's Young Englishwoman, actual size, 1871.
Courtesy Amoret Tanner

FACING PAGE TOP LEFT and BELOW
Combined map and commentary on the London and North
Eastern Railway's east coast route to Scotland.
Folding booklet, 226 x 192mm (open), 1939.

FACING PAGE TOP RIGHT
The named trains on this route provided proud embellishment for
the passenger's luggage.
Luggage label, 115mm diameter, 1939.

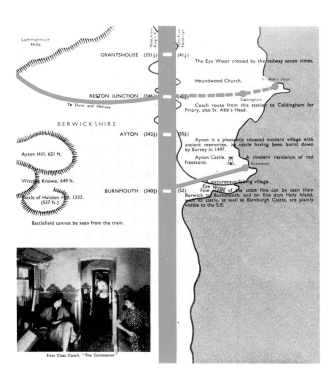

GRANTSHOUSE (351¾) (41¼) The Eye Water crossed by the railway seven times.

Houndwood Church.

RESTON JUNCTION (346¼) (46¼) Coach route from this station to Coldingham for Priory, also St. Abb's Head.

BERWICKSHIRE

AYTON (342½) (50½) Ayton is a pleasantly situated modern village with ancient memories, its castle having been burnt down by Surrey in 1497.

Ayton Castle. A modern residence of red freestone.

A picturesque fishing village.

Eye Water.

BURNMOUTH (340½) (52) Fine views of the coast line can be seen from Berwick to Burnmouth, and on fine days Holy Island, with its castle, as well as Bamburgh Castle, are plainly visible to the S.E.

Battlefield cannot be seen from the train.

First Class Coach, "The Coronation"

LONDON & NORTH EASTERN RAILWAY

ABERDEEN

THE FLYING SCOTSMAN

ON EITHER SIDE

ON EITHER SIDE

FEATURES OF INTEREST TO BE SEEN FROM THE TRAIN

FEATURES OF INTEREST TO BE SEEN FROM THE TRAIN

No. II

KING'S CROSS TO SCOTLAND

SCOTLAND TO KING'S CROSS

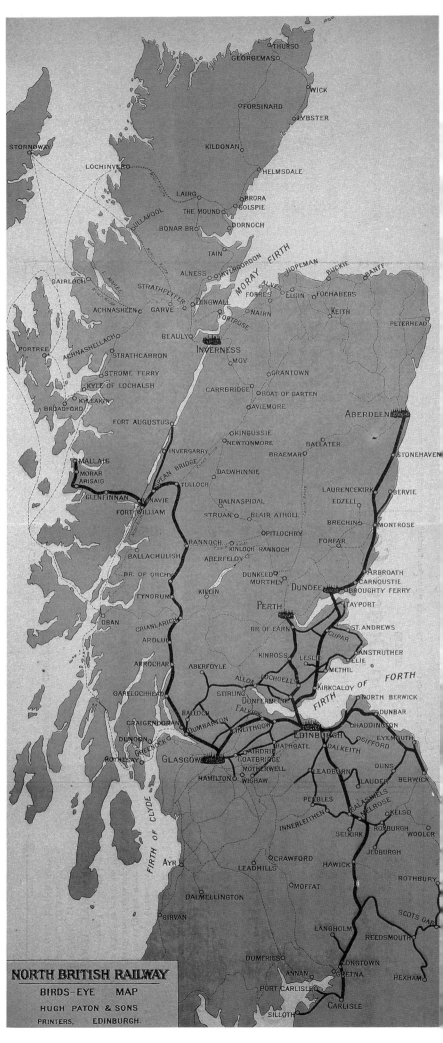

ABOVE and RIGHT
A so-called 'bird's-eye view' map suggesting a
bird with defective vision. The condensed
width meant unnecessary triple folding for
inclusion in the guide.
Page size 175 x 122mm, map 400 x 175mm.
1912.

BELOW
North Eastern Railway area guide.
Booklet folder, 175 x 102mm, c.1907.

ABOVE LEFT

Part of a simplified British Rail map showing the same area as the Highland Guide opposite.
Folding map, 220 x 195mm, 1966.

ABOVE

The cartouche was often better than the map.
Folding map, 170 x 106mm, 1855.

BELOW LEFT

The journey and the end.
Folding map, 175 x 115mm, c.1862.

BELOW

Hopefully, not all passengers booked one way.
Advertisement, actual size, 1838.

DUDDESTON HALL
LUNATIC ASYLUM,

NEAR BIRMINGHAM;

MR. LEWIS

Respectfully informs the Public that he receives Patients, of either sex, labouring under mental or nervous diseases, into his Establishment, on terms which cannot fail to meet the approbation of persons desirous of placing their friends, who may be so circumstanced, in so comfortable and pleasing a retreat.

The well-known beauty and variety of the Gardens and Pleasure Grounds, and the entire adaptation of the House and Premises to the purposes of an Asylum, render an elaborate description unnecessary; suffice it to say, there is everything that can be desired of this nature.

The Proprietor resides in and conducts the Establishment with properly qualified Assistants: the Female department is under the superintendance of Mrs. and Miss LEWIS, who devote all their time to the health and comfort of the Patients, and whose qualifications in this respect are well known in Birmingham and its neighbourhood.

Dr. EVANS is the consulting Physician. Mr. FREER and Mr. HEELEY, Surgeons, one of whom visits the Patients daily.

The situation is extremely desirable, the Vauxhall Station of the Grand Junction Railway being at the Lodge Gates, and the Railway itself bounding the Premises.

ACING PAGE LEFT
Booklet targeted on American tourism.
20 x 212mm, c.1908.
Courtesy Michael Brooks.

BELOW
Clever stuff, as an introduction to *Places of
Pilgrimage,* aimed at the same market.
Booklet, page size 185 x 118mm, 1913.

ACING PAGE BELOW and LEFT
Morton produced penny guides to all the major
railways. All followed this flamboyant style

of cover and even carried it through from the
introductory page to the advertisement section.
Cover, 238 x 150mm.
Advertisement cartouche, actual size, 1883.

FOOT OF PAGE
One of many typical area guides produced by the
Great Western Railway in the inter-war years.
Booklet, 183 x 125mm, 1936.

BELOW
A timely reminder for the potential passenger
during a period when accidents were not
uncommon.
Leaflet, actual size, late 19th c.

BRITAIN'S
NATIONAL HOLIDAY LINE

THE LINE OF THE
AMERICAN PILGRIM

o o o

Glad is the welcome wherewith Britain hails,
Remembering hallowed bonds of Cousinship,
Each New-world Pilgrim as he lands in Wales,
And guides his footsteps through his touring trip,
Till, cloy'd with beauty, for his home he sails.

Warwickshire wooes him on our **Western Line,**
Erstwhile her Castles held the land in fee.
Stratford, with **Harvard,** and the Bard Divine
Their witching spell have cast across the sea,
Even as luring **Bath** and **Bristol** shine
Recalling Burke, Wolfe, Cabot's Odyssey;
No less than Frobisher's deeds of gallantry.

Rich is the Pilgrim's hoard of Dorset names:
At **Sherborne** Ralegh, and at **Portland** Penn,
(**I**nterred at **Chalfont,** which sweet Milton claims)
Linking John White and Endicott again,
Weymouth with **Dorchester** one's heart inflames.
At **Kingston Russell** ended Motley's life,
Yet **Whitchurch** treasures tales of Somers' strife.

THE
**COTSWOLD
COUNTRY**

£100 **MAY SECURE** FOR THEIR FAMILIES

IN CASE OF
DEATH BY RAILWAY ACCIDENT,
IN A TRIP OF ANY LENGTH,
With an allowance for themselves when hurt of £1 0s. 0d. per Week
for a period not exceeding Six Months,
BY TAKING

AN INSURANCE
TICKET, COSTING } **TWO PENCE.**

Premium to Insure £500 in a First Class Carriage of Excursion
Train, or £3 per Week for Injury—SIXPENCE.

**N.B.—For Insurance Tickets ask the Clerk to whom you
Pay your Railway Fare.**

64, CORNHILL. WM. J. VIAN, *Secretary.*

GRANT & Co., LONDON, MANCHESTER & PARIS. [TURN OVER.

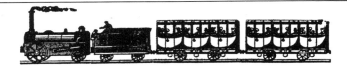

GARNKIRK AND GLASGOW RAILWAY.

WINTER HOURS,
From 12th OCTOBER to 5th APRIL.

THE PASSENGER TRAINS leave the DEPOT, TOWNHEAD, GLASGOW, and LEAEND DEPOT, AIRDRIE, as follows:—

FROM GLASGOW:	FROM AIRDRIE:
Quarter-past Seven, morn.	Half-past Eight, morning,
Quarter-past Ten, do.	Half-past Eleven, do.
Quarter-past One, aftern.	Half-past Two, afternoon,
Quarter-past Four, do.	Half-past Five, do.

INTERMEDIATE STATIONS.

COATBRIDGE to GLASGOW,	about	20 Minutes to 9, 12, 3, and 6 o'clock.
GARTSHERRIE to GLASGOW,	do.	10 Minutes to 9, 12, 3, and 6 o'clock.
GARTCOSH to GLASGOW,	do.	9, 12, 3, and 6 o'clock.
GARNKIRK WORKS to GLASGOW,	do.	5 Minutes past 9, 12, 3, and 6 o'clock.
STEPPS to GLASGOW,	do.	10 Minutes past 9, 12, 3, and 6 o'clock.

The WISHAW and COLTNESS RAILWAY COACH, from HOLYTOWN and NEWARTHILL, joins the morning Train from Gartsherrie to Glasgow, and returns with the last afternoon Train.

The SLAMANNAN RAILWAY COMPANY's TRAINS, for Passengers, from GLASGOW to SLAMANNAN, AVONBRIDGE, and CAUSEWAYEND, by Railway, and thence to EDINBURGH, by Canal, start from the Garnkirk and Glasgow Railway Company's Depôt, at a quarter-past 10, forenoon, and half-past 2, afternoon.

AN OMNIBUS FROM BRUNSWICK PLACE, TRONGATE.

☞ Passengers, whether by Omnibus or not, are requested to be at the Depôt in time to purchase Tickets and be seated in the Carriages, as the Trains will not wait beyond the specified hours of starting.

GLASGOW, 12th October, 1840.
Graham, Printer, 181, Trongate.

LEFT
Time bill, actual size, 1840.

BELOW
The same engine with a different train.
Press advertisement from the *Norfolk Chronicle.*
Actual size, 1846.

The printers' trains are by Stephenson Blake, 1839.

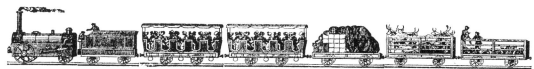

NORFOLK AND EASTERN COUNTIES RAILWAYS TIME TABLE.
Yarmouth, Norwich, Ely, Cambridge, and London.

*** Passengers are recommended to be at the Stations five minutes earlier than the time specified in the Table, which is the approximate time only.

AUGUST 15, 1846.

DOWN TRAINS, Sundays excepted. / SUNDAY TRAINS.

Miles	LONDON TO YARMOUTH	A.M.	A.M.	A.M.	P.M.	P.M.	MAIL P.M.	A.M.	A.M.	A.M.	P.M.	MAIL P.M.
0	LONDON	**7 15**	**11 30**	**2 0**	**6 0**	**8 40**	6 45	2 0	8 40
57¼	CAMBRIDGE	**6 50**	9 22	1 46	5 30	7 55	11 26	**7 0**	9 48	5 8	11 26
88	BRANDON	8 7	10 45	3 0	6 50	9 0	12 49	8 22	11 13	6 25	12 49
95¼	THETFORD	8 19	10 59	3 14	6 55	9 12	1 10	8 34	11 30	6 37	1 10
103¼	Harling Road	8 30	11 9	3 26	7 7	8 46	11 42	6 48
106¼	Eccles	8 39	7 15	8 54	11 50	6 56
110	ATTLEBOROUGH	8 52	11 29	3 44	7 27	9 39	1 43	9 7	12 6	7 11	1 43
113	Spooner Row	8 57	7 32	9 12	12 11	7 15
115½	WYMONDHAM	9 12	11 45	4 0	7 46	9 54	1 58	9 27	12 26	7 29	1 58
119½	Hethersett	9 18	7 54	9 33	12 32	7 34
125	Trowse	9 47	4 32	8 17	10 2	1 2	8 2
126	NORWICH { arrive	9 52	12 22	4 37	8 22	10 20	2 40	10 7	1 7	8 7	2 40
126	NORWICH { depart	10 0	12 30	4 45	8 30	10 30	2 48	**8 0**	10 15	1 15	8 15	2 48
132	Brundall	10 6	12 39	4 54	8 39	8 9	10 24	1 24	8 24
134	Buckenham	10 12	5 0	8 45	8 15	10 30	1 30	8 30
136	Cantley	10 18	8 51	8 21	10 36	1 36	8 36
138	Reedham	10 24	12 48	5 9	8 57	8 27	10 42	1 42	8 42
142	Berney Arms	10 36	9 7	8 37	8 57
146	YARMOUTH	**10 55**	**1 10**	**5 30**	**9 25**	**11 15**	**3 28**	8 55	**11 10**	**2 10**	**9 10**	**3 28**

UP TRAINS, Sundays excepted. / SUNDAY TRAINS.

Miles	YARMOUTH TO LONDON	A.M.	A.M.	A.M.	P.M.	P.M.	MAIL A.M.	A.M.	P.M.	P.M.	P.M.	MAIL P.M.
0	YARMOUTH	**5 0**	**10 15**	**3 0**	**7 0**	**9 43**	**8 0**	**1 30**	**6 0**	**8 30**	**9 43**
4	Berney Arms	10 22	7 6	8 6	8 36
8	Reedham	10 27	3 12	7 15	8 12	1 42	6 12	8 45
10	Cantley	10 35	7 22	8 19	1 49	6 19	8 52
12	Buckenham	10 38	3 23	7 28	8 25	1 55	6 25	8 58
14	Brundall	10 44	3 29	7 34	8 31	2 1	6 31	9 4
20	NORWICH { arrive	5 37	11 7	3 52	7 52	10 28	8 52	2 22	6 52	**9 25**	10 28
20	NORWICH { depart	5 45	**7 30**	11 15	4 0	8 0	10 38	9 0	2 30	7 0	10 38
21	Trowse	7 35	11 20	8 5	9 5	2 35	7 5
26½	Hethersett	7 42	8 12	9 12	2 42	7 12
30½	WYMONDHAM	6 3	7 57	11 38	4 19	8 24	10 54	9 28	2 58	7 28	10 54
33	Spooner Row	8 1	8 28	9 32	3 2	7 32
36	ATTLEBOROUGH	6 13	8 15	11 53	4 38	8 43	11 7	9 47	3 17	7 47	11 7
39¾	Eccles Road	8 20	4 43	8 48	9 52	3 22	7 52
42¾	Harling Road	8 28	12 3	4 52	8 58	10 0	3 30	8 0
50¾	THETFORD	6 45	8 51	12 24	5 16	9 24	11 40	10 25	3 55	8 25	11 40
58	BRANDON	7 5	9 15	12 45	5 40	**10 0**	12 6	10 50	4 20	8 50	12 6
88¾	CAMBRIDGE	8 17	10 41	2 1	6 57	1 34	5 49	10 12	1 34
146	LONDON	**10 15**	**1 5**	**4 0**	**9 55**	**4 26**	**9 15**	**4 26**

Third Class Passengers can Book by every Train between Yarmouth and Norwich, and by Trains leaving Norwich at 7 30 a.m. to London, at 4 and at 8 p.m. to Brandon. Also by the Train leaving London at 2 p.m., and from Brandon 8 7 and 10 45 a.m. to Norwich.

Children under three years of age are conveyed free, above three and under twelve years, half-price.

On Saturdays a Market Train will run from Yarmouth to Norwich at Twelve o'clock at Noon, and from Norwich to Cambridge at 6 30 p.m., calling at all Stations.

TIME TABLE,

CALCULATED UPON THE DIFFERENCE OF LONGITUDE BETWEEN
LONDON AND BIRMINGHAM, AND INTERMEDIATE STATIONS.

STATIONS.	Slower than Euston Station.		Faster than Birmingham Station.	
	min.	sec.	min.	sec.
CAMDEN STATION ..	0	..	7	..
HARROW	1	..	6	15
WATFORD	1	..	6	..
BOXMOOR	1	30	5	45
BERKHAMPSTEAD ..	1	45	5	15
TRING	2	..	5	.
LEIGHTON	2	15	5	.
WOLVERTON	3	..	4	15
ROADE	3	15	4	..
BLISWORTH	3	15	4	..
WEEDON	4	..	3	15
CRICK	4	..	3	..
RUGBY	4	45	2	30
BRANDON	5	15	2	..
COVENTRY	5	45	1	30
HAMPTON	6	30	1	..
BIRMINGHAM	7	15

N.B. The intermediate Station Clocks are regulated by the above
Table, and the Office Clocks in London and in Birmingham are set
three minutes later than the correct time.

ABOVE

Timetable, in the true sense of the word; from Osborne's
London and Birmingham Railway Guide.
Actual size, 1841.

BELOW

'Pop-up' pocket timetable for Great Central Railway local
services to South Harrow on the newly opened line avoiding
the Metropolitan Railway.
Actual size, 1907.
Courtesy Michael Brooks

ABOVE RIGHT

Timetable folder; actual size, 1884.

FACING PAGE

Timetable of the winter services of the company's first year of
operation from London.
Actual size, 1899.

OCTOBER 1ST 1899

AND UNTIL FURTHER NOTICE

FORWARD.

GREAT CENTRAL RAILWAY

AND OTHER RAILWAYS IN CONNECTION.

NEW & DIRECT ROUTE

LONDON (Marylebone),
AND
BRACKLEY, RUGBY, LUTTERWORTH, LEICESTER, LOUGHBORO', NOTTINGHAM, SHEFFIELD, WORKSOP, RETFORD, LINCOLN, GRIMSBY, CLEETHORPES, HULL, BARNSLEY, HUDDERSFIELD, DONCASTER, ROTHERHAM, WARRINGTON, LIVERPOOL, SOUTHPORT, CHESTER, MANCHESTER.

HENRY BLACKLOCK & CO. LTD., MANCHESTER.

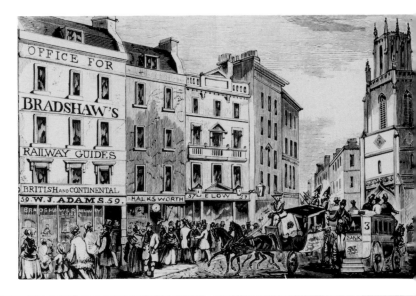

Sent by Post 1847
Nov. 8

Manchester, 27 Brown Street,
11th Mo. 2nd 1847.

To the Secretary of the Chester & Holyhead R'way

We purpose publishing a Railway Almanack, to contain a variety of useful information pertaining to Railways, &c. and shall feel obliged by your furnishing us with the Names and Addresses of the Principals connected with your Lines of Railway.

As the time of Publication is drawing near, we shall esteem it a favour if you will cause the annexed form to be filled up and returned to us by an early post.

We remain,

Yours respectfully,

Bradshaw & Blacklock.

Bradshaw & Blacklock, Lithog.

BRADSHAW'S

Railway Companion,

CONTAINING

THE TIMES OF DEPARTURE

FARES, &c.

OF THE RAILWAYS IN GREAT BRITAIN AND IRELAND,

AND ALSO

Hackney Coach Fares,

FROM THE PRINCIPAL RAILWAY STATIONS

ILLUSTRATED WITH

MAPS OF THE COUNTRY THROUGH WHICH THE

RAILWAYS PASS,

AND PLANS OF

LONDON, BIRMINGHAM, BRISTOL.

LIVERPOOL, AND MANCHESTER.

PRICE ONE SHILLING

SECOND EDITION.

LONDON:

PUBLISHED AT BRADSHAW'S RAILWAY INFORMATION
OFFICE, 59, FLEET-STREET, W. J. ADAMS, AGENT;
AND SOLD BY ALL BOOKSELLERS & RAILWAY COMPANIES

8th Mo. (August) 1st, 1845.

THE FIRST "BRADSHAW."

A Reminiscence of Whitsun Holidays in Ancient Egypt. From an Old-Time Table feature

ACING PAGE TOP LEFT

eorge Bradshaw, 1800-1853, the name
hat became synonymous with timetables.
ailway News, actual size, 1914.

ACING PAGE TOP RIGHT

he London office in Fleet Street.
ngraving, 89 x 130mm, c.1849.
ourtesy Birmingham City Library

EFT

ithographed letter to the Chester and
olyhead Railway suggesting difficulties
getting co-operation from individual
ailway companies. As a member of the
ociety of Friends, Bradshaw favoured
th Mo. rather than using the names of
agan deities; a practice he carried
rough to his timetables.
55 x 202mm, 1847.
ourtesy Birmingham City Library

BOVE LEFT

itle page of *Bradshaw's Railway
ompanion.* Actual size, 1845.

BOVE RIGHT

any passengers considered Bradshaw's
metables to be totally incomprehensible.
unch effectively makes the point.
5 x 155mm, 1900.

IGHT

espite 5pt. type, footnotes left, right and
elow, vertical column inserts, 1,138pp,
nd weighing 1½ lbs, this monumental
onthly publication remained popular to
e end.
ypical page, actual size, 1935.

Carlisle and Glasgow.] **734** **[Main**

LONDON, CARLISLE, DUMFRIES, MAUCHLINE, KILMARNOCK, and GLASGOW.

(Timetable too detailed to transcribe fully.)

BRISTOL AND BIRMINGHAM RAILWAY.

[19] From_____ to _____

Carriage

Paid on...........

Total.........

No charge is made for Porterage : and any Servant of the Company taking more than is stated on this Ticket, will be dismissed. *Notice.*—The Company are not responsible for any Parcel above the value of £10, unless *declared as such at the time of booking*, and entered and paid for accordingly.

46/772 CALEDONIAN RAILWAY.

BALLOCH

Via STIRLING,

FROM

(23)

PERTH.

London and South Western Ry.

787 B

FROM WATERLOO TO

WROXALL

Via PORTSMOUTH.

NORTH EASTERN RAILWAY.

From_____ YARM

BLACKPOOL,

L. & Y., via NORMANTON.

(341.)

Cheshire Lines Committee.

Manchester

(Central)

(324) M.R.

Great Missenden

TO

Swiss Cottage

L. & S. W. R Y Co

O

St MALO.

6/46 SOUTHERN RAILWAY. Stock 34 BB 5/83

T. C. F.

L. & Y. R.

Rainford Jn.

TO

Pimbo Lane

Midland Railway

Holbeach

GUISBRO'

L. & N. W. RY.
Old Colwyn

Dover Harbour

B & E R

Yatton to
Glastnbry

G. E. R.

Dunham

96 **S.D.R.**

Passenger Luggage.

Lidford to
Ivybridge

Passengers' personal luggage was normally carried free. Most companies limited this to about 150lbs. first class or 100lbs. third class. Labels in a wide variety of shape, size and typeface came in quantity rather than quality. Some early types were totally basic, e.g. Guisbro' (Stockton and Darlington Railway) or Dover Harbour (South Eastern Railway). Simple initials could be misleading. C.R. (Cornwall Railway) might have been any one of a dozen titles.

C. K.

St. Germans to
GRAMPOND.
ROAD.

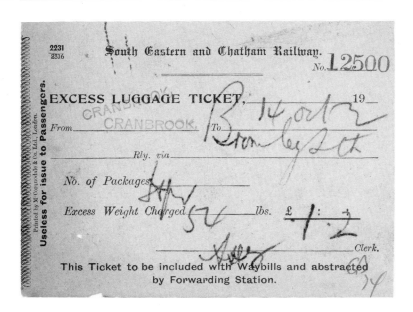

TO BE DELIVERED TO

HIS GRACE
The Duke of WELLINGTON'S
SERVANT,
At Paddington Station.

WILLIAM CARTER & Co.,
Stationers & Printers,
16, South Audley Street, Grosvenor Square, W.

2231
2316

South Eastern and Chatham Railway.

No. 12500

EXCESS LUGGAGE TICKET, 19—

From CRANBROOK, To _____

Rly. via _____

No. of Packages _____

Excess Weight Charged _____ lbs. £ _____

Clerk.

This Ticket to be included with Waybills and abstracted
by Forwarding Station.

Printed by M·Corquodale & Co. Ltd., London.
Useless for issue to Passengers.

North Eastern Railway.

No. 31

CARTED LUGGAGE.

From HARTLEPOOL

To _____ Station.

The North Eastern Railway Company hereby give notice that when
luggage is booked to be deposited in a cloakroom it will be subject to the
conditions in operation in such cloakroom.

(This portion to be given to the Passenger.)

TOP OF PAGE
Personal luggage label, actual size, c.1850.

CENTRE LEFT, 95 x 124mm, 1912.

BELOW LEFT, 107 x 125mm, c.1912.

ABOVE, Actual size, c.1900.

BELOW, 65 x 118mm, 1937.

RIGHT, Poster, 450 x 285mm, 1874.

(Under 3785.)

GREAT CENTRAL RAILWAY.

Passengers' Luggage
in Advance
TO
MENAI BRIDGE,
Via LIVERPOOL (Cen.) AND STEAMER.

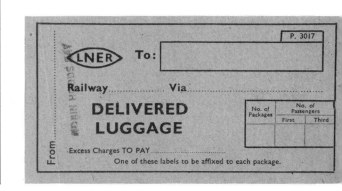

P. 3017

LNER To:

Railway _____ Via _____

DELIVERED
LUGGAGE

From _____

No. of Packages	No. of Passengers	
	First	Third

Excess Charges TO PAY _____

One of these labels to be affixed to each package.

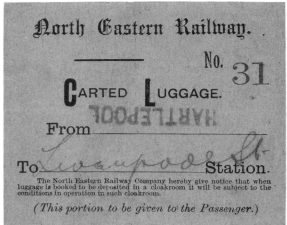

130

 London Brighton and South Coast Railway.

TABLE OF FARES

FOR

OUTSIDE PORTERS

IN ATTENDANCE AT

London Bridge Terminus.

A Letter or Parcel not exceeding 14 lbs., any distance not more than ¼ of a mile . . . **3d.**

And for every additional ¼ of a mile . . . **1d.**

A Parcel or Parcels exceeding 14 lbs. and not exceeding 56 lbs., any distance not more than ¼ of a mile **4d.**

And for every additional ¼ of a mile . . . **2d.**

A Parcel or Parcels exceeding 56 lbs. and not exceeding 112 lbs., any distance not more than ¼ mile **6d.**

And for every additional ¼ of a mile . . . **3d.**

Any load on a barrow, exceeding 112 lbs., not more than a ¼ of a mile **8d.**

And for every additional ¼ of a mile . . . **4d.**

And when detained more than ¼ hour at loading or unloading, for every additional ¼ hour **3d.**

One half more to be charged after 8 o'clock in the Winter Season and after 10 o'clock in the Summer.

(*By Order*) J. P. KNIGHT, General Manager.

LONDON BRIDGE TERMINUS, *May*, 1874.

 LETTS, SON & CO. LIMITED, LONDON.

YORK, NEWCASTLE, AND BERWICK RAILWAY.

CHEAP TRAIN
TO
LONDON
ON
Monday, Aug. 30,
RETURNING THE FOLLOWING MONDAY.

On the above-named Day a TRAIN, consisting of First, Second, and Third Class Carriages, will leave the GATESHEAD STATION at 6 A.M. stopping at BROCKLEY WHINS for SUNDERLAND and SHIELDS, BELMONT for DURHAM, DARLINGTON, DALTON for RICHMOND, NORTHALLERTON, THIRSK, and PILLMOOR for BOROUGHBRIDGE, and will arrive in LONDON about Half-past Eight in the Evening.

The RETURN TRAIN will leave LONDON at 6·30 P.M. on the 6th of SEPTEMBER, and will arrive in NEWCASTLE about Eight o'Clock the following Morning.

Passengers from SUNDERLAND and SHIELDS will proceed to BROCKLEY WHINS by the 5·30 A.M.; Trains in Connexion will also leave DURHAM at 6·30, RICHMOND at 7·45, and BOROUGHBRIDGE at 8·45 A.M.

FARES THERE & BACK.

FIRST CLASS.	SECOND CLASS.	THIRD CLASS.
£2. 15s.	£2.	£1. 5s.

Tickets may be had on and after August 23rd, and early Application for them after that Date is requested.

BY ORDER,

JAMES ALLPORT,
MANAGER.

Newcastle-upon-Tyne, August 16th, 1847.

GREAT WESTERN RAILWAY.
CHEAP TRIP TO CARDIFF.

On SATURDAY, JULY 8th,

A

CHEAP EXCURSION TRAIN

WILL LEAVE

	A.M.		A.M.
Cheltenham - at	7 45	Newnham - - - at	8 25
Gloucester - - ,,	8 5	Lydney - - - - ,,	8 45
		Chepstow - - - ,,	9 5

FOR

CHEPSTOW
AND
CARDIFF

FARES FOR THE DOUBLE JOURNEY.—THIRD CLASS.

To CHEPSTOW.	To CARDIFF.			
From CHELTENHAM and GLOUCESTER.	From CHELTENHAM and GLOUCESTER.	From NEWNHAM.	From LYDNEY.	From CHEPSTOW.
s. d.	s. d.	s. d.	s. d.	s. d.
2 6	**4 0**	**3 0**	**2 6**	**2 0**

First Class Tickets will be issued at Double above Fares.

The Return Train will leave Cardiff at 8.0 and Chepstow at 9.0 p.m. the same day.
Children under Twelve years of age, Half-price.

PADDINGTON, *June*, 1882. J. GRIERSON, *General Manager.*

(H 84.) Waterlow & Sons Limited. Printers. London Wall. London.

o
PLEASE RETAIN THIS BILL FOR REFERENCE L244/R

This announcement cancels Handbill L441/R

HALF-DAY EXCURSION TICKETS
TO

LEICESTER

SATURDAYS

5th July, 1952 and until further notice

FROM	DEPARTURE TIMES	RETURN FARE THIRD CLASS
		s. d.
	p.m.	
MELTON MOWBRAY (North) ..	1 55	2 0
GREAT DALBY	2 2	2 0
JOHN O' GAUNT	2 8	1 9
LOWERSBY	2 13	1 6
INGARSBY	2 19	1 0
THURNBY & SCRAPTOFT ..	2 25	8
HUMBERSTONE	2 30	3
LEICESTER (Belgrave Rd.) arr	p.m. 2 35	

RETURN ARRANGEMENTS

Passengers return same day from LEICESTER (Belgrave Rd.) at 6.10 p.m.

CHILDREN under three years of age, free ; three years and under fourteen, half-fares.

CONDITIONS OF ISSUE

Day, Half-day and Evening tickets are issued subject to the conditions applicable to tickets of these descriptions as shown in the Bye-Laws and Regulations, General Notices, Regulations and Conditions exhibited at Stations, or where not so exhibited, copies can be obtained free of charge at the Station booking office.
For LUGGAGE ALLOWANCES also see these Regulations and Conditions.

TICKETS CAN BE OBTAINED IN ADVANCE AT STATIONS AND AGENCIES

Further information will be supplied on application to Stations, Agencies or to Mr. H. TANDY, District Commercial Superintendent, Leicester. Tel. 5542, Extn. 34.

June 1952
BR 35000 BRITISH RAILWAYS (PX2/Halfex/Reg.)

Lees, Northampton

pecial Offers.

EFT
oster, 435 x 270mm, 1847.

BOVE RIGHT
Handbill, 226 x 143mm, 1882.

BOVE
Handbill, 322 x 165mm, 1914.

IGHT
Handbill, 248 x 156mm, 1952.

Stockton and Darlington Railway.

COUNTY VOLUNTEER
REVIEW
AT YORK,
On FRIDAY, Sep. 28, 1860,

An EXCURSION TRAIN will leave the following Stations as under for

YORK,

VIZ:

Fare there and back in Covered Carriages.

GUISBRO	-	-	at 6·15	
REDCAR	-	:	" 6·25	3s. 6d.
MIDDLESBRO'	-		" 6·45	

Volunteers in Uniform will be charged 2s. 6d. each.
The Return Train will leave York at 6·30p.m.
NO HALF FARES OR LUGGAGE ALLOWED.

Darlington, September 21st, 1860.

DARLINGTON: PRINTED AT THE OFFICE OF RAPP & DRESSER, 41, HIGH ROW.

Special offers for special occasions

ABOVE
Poster, 412 x 322mm, 1860.

FACING PAGE TOP LEFT
Handbill, 187 x 118mm, 1880.

FACING PAGE TOP RIGHT
Poster, 380 x 248mm, 1884.

FACING PAGE BELOW LEFT
Handbill, 252 x 157mm, 1913.

FACING PAGE BELOW RIGHT
Handbill, 220 x 144mm, 1916.

LONDON, CHATHAM & DOVER RAILWAY.

Cheap Excursion to Crystal Palace & London.

GREAT CRICKET MATCH

AT THE

CRYSTAL PALACE

AUSTRALIANS v. PLAYERS.

MONDAY, SEPTEMBER 27th, 1880.

A CHEAP EXCURSION TRAIN
WILL LEAVE

		FARES THERE & BACK:—	
		To LONDON. THIRD CLASS.	To PENGE (including admission to the Crystal Palace). THIRD CLASS.
Dover Harbour at 9. 0 a.m.			
Dover Priory „ 9. 2 „			
Shepherd's Well „ 9.16 „			
Bekesbourne „ 9.31 „			
Canterbury „ 9.38 „	5/0	5/0	
Ramsgate „ 8.55 „			
Broadstairs „ 9. 0 „			
Margate „ 9. 7 „			
Birchington-on-Sea „ 9.17 „			
Herne Bay „ 9.34 „			
Whitstable „ 9.43 „	4/6	4/6	
Selling „ 9.53 „			
Faversham „ 10. 0 „	4/0	4/6	
Teynham „ 10.14 „	3/6	4/0	

Arriving at PENGE (within Five Minutes' Walk of the Garden Entrance to the CRYSTAL PALACE) about 11.35 a.m., and VICTORIA STATION, LONDON, about 12.0 noon.
Returning the same day from VICTORIA STATION at 7.20 p.m., and PENGE at 7.40 p.m.

The Tickets are available to return on the day of issue only, and by the Train named.
No Luggage allowed. *Children under Twelve half-price.*
September 15th, 1880. (BY ORDER).

VICTORIA STATION is close to the Royal Aquarium at Westminster.

*** Trains every few minutes from Victoria (District Railway) to all parts of London.

S.E.D.—135.—80. Printed at the Company's Works, Victoria Station, Pimlico.

(L. 3)

Great Western Railway.

FLOWER SHOW

AT CARDIFF.

BLACK WATCH
AND
CYFARTHFA BANDS.

On WEDNESDAY, August 20th, 1884,

RETURN TICKETS

At a Single Fare and a Quarter, 1st, 2nd, and 3rd Class,
WILL BE ISSUED TO

CARDIFF

FROM THE UNDERMENTIONED STATIONS:—

STATIONS.	Leaving at	Times of Return Trains.
Chepstow - - -	12 16 p.m.	6 10 p.m.
Magor - - -	12 51	
Newport - - -	11 25 1 0 a.m.	4 0 or 7 30 p.m.
Pontypool Road -	11 17 a.m.	6 40
Pontnewydd - -	11 25	
Llantarnam - -	11 30	7 30
Caerleon - - -	11 40	
Bridgend - - -	11 10	6 5
Llantrissant - -	11 39	

Tickets not transferable, and are available only on the day of issue and by the Trains specified above.
No Luggage allowed. Children under 12 Years, Half-price.

PADDINGTON, *August*, 1884. J. GRIERSON, General Manager.

SOUTH WALES PRINTING WORKS, CARDIFF.

No. 473.

GREAT NORTHERN
AND
LANCASHIRE and YORKSHIRE RAILWAYS.

FINAL TIE
English Association Cup
At CRYSTAL PALACE, April 19th, 1913.

SUNDERLAND v. ASTON VILLA.

FRIDAY MIDNIGHT, APRIL 18th,
For 1, 2 or 3 DAYS,
EXPRESS EXCURSION TO

LONDON
(KING'S CROSS)
(Via G.N. LINE).

(left margin) "THE QUICKEST ROUTE." ASK FOR TICKETS BY GREAT NORTHERN, L. & Y. STATIONS.

(right margin) FOR OTHER EXCURSIONS TO LONDON DURING APRIL, SEE SEPARATE BILLS.

FROM	Departure Times Friday midnight 18th April.			Return Fares—Third Class.		
	For 1, 2 or 3 days.			Day. s. d.	2 Days. s. d.	3 Days. s. d.
	p.m.	p.m.	a.m.			
LOWMOOR dep.	11 30					
CLECKHEATON ...	11 25					
LIVERSEDGE	11 20					
HECKMONDWIKE ...	11 15					
GREETLAND		11 49				
BRIGHOUSE		11 57				
MIRFIELD		12 5				
THORNHILL		12 10		12 0	13 6	17 0
HORBURY		12 18				
CROFTON			1 40			
SHARLSTON			1 48			
FEATHERSTONE ...			1 55			
TANSHELF			2 5			
PONTEFRACT ... (L. & Y.)			2 8			
KNOTTINGLEY			2 23	11 9	12 9	16 9
WOMERSLEY			2 35	11 3	12 3	16 3
NORTON			2 43	11 0	12 0	16 0
ASKERN			2 50			
LONDON arr abt. (King's Cross)		4 50	5 13			

FOR RETURN ARRANGEMENTS AND OTHER PARTICULARS SEE OTHER SIDE.

London, April, 1913.
BY ORDER.

5,000—H.4/13—P.A.S.I. P98228

Lancashire & Yorkshire Rly.

ROYAL
AGRICULTURAL
SHOW
MANCHESTER

JUNE 27th to JULY 1st, 1916

HORSES, CATTLE, SHEEP, GOATS, PIGS, POULTRY, DOGS, BUTTER, CHEESE, CIDER, PERRY, BACON, HAMS, WOOL, HIVES, HONEY, BOTTLED FRUITS, BUTTER-MAKING, CHEESE-MAKING, MACHINERY AND IMPLEMENTS, AND A MISCELLANEOUS COLLECTION OF ARTICLES OF INTEREST

Jumping, Riding and Driving

FLOWER SHOW
Band of the Coldstream Guards

FOR FULL PARTICULARS SEE DAILY PROGRAMME.

PRICES OF ADMISSION	Tuesday, June 27th - - 5/-	SEASON TICKET
	Wednesday & Thursday 2/6	
	Friday & Saturday - - 1/-	10/6

FOR PARTICULARS OF TRAIN SERVICE TO MANCHESTER SEE THE COMPANY'S TIME TABLE

135

York & North Midland Railway.

SECOND CLASS.

Church Fenton to _____

Departure _____ _o'Clock._

	£.	s.	d.
_____ 18			

No. _____

Name _____

Paid _____

_____ 18

No. _____

Name _____

Paid _____

_____ 18

No. _____

Name _____

Paid _____

_____ 18

No. _____

Name _____

Paid _____

_____ 18

No. _____

Name _____

Paid _____

AMOUNT ... £

York and North Midland Railway.

SECOND CLASS.

No. _____ 18

o'Clock—Departure.

CHURCH FENTON to _____

PAID _____

_____ **Agent.**

Passengers' Note Books are kept in the Booking Offices, in which Passengers may enter complaints of incivility or want of attention on the part of any of the Company's Servants. (See over.)

York and North Midland Railway.

SECOND CLASS.

No. _____ 18

o'Clock—Departure.

CHURCH FENTON to _____

PAID _____

_____ **Agent.**

Passengers' Note Books are kept in the Booking Offices, in which Passengers may enter complaints of incivility or want of attention on the part of any of the Company's Servants. (See over.)

York and North Midland Railway.

SECOND CLASS.

No. _____ 18

o'Clock—Departure.

CHURCH FENTON to _____

PAID _____

_____ **Agent.**

Passengers' Note Books are kept in the Booking Offices, in which Passengers may enter complaints of incivility or want of attention on the part of any of the Company's Servants. (See over.)

York and North Midland Railway.

SECOND CLASS.

No. _____ 18

o'Clock—Departure.

CHURCH FENTON to _____

PAID _____

_____ **Agent.**

Passengers' Note Books are kept in the Booking Offices, in which Passengers may enter complaints of incivility or want of attention on the part of any of the Company's Servants. (See over.)

York and North Midland Railway.

SECOND CLASS.

No. _____ 18

o'Clock—Departure.

CHURCH FENTON to _____

PAID _____

_____ **Agent.**

Passengers' Note Books are kept in the Booking Offices, in which Passengers may enter complaints of incivility or want of attention on the part of any of the Company's Servants. (See over.)

ABOVE

A page of tickets from a 200 page book.
Optimistically, even remote stations had enough books
of each class in stock to produce 50,000 tickets.
Each ticket had to be laboriously filled in and cut out,
hence early arrival at the station was essential.
283 x 219mm, c.1839.

FACING PAGE TOP LEFT

Conditions on the back of these tickets.
Actual size.

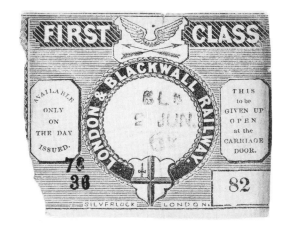

This Ticket must be produced when required by the Guard, and delivered up on demand, under a Penalty of 40s. *in case of refusal.*

Any Passenger riding in a superior Carriage, having paid for an inferior Class only, is liable to a Penalty of 40s.

No Dogs allowed in any of the Company's Carriages—Smoking is strictly prohibited, and Passengers persisting in smoking after being warned, are liable to a Penalty of 40s.

No fees or gratuities are permited to be taken by any of the Company's Servants.

Any Passenger wilfully damaging any of the Company's Carriages will be fined £5.

Passengers are recommended to read the regulations affixed in the Booking Offices.

ABOVE RIGHT
Hand-cut ticket, actual size, c.1840.

RIGHT
Stockton and Darlington Railway, Hand-cut ticket, actual size, 1840.

BELOW RIGHT
Ticket for carriages similar to that shown below. Actual size, 1850.

BELOW
Printers' stock blocks by Harrild and Sons. Actual size, 1860.

Fighting Cocks
TO
St. Helen's.

No. Second Class, 2 0

day of 184

Please to hold this Ticket til called for,

Oxford, Worcester, & Wolverhampton Railway.

TICKET FOR HORSES, CARRIAGES, &c.

No 76 Date 185

.................... o'Clock Train.

From to

 AMOUNT PAID.
 £. s. d.

.................... Horse at : :

.................... Carriage, with Luggage, &c.... at : :

.................... Dog at : :

 : :

Name of Owner

 It is hereby agreed that the Company shall not be responsible for any loss, injury, or damage, that may occur to any Horse, Carriage, Luggage, &c., or Dog, above paid for, either on the journey, or in loading, unloading, or delivery, and that the Owner shall undertake all risks whatever.

.................... *Booking Clerk.*

.................... *Owner or Owner's Agent.*

This Ticket is to be shown at every examination of Tickets, and given up on arrival.

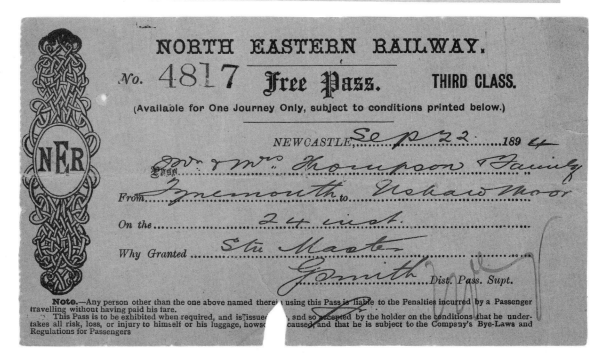

London & North Western Railway

No. 210 **UP** No. 210

FREE TICKET, FIRST CLASS.

DEPARTMENT.

Any Train 15 Jan.y 1856

From *Stafford* to *London*

Name *Reporter of Railway Post*

Why granted *Press*

R Bailey for Head of Dep.t

N.B. Free Tickets are granted to Persons employed on the Company's Business only, and must be given up when

THE GREAT NORTHERN RAILWAY.

Free Pass, FORM No. **2.** SECOND CLASS. NOT TRANSFERABLE.

No. 4803 *27 March* 185

From BOSTON Station

To *London* Station.

Granted to *Mr Baggott*

a *Clerk* in the *Stores* Department.

Issued by *Walter in the ford*

By Order,

J. R. Munitt Secretary.

NOTE.—Any party, other than the person named herein, using this Pass, is liable to the penalties which a Passenger incurs by travelling without having paid his Fare.
This Pass is to be given up at the end of the Journey, and exhibited when required, and the holder of it is subject to the Regulations for Passengers.

Waterlow and Sons, Printers, London Wall.

NORTH EASTERN RAILWAY.

No. 4817 Free Pass. THIRD CLASS.

(Available for One Journey Only, subject to conditions printed below.)

NEWCASTLE, *Sep 22* 1894

Pass. *Mr & Mrs Thompson & Family*

From *Tynemouth* to *Ushaw Moor*

On the *24 inst.*

Why Granted *Stn Master*

J. Smith Dist. Pass. Supt.

Note.—Any person other than the one above named therein using this Pass is liable to the Penalties incurred by a Passenger travelling without having paid his fare.
This Pass is to be exhibited when required, and is issued and so accepted by the holder on the conditions that he undertakes all risk, loss, or injury to himself or his luggage, howsoever caused, and that he is subject to the Company's Bye-Laws and Regulations for Passengers

Free or discount travel has always been available for railway staff. . . and a select few.

TOP

One of the favoured; first class for the *Morning Post* reporter.
93 x 143mm, 1851.

CENTRE

Second class for a clerk in the stores department.
98 x 152mm, 1851.

BELOW

Forty years ahead and the station master and his family are down to third class.
94 x 158mm, 1894.

THIS PAGE

TOP

Six months free ticket.
Actual size, 1848.

CENTRE

Brake van = second class? Economy at Conisborough. (The Great Central Railway ceased to exist in 1922).
Actual size, 1961.

BELOW

Actual size, 1898.

Stockton and Darlington Railway.

SECOND CLASS.—FREE TICKET.

From *July 1* 1848 to *Dec 31* 1848

Six MONTHS.

NOT TRANSFERABLE.

Mr John Taylor

Is entitled to travel free by any of the Company's Trains, between

Darlington & Middlesbro

The holder of this Ticket is subject to the same Rules and Regulations as other Passengers.

Oswald Gilkes
Secretary.

GREAT CENTRAL RAILWAY.

SERVICE ORDER. No. K 30244

STATION MASTER'S OFFICE
CONISBROUGH Dept.

Oct 20th 1961 Station,

To be used only by Servants of the Company travelling on the Company's Business.

This Order entitles *Wm Ashford* to travel to *Doncaster Back* in 3rd class Carriage of Passenger Train, or in Brake Van of Goods Train.

Station Master or Inspector.

These Orders are to be issued to men returning after working a Train or proceeding to work a Train, and to Inspectors and others travelling in charge of Meat, Fish, and Unsheeted Cotton or other Special Consignments—or returning from the charge of the same—and to men in the Carriage and Wagon Departments. Should an Order be required for the return journey, such Order must be obtained at the Station from which the return journey commences.

SAM FAY, General Manager.

This Order must be given up on completion of journey

(1956—Quarter Fare Privilege)
(Ticket Order Requisition.)

No. of Order issued 78054

L. & N. W. Ry.—APPLICATION FOR QUARTER FARE PRIVILEGE TICKETS.

I beg to apply for the following Quarter Fare Privilege Ticket Orders:—

Signed *H Pullar* Grade *Station Master*
Department *Coaching* Station *Glazebury*

Description.	No. of Tickets required.	Class.	Single or Return.	Date travelling.	Between what Points. From.	To.	Relationship to Applicant.
MALES							
FEMALES	one	3rd	Rtn	20. 8. 8	Glazebury	Patricroft	wife
CHILDREN under 12							

NOTE.—In the case of Members of the family it is to be distinctly understood that Quarter Fare Privilege Tickets are only to be asked for in their favour when they are permanently resident with, and dependent upon, the applicant, and any abuse of the privilege will render the servant liable to Dismissal.

Approved 3838 Authorised Officer.

NORTH EASTERN RAILWAY.

ISSUE OF TICKETS.

TICKETS will be issued at this Office, on application, 15 minutes before the advertised time of departure of each train.

A. K. BUTTERWORTH,

YORK, 1st January, 1920.

GENERAL MANAGER.

9/4179.

Thomas Edmondson, station agent at Milton, (Newcastle and Carlisle Railway), became disenchanted by writing out tickets and set about making life easier for himself. From 1836, when his first card ticket appeared, until his death in 1851, he devised and constantly improved most of the basic machinery (ticket counting machine above) involved in the production and issue of card tickets.

LEFT
Probably the stimulus for the tailor's stock question: 'Ticket pocket sir?'
Actual size, source and date unknown.

FACING PAGE TOP
Early, middle and late 'Edmondsons' against the 'labour intensive' paper ticket they were designed to replace.
All actual size.

FACING PAGE BELOW
Double page spread from the London and South Western Railway's *Instructions to Station Masters, Ticket Inspectors, Collectors and All Others Concerned as to Passenger Excess Fare Regulations, Availability of Tickets. etc.*
166 x 210mm, 1921.

THE NEW RAILWAY-TICKET REGIME.

["In consequence of the enormous expense of the Railway Tickets, some of the Companies contemplate a great reduction in their size."—*Daily paper*.]

1. "What! gie seven bob for that litt'e thingummyjig? Not me."

2. *Glove-fight for the Ticket*—"Confound it! they ought to have special ones for Winter."

3. "Excuse me, sir, but you've a 'black' on your nose." "Nay, sir, that's how I carry my ticket."

4. Microscopes will have to be provided at every station for the use of Ticket Collectors.

CAPITAL
TO
DACRE
GOV. TICKET
12

L. & S.W.R.
EXETER (QUEEN ST.) TO
BUDE
(Via Bideford)
THIRD CLASS PARLIAMENTARY
(Bude) (Bude)
THIS COMPANY WILL NOT BE LIABLE FOR
(S.1) (See over)
50

2nd - SINGLE SINGLE - 2nd
2937 2937
Canterbury (East) to
Canterbury (East) Canterbury (East)
Kearsney Kearsney
KEARSNEY
2937 2937
(S) 3/6 Fare 3/6 (S)
For conditions see over For conditions see over

Potteries, Shrewsbury, and North Wales Railway Company.

For Soldiers, Policemen on Duty and Shipwrecked Mariners.

No. 56

_____ Ticket.

_____ o'clock _____ Train _____ 186

From _____

To _____

_____ Miles.

	£	s.	d.
Officers............................ at _____			
.. ,, _____			
Soldiers.................... ,, _____			
Do. Wives........................ ,, _____			
Children........................ ,, _____			
Police............................ ,, _____			
Shipwrecked Mariners........ ,, _____			
Volunteers, Officer.............. ,, _____			
Do. Private.................... ,, _____			
TOTAL....			

No. of Warrant _____ Payable at _____

_____ Booking Clerk.

36

PRINTING AND COLOR OF PASSENGER TICKETS

In order to enable the staff to distinguish the various descriptions of tickets initial letters overprinted in red ink are used, as shewn hereafter. The backward halves of ordinary tickets are overprinted with the initial letter "R."

Tickets are printed on cards of the colors indicated below :—

(a) **Ordinary**

1st class	White.
3rd class	Pink.

Workmen Grey.

Excursion Buff.

(b) **"Special Arrangement"**

1st class	White.
3rd class	Green.

Platform Tickets Orange.

Bicycle and Dog, &c. ... Red.
(Accompanied traffic.)

(a) Includes Government Tickets, Privilege Tickets and any others of a general character.

(b) Embraces tickets issued under Special Arrangements such as :—

Market Tickets.
Officers on leave.
Men on furlough.
Music Hall Artistes.
Theatrical Companies.

37

Illustration showing initial letters overprinted on certain tickets.

1009
L.&S.W.R. 3rd Class
...ditions stated ...
TO
YEOFORD
Revised Fare 1/-
L.&S.W.R.
YEOFORD
TO Yeoford Crediton
CREDITON
Revised
Fare 1/- 3rd Class
1009
Ordinary (Return).

2250
London & South Western Ry.
M.H.&T. SPECIAL 3/4 FARE
PORTSMOUTH TOWN to
3rd Class Revised Fare 8/-
WATERLOO
FOR CONDITIONS SEE BACK
2250
Special Arrangement
(For tickets of an exceptional nature at reduced rate).

2021
Via
London & South Western Ry.
STAFF PRIVILEGE TICKET
SUDBURY to
THIRD CLASS
2021
Privilege (Single), Local and Interchange.

0000
L.&S.W.R. 3rd Class
Issued subject ... the Conditions ... relating thereto
HOUNSLOW
TO
KEW BRIDGE
L.&S.W.R.
Staff Privilege Ticket
KEW BRIDGE
TO Kew B'dge Hounslow
HOUNSLOW
THIRD CLASS
0000
Privilege (Return), Local and Interchange.

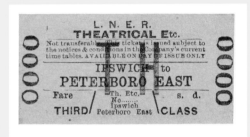

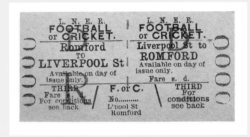

A selection from many of the stock tickets carried by the London and North Eastern Railway in 1937. Most were also available as first class and a few as second class, although this class ceased to exist, except on some boat trains, on December 31st, 1937.
All actual size.

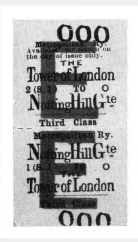

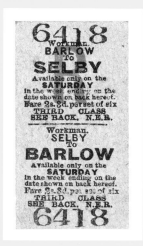

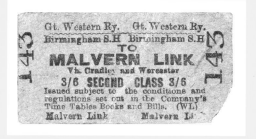

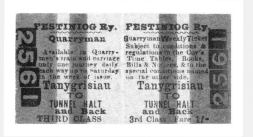

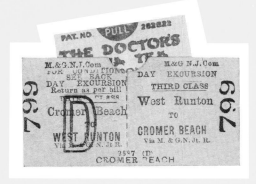

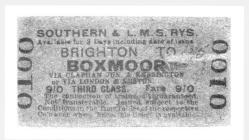

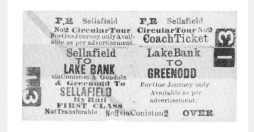

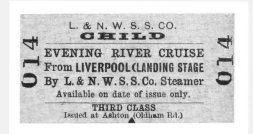

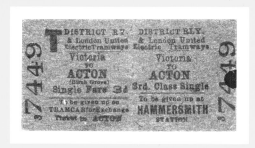

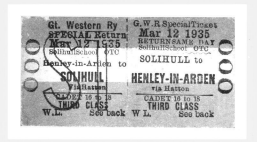

A miscellany.

The Metropolitan Circle line overprinted its tickets with the initial letter 'I' 'O' or 'E' to denote direction of travel. 'I' was by the inner rails of the circle, 'O' by the outer and 'E' to points equidistant either way.
Certain companies printed conditions of issue on the reverse side of the ticket, others would sell the space for advertising. In the mid 1930's the best of both worlds was achieved by creating a pocket into which a minute advertisement was inserted.
All actual size. 1900-1938.

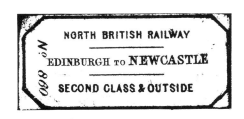

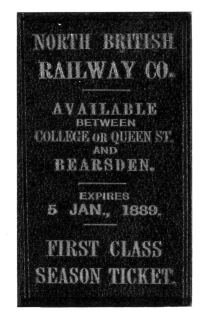

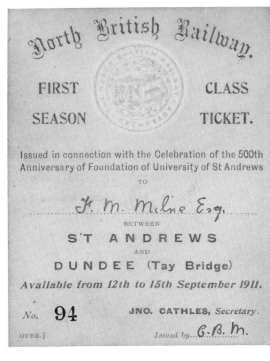

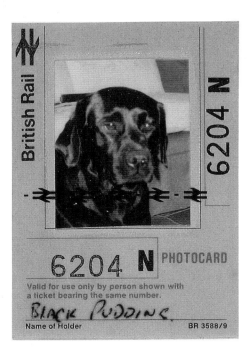

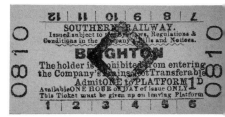

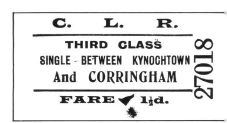

A miscellany . . . continued

Before the railway was completed between Edinburgh and Newcastle the intermediate stage had to be travelled by stage coach, hence second class & outside. c.1843. (top left).
If one broke one's journey it was not uncommon to leave the ticket at the station in exchange for a receipt type ticket; Wormald Green c.1900 (top left).
First class season tickets looked like first class season tickets. The North British example of 1888 is a red leather folder gold blocked (top centre).
London through Brittany and back (facing page top left) is the cover of a 64pp book of tickets perforated in the spine to

be detached for each stage of the journey.
Great Western rural branch lines worked by push/pull auto trains often issued bus type tickets on the train, punched against the destination station name. (facing page top right)
For the uninitiated the 10.0am from Edinburgh Waverley reserved seat (facing page below right) is for the 'Flying Scotsman'.
At the beginning of automatic gate entry control on the London Underground tickets could only be inserted one way (bottom right).
All actual size.

North British Railway second class & outside courtesy Jeoffrey Spence
British Railways dog ticket 'Black Pudding' courtesy Amoret Tanner

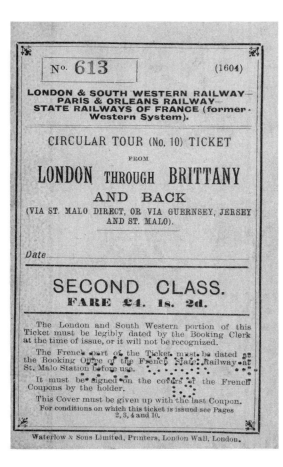

No. 613 (1604)

**LONDON & SOUTH WESTERN RAILWAY—
PARIS & ORLEANS RAILWAY—
STATE RAILWAYS OF FRANCE (former·
Western System).**

CIRCULAR TOUR (No. 10) TICKET

FROM

LONDON THROUGH **BRITTANY**

AND BACK

(VIA ST. MALO DIRECT, OR VIA GUERNSEY, JERSEY
AND ST. MALO).

Date

SECOND CLASS.
FARE £4. 1s. 2d.

The London and South Western portion of this
Ticket must be legibly dated by the Booking Clerk
at the time of issue, or it will not be recognized.

The French part of the Ticket must be dated at
the Booking Office of the French State Railway at
St. Malo Station before use.

It must be signed on the covers of the French
Coupons by the holder.

This Cover must be given up with the last Coupon.
For conditions on which this ticket is issued see Pages
2, 3, 4 and 10.

Waterlow & Sons Limited, Printers, London Wall, London.

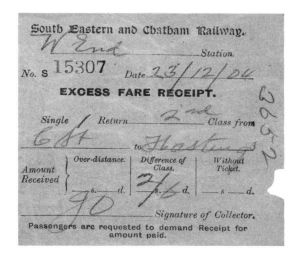

South Eastern and Chatham Railway.

W End Station.

No. S 15307 Date 23/12/06

EXCESS FARE RECEIPT.

Single Return 2nd Class from

6d to Hastings

Amount Received	Over-distance.	Difference of Class.	Without Ticket.
	s. d.	2/ s. 6 d.	s. d.
	90		

......... Signature of Collector.

Passengers are requested to demand Receipt for
amount paid.

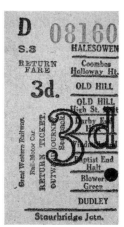

D 08160
S.S HALESOWEN
RETURN FARE Coombes Holloway Ht.
3d. OLD HILL
 OLD HILL High St.
 Darby E...
 ...
 Baptist End Halt
 Blower Green
 DUDLEY
Stourbridge Jctn.

METROPOLITAN RAILWAY.

RECEIPT FOR EXCESS
FARE PAID AT
FINCHLEY ROAD STA.

3d.

1491

All complaints or sugges-
tions to be addressed to the
GENERAL MANAGER, 32, Wes-
bourne Terrace, W.

RESERVED SEAT - C. L. C.
From MANCHESTER (CEN)
TRAIN.........
Date.........
COMPARTMENT | SEAT No.

Not valid except on production of
Rail Ticket covering the journey.
FOR CONDITIONS SEE BACK FARE 1/-

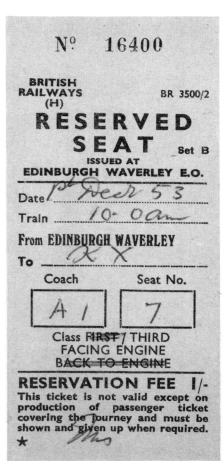

Nº 16400

**BRITISH
RAILWAYS
(H)** BR 3500/2

**RESERVED
SEAT** Set B

ISSUED AT
EDINBURGH WAVERLEY E.O.

Date 1st Decr 53

Train 10· 0am

From **EDINBURGH WAVERLEY**

To X X

Coach	Seat No.
A 1	7

Class ~~FIRST~~ / THIRD
FACING ENGINE
~~BACK TO ENGINE~~

RESERVATION FEE 1/-
This ticket is not valid except on
production of passenger ticket
covering the journey and must be
shown and given up when required.

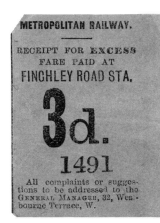

**HUNDRED OF MANHOOD AND SELSEY
TRAMWAYS, Co., Ltd.**

CLOAK ROOM.

This deposit is accepted by the Company subject to the
conditions endorsed on the back of this Ticket.

Date 30/8/24

No. 30

ARTICLES.

Excess Days

Declared Value £
Company not liable for Articles beyond £10 in value unless extra value be
declared.

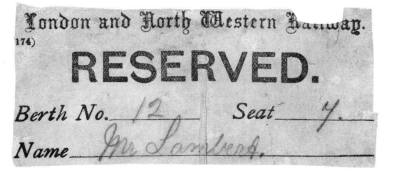

London and North Western Railway.

174)

RESERVED.

Berth No. 12 Seat 4

Name Mr Lambert

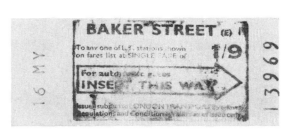

BAKER STREET (E) 1/9
To any one of L.T. stations shown
on fares list at SINGLE FARE of

For auto...
INSE... THIS WAY ▷

Issued subject to LONDON TRANSPORT...
Regulations and Conditions...

13969

Railway Conveyance

OF

GOODS, GRAIN,

FURNITURE, &c.,

At Reduced Rates of Carriage, by the Brandling Junction, Newcastle, and Darlington, Clarence, Stockton and Hartlepool Railways.

Jas. & Isaac Thompson,

RAILWAY CARRIERS.

Respectfully inform the Public that they have made arrangements for the conveyance of Goods, &c., &c. by the above named Railways, to and from the following places.

NEWCASTLE	FERRY HILL
GATESHEAD	COXHOE
SOUTH SHIELDS	SHINCLIFFE
MONKWEARMOUTH	FENCE HOUSES
DURHAM	HOUGHTON-LE-SPRING
HARTLEPOOL	HETTON-LE-HOLE
SEATON	SEAHAM HARBOUR and the
STOCKTON	NEWCASTLE & CARLISLE
DARLINGTON	RAILWAY STATION

Goods forwarded to all parts of the North of England and Scotland

☞ **Orders for Goods forwarded by Post addressed to J. and I. Thompson, Railway Carriers, Brandling Junction Railway Station, Gateshead, will be attended to without the least delay.**

Gateshead, July, 1844

J. PROCTER, PRINTER, HIGH STREET, HARTLEPOOL.

The goods

'. . . he may not without lawful excuse refuse to carry goods offered to him by any person who is ready to pay his reasonable charges, provided the goods are such as he professes to carry, and provided his business extends to the place to which he is required to carry them. So important is this rule, that the law considers a common carrier guilty of criminal offence who without lawful excuse refuses to accept goods offered to him and he is indictable therefor as for a misdemeanor.'

Henry W. Disney,
The Law of Carriage by Railway,
1912.

RIGHT
Not merely a list of goods accepted for carriage by rail but of articles long forgotten.
Folder, actual size, 1846.

LEFT
Notice, actual size, 1844.

Courtesy John Lewis

Eastern Counties Railway.—*Cambridge Line.*

SCALE OF RATES,

Including Toll, Locomotive Power, Waggons, Sheets, Ropes, also Laborage at the Termini, but exclusive of Collection or Delivery.

CLASSIFICATION.

SPECIAL CLASS.

The following Articles, when carried a distance exceeding 20 miles, in quantities not less than 5 tons, will be charged the Special Rate (see Scale of Rates), smaller quantities will be charged the First Class Rate.

Ale and Beer, in casks	Cement	Guano	Mangul Worzel	Porter, in casks
Asphaltum	Coke	Iron Ballast	Manganese	Potatoes, old
Barley	Clay	Iron, Pig	Meal	Railway Bars, Pins, Chairs, Wheels, Axles, and Turntables
Beans	Culm	Ironstone	Metal, old	
Bones for Manure	Deals	Iron Bars	Oats	
Bran	Flags	Lead, in Pigs or Sheets	Ore, Iron, Copper and Lead	
Breeze	Flour	Lime	Peas	Road Material
Bricks	Flints, in casks	Limestone	Pitch	Rye
Carrots	Fuller's Earth	Logwood	Plaster	Salt
Chalk	Greaves, as Manure	Malt	Pollard	Sand

Stones
Timber
Tares
Tar
Tiles, flat and draining
Turnip
Vinegar
Vetches
Wheat
Slates

FIRST CLASS.

Alum	Cedar, in logs	Flints, loose	Iron — Rods, Plates	Mustard Seed, in sacks	Rosin
Alabaster, in blocks	Chains	Flocks	Iron, Sheet and Hoop	Nails	Soap, in chests
Anvils	Chiccory Root	Fat, in sacks		Nips	Sheepskins
Ashes, in casks	Charcoal	Gas Tar	Iron Scrap	Nitrate of Soda	Soda
Bacon	Cheese	Gas & Water Pipes	Joists, Framing	Oakum	Sugar in—hhds.
Bark	Clover Seed	Grease	Lard, in casks	Oil, in casks	„ bags
Barrel Staves	Colours	Grindstones	Lathwood	Oil Cake	„ or Mats
Boiler Plates	Cotton, raw	Gum	Lead, Pipe	Oil Rope	Spelter
Boxwood	Copper	Hams	Lead — Red and White	Pelts	Terra Japonica
Butter, in firkins	Copperas	Hay		Pipe Staves	Tallow
Coach and Cart Springs	Currants, in butts	Hemp	Linseed	Pipes—Draining	Tin, in boxes
Cables	Divi Divi	Hides	Mahogany	Rags	Tow
Castings	Dyewoods	Hoopwood	Manganese	Rope—Wire and Common	Whiting
	Flax	Hoofs and Horns	Marble, in blocks		Wooden Blocks for paving
	Flints	Iron Bedsteads			

SECOND CLASS.

Agricultural Implements	Coffee	Groceries, not specified	Meat, cured	Rice	Stationery
Almonds	Cordage	Gun Stocks	Millboards	Rollers, Wood	Stamps
Aloes	Corkwood	Garden Seeds	Molasses	Rushes	Sugar, loaf, loose
Anchovies	Cream of Tartar	Haberdashery	Mop and Broom Handles	Safes, new	Tea
Annatto	Door Mats	Hair, in bales	Mustard	Safes, Iron	Thread
Apples, in casks	Drapery	Hay Rakes, in bundles	Naptha	Safety boxes	Tin & japan ware
Archil	Drills	Hardware	Needles	Safflower	Tobacco leaf
Argols	Drysalteries	Honey	Nutria Skins	Sarsaparilla	Tool chests
Bagging, in bales	Drugs	Hops	Nuts	Sassafras	Trees and shrubs —nurserymen's
Beeswax	Dye-lac	Hosiery	Nutmegs	Scythes	Types
Beer and Ale, in bottle	Dye-goods	Hurdles, Iron or Wood	Oil, in jars	Scythe Stones	Umbrella stretchers
Bellows	Earthenware	India Rubber	Onions	Seal skins, in casks	Veneers
Berries	Edge Tools	Indigo	Oranges	Seeds, Garden	Whalebone
Blacking	Elephant's Teeth	Ink	Oxalic Actd	Shel-lac	Weighi'gMachine
Blacking Powder	Emery	Isinglass	Oysters	Shot	Whetstones, in baskets or bags
Bottles, Black	Felt	Juice	Paper	Shoes in Hprs.	Window frames —cast iron
Bristles	Fenders	Lard in bladders, loose	Ditto, Hangings	Shumac	Wines, in casks or hampers
Brooms	Fire-irons	Leather	Patent Medicines	Silk waste	Wire of all kinds
Camlet Bales	Fish, dried	Lemon Juice	Pepper	Size	Wool
Candles	Ditto, shell	Lemons	Perry, in casks	Slates, Writing	Woollen goods
Candy	Figs	Linen	Pickles, in bottles	Smalts	Yarn
Canvas	Flannels	Machinery	Pimento	Snuff	Zaffers
Carpeting	Floor Cloth	Madder	Pins, in boxes	Soda Water	Zinc
Chiccory, in casks or bags	Fruit (ripe)	Manchest'r packs	Powder, Blue	Spades & Shovels	
Cider	Galls	Mastic	Provisions, Salt	Spirits, in casks or hampers	
Cocoa	Ginger		Quills	Spice	
	Glass, in crates and boxes		Quicksilver	Starch	
	Glue		Raisins		

THIRD CLASS.

Alabaster, in cases	Corks, in bags	Game	Lace	Poultry, dead or alive
Baskets	Cochineal	Garden Plants	Meat, fresh	Pianofortes
China	Feathers	Garden Seats	Millinery, in boxes	Pictures
Chairs	Fish, fresh	Glass Plate		Salmon, in boxes
Cigars	Furniture	Hats	Organs, in cases	Silks, raw, and manufactured
Clocks	Furs	Luggage, as trunks, &c.	Organ work	

Sponge
Straw Plait
Tortoiseshell
Toys
Turtle

Lucifer or Congreve Matches, Fireworks, Gunpowder, Oil of Vitriol, Aqua fortis, or such like combustible or dangerous articles not carried on any terms.

Wheat, Rye, Beans, Peas, and Tares are calculated and charged as 5 quarters to the ton, Barley 6 quarters, Malt and Oats 8 quarters, Pollard and Bran 10 quarters, Flour 8 Sacks to the ton; other goods computed at 112 lbs, to the cwt., and 20 cwt. to the ton.

Trucks with 4 wheels not allowed to be loaded with more than 5 tons, ditto with six wheels, not more 6½ tons.

The Company carry upon the terms of the Act of the 1st William 4th, cap. 68, as set forth in their public notices, and to which they, hereby refer.

SOUTH WESTERN RAILWAY
AND
GENERAL WAGGON OFFICE,
White Horse, Friday Street.

M *Sheddon &* *1 Parcel Case*

Carriage - - - - - *6 4*

Porterage - - - - - *2 6*

22 Sep 1891

BENJAMIN GUNTER, } *Porters.*
JOHN BALL,

8/10

CARRIERS TO HER MAJESTY
BY SPECIAL APPOINTMENT.

BLOSSOMS INN
LAWRENCE LANE, CHEAPSIDE.

BRIGHTON
ROYAL BLUE VANS
Daily, at FIVE o'Clock in the Afternoon,
BY RAILWAY,
By M. Gilbert, Strevens & Co. (late Crosweller & Co.)

GENERAL RAILWAY OFFICE.
Goods forwarded by the GREAT WESTERN AND BIRMINGHAM RAILWAYS.

| OXFORD | HEREFORD | CHELTENHAM | WORCESTER |
| WITNEY | MONMOUTH | GLOUCESTER | KIDDERMINSTER |

And all parts of the West of England, and South Wales, daily, at Three.
By HAINES & Co.

Also, BIRMINGHAM, BATH, BRISTOL, BRIDGEWATER, & EXETER.

VANS & WAGGONS daily to

DOVOR	CANTERBURY	ASHFORD	MAIDSTONE
HASTINGS	TUNBRIDGE WELLS	CHATHAM	AND
RAMSGATE	PORTSMOUTH	FOLKSTONE	SANDGATE

By GILBERT & Co.

Goods received and Berths secured for the ROYAL WILLIAM, ROYAL ADELAIDE, and ROYAL VICTORIA STEAM VESSELS, to
EDINBURGH, LEITH, AND GLASGOW.

M *Gowlard* £.

Carriage *18 10*

Porterage (agreeably to the Act)

Cartage *2 Articles* ... *4 —*

JOHN KNOWLES, }
GEORGE BRADSHAW, } Porters.
JOHN JASPER, }

6 Sep 1842 £ *1 2 10*

Not accountable for Loss by Fire, nor for any Package above the Value of TEN POUNDS, at their Offices, unless entered and paid for accordingly. Not accountable for Loss or Accident to any Live Animal, or Carriage drawn at the end of any Waggon or Van.
Goods left till called for will be at the risk of the Owners.
EXTRA VANS AND WAGGONS AT A SHORT NOTICE.
MARY GILBERT, Proprietor & Agent.
Goods carted in from any part of Town, by addressing a line as above.

Balne Brothers, Printers, 38, Gracechurch Street.

Until the railway companies introduced their own collection and delivery service this was provided by private carriers. (See also p.146).

LEFT
Receipt, actual size, 1841.

BELOW LEFT
Receipt, actual size, 1842.

RIGHT
Receipt, 144 x 112mm, 1850.

BELOW
Calendar for an unusually amicable 50:50 goods and parcels agreement between the Great Western Railway and the London and North Western Railway. 232 x 291mm, 1876.

Mrs Waller
10 May 1850

SOUTH WESTERN
AND BRIGHTON & SOUTH COAST RAILWAYS,
WHITE HORSE, FRIDAY STREET.

LIPSCOMB.
Winchester, Southampton, Ringwood, Wimborn, Poole, & Christchurch, DAILY.

HYSLOP.—GOSPORT, &c.—DAILY.

T. KING. — Portsmouth, Portsea, &c. — DAILY.

LIPSCOMB AND KNIGHTON,
Salisbury, Wincanton, Yeovil, Sherborne, Dorchester, & Weymouth—DAILY.

JONES,
Overton, Whitchurch, and Andover—Tuesday, Thursday, & Saturday.

LACOMB,
Stockbridge, Sutton Scotney, &c.—Tuesday & Friday.

HARRISON—Guildford & Ripley—DAILY.

HOPE & Co.—Brighton—**Daily, Afternoon.**

SHERWOOD—Chertsey, Sunbury, &c.—DAILY.

BALDWIN—Crayford & Dartford—Wednesday & Saturday, NOON.

WOOLRIDGE,
Hampton & Hampton Court—Monday, Wednesday, & Saturday.

BARTLETT—Kingston & Wandsworth—every Evening.

SMITH—Hounslow—DAILY.

M —— Carriage —— ——

Porterage —— —— ——

JOHN MOLE,
CHARLES TRIMMINGS, } Porters.

GOODS CARTED IN.
W. H. MANSELL, *Proprietor.*

SHREWSBURY AND HEREFORD,
SHREWSBURY AND WELLINGTON, SHREWSBURY AND WELSHPOOL,
AND BIRKENHEAD AND MANCHESTER JOINT RAILWAYS.

TABLE SHOWING THE DAYS

On which UNCONSIGNED Local Goods, and Competitive Through Goods and Parcels Traffic is to be forwarded by the two Companies for the Year 1876.

London & North Western Days, RED. Great Western Days, BLACK.

	1	2	3	4	5	6	7	8	9	10	11	12	13	14	15	16	17	18	19	20	21	22	23	24	25	26	27	28	29	30	31
JANUARY	1	2	3	4	5	6	7	8	9	10	11	12	13	14	15	16	17	18	19	20	21	22	23	24	25	26	27	28	29	30	31
FEBRUARY	1	2	3	4	5	6	7	8	9	10	11	12	13	14	15	16	17	18	19	20	21	22	23	24	25	26	27	28	29		
MARCH	1	2	3	4	5	6	7	8	9	10	11	12	13	14	15	16	17	18	19	20	21	22	23	24	25	26	27	28	29	30	31
APRIL	1	2	3	4	5	6	7	8	9	10	11	12	13	14	15	16	17	18	19	20	21	22	23	24	25	26	27	28	29	30	
MAY	1	2	3	4	5	6	7	8	9	10	11	12	13	14	15	16	17	18	19	20	21	22	23	24	25	26	27	28	29	30	31
JUNE	1	2	3	4	5	6	7	8	9	10	11	12	13	14	15	16	17	18	19	20	21	22	23	24	25	26	27	28	29	30	
JULY	1	2	3	4	5	6	7	8	9	10	11	12	13	14	15	16	17	18	19	20	21	22	23	24	25	26	27	28	29	30	31
AUGUST	1	2	3	4	5	6	7	8	9	10	11	12	13	14	15	16	17	18	19	20	21	22	23	24	25	26	27	28	29	30	31
SEPTEMBER	1	2	3	4	5	6	7	8	9	10	11	12	13	14	15	16	17	18	19	20	21	22	23	24	25	26	27	28	29	30	
OCTOBER	1	2	3	4	5	6	7	8	9	10	11	12	13	14	15	16	17	18	19	20	21	22	23	24	25	26	27	28	29	30	31
NOVEMBER	1	2	3	4	5	6	7	8	9	10	11	12	13	14	15	16	17	18	19	20	21	22	23	24	25	26	27	28	29	30	
DECEMBER	1	2	3	4	5	6	7	8	9	10	11	12	13	14	15	16	17	18	19	20	21	22	23	24	25	26	27	28	29	30	31

SUPERINTENDENT'S OFFICE,
SHREWSBURY, *January* 1876.

McCORQUODALE AND CO., PRINTERS, LONDON—WORKS, NEWTON.

W. PATCHETT,
Superintendent.

CALEDONIAN RAILWAY. No. 44

103

GUARD'S WAY-BILL for Carriages, Luggage, &c.,
Horses, Cattle, Asses, Mules, Dogs, and other
Quadrupeds, and for Poultry and other Live
Birds by Passenger Train. *WB*

From *Dunblane* To *Milnathort*

Via *Stirling*

2 15/pm Train *4 . 9 . 1896*

No. of Horse Box No. of Carriage Truck

No.	DESCRIPTION.	Rate.	Paid on. £ s. d.	To Pay. £ s. d.	Paid. £ s. d.
	Carriage Wheels				
	Carriage Trucks				
	Covered Truck extra				
	Luggage				
	Invalid Road Carriage				
*	Horses				
	Bulls				
	Neat Cattle				
	Rams				
	Sheep				
	Pigs				
	Asses or Mules				
	Dogs				
	Other Quadrupeds, viz. :—				
1	Poultry or other Birds, *Poultry*			0s	— 7

Declared value, £

Percentage on £ at 1¼ per cent.

Total, £

Name of Consignee *Secretaries*

Address *Ornithological Socy*

Milnathort

The Guard must deliver this Way-bill to the Officer on duty or
other appointed person at the Arrival Station.

Wm. GORDON, N.B.R. Guard.

DAVID RITCHIE N.B.R. Guard.

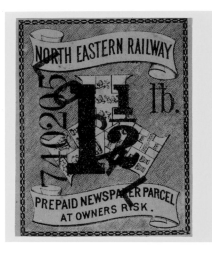

HOME
MIDLAND
ROUTE

G F. 1038.
10,000—S/4610.

ARRIVED
MID

............
Date

TO BE RETURNED
SAME ROUTE.

By

London and South Western Ry.
(882)

NOT WEIGHED

(2/39) (Stock 37U)

SOUTHERN RAILWAY

To expedite transit, please request
your Senders to include in the
address of future consignments :—

"To _____ Station."

Goods by passenger train.

Poultry, parcels, papers, pushers and proceedings to pay for the poached salmon.
All actual size except Great Northern Railway memorandum, 130 x 202mm.

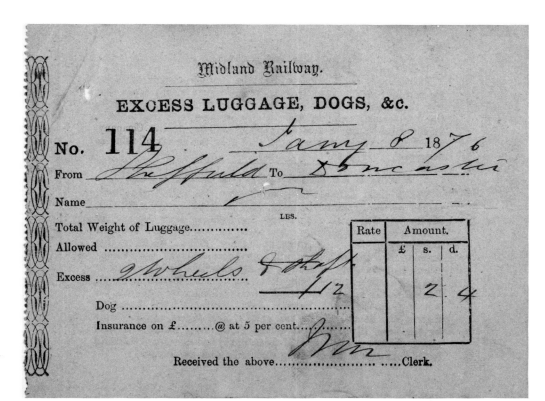

Midland Railway.

EXCESS LUGGAGE, DOGS, &c.

No. 114 Jany 8 1876

From Sheffeld To Doncaster

Name

Total Weight of Luggage............... LBS.

Allowed

Excess 2 Wheels & Shaft

Dog ..

Insurance on £........@ at 5 per cent....

Rate	Amount.
	£ s. d.
12	2 4

Received the above.............................Clerk.

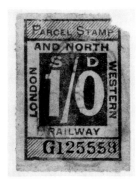

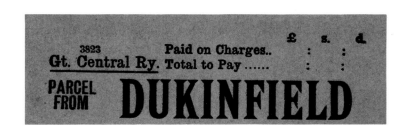

3823
Gt. Central Ry.

Paid on Charges.. £ s. d.
Total to Pay : :

PARCEL FROM **DUKINFIELD**

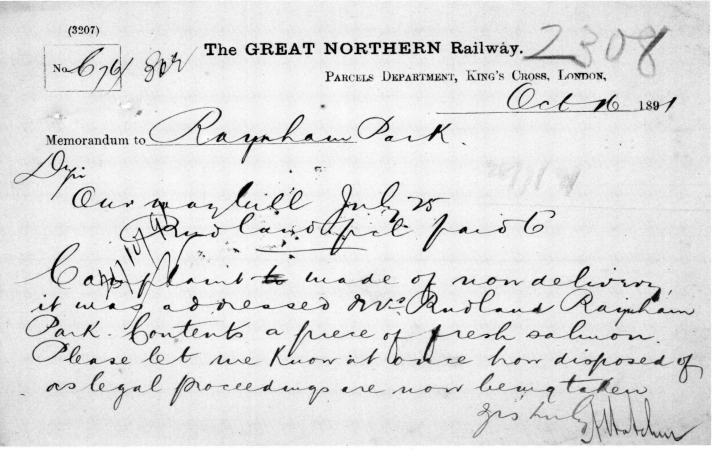

(3207)

No 676 80²

The **GREAT NORTHERN** Railway. 2308

PARCELS DEPARTMENT, KING'S CROSS, LONDON,

Oct 16 1891

Memorandum to Raynham Park.

Dr

Our waybill July 25

Midland pd paid 6

Complaint made of non delivery
it was addressed Mrs Rudland Raynham
Park. Contents a piece of fresh salmon.
Please let me know at once how disposed of
as legal proceedings are now being taken

Yrs truly

LONDON & NORTH WESTERN RAILWAY..

EXPLOSIVES.

**SHUNT
WITH
GREAT
CARE.**

LOADING and **UNLOADING** must take place **OUTSIDE** GOODS SHEDS.

Place as far as possible from Engine and from Inflammable Liquids and Dangerous Goods.

This label must be used for **GUNPOWDER** and all other **EXPLOSIVES.**

(3711) GREAT CENTRAL AND MIDLAND JOINT COMMITTEE.

BRITTLE GOODS, WITH CARE.

EGG LABEL. SC 2093—25,000—19/1/05—F 35.

NORTH EASTERN RAILWAY.

EGGS
WITH CARE.

Wagon and product labels.
Explosives 155 x 254mm;
Brittle goods 63 x 240mm;
Eggs 94 x 220mm;
Live stock 63 x 240mm;
Meat 127 x 156mm;
Dead meat 127 x 156mm.

Pig iron warrant 151 x 218mm.

(P. 1168) **THE HIGHLAND RAILWAY.**

LIVE STOCK.

Loaded. Date_____ Time_____

From INVERNESS
To NEWCASTLE, N.E.
Via DUNKELD, FORTH BRIDGE & BERWICK.

Consignee_____ Truck_____

Watered and (or) fed at _____ Time_____ Date____

„ „ „ at _____ Time_____ Date____

 PAID TO PAY

Carriage Charges : : : :

(385)
Glasgow and South Western Railway

M E A T.

CASTLE-DOUGLAS
TO
LONDON, BROAD ST., L. & N.-W. Ry.
Via CARLISLE.

Consignee,_____ Charges, £____ s.____ d.____

Wagon No._____ Date_____ 19__

(385)
Glasgow & South-Western Railway.

DEAD MEAT.

TO
ST. PANCRAS STATION, LONDON,
Per Midland Railway from Carlisle.

Consignee,_____

Wagon No._____ Date,_____

FURNESS RAILWAY
CAVENDO TUTUS

Furness Railway Company's Pig Iron Warrant.

 Tons No._____
 No._____
Warrant No. 169 for No._____ **Tons PIG IRON.**
 No._____
 No._____
 Tons.

ASKAM IRON WORKS. Station,_____ 1

We have received into our Stores, and entered in our Books in the name of

_____ and we

now hold to_____ Order,_____ TONS PIG IRON,

of No._____ and we will deliver to_____ Order, by endorse-

ment hereon,_____ that quantity of Pig Iron, same Number and

Brand, on payment of the Charges noted at foot, and on return of this Warrant.

For the FURNESS RAILWAY COMPANY,

_____ Agent.

CHARGES—
Rent, One Penny per ton, per month of 28 days.
Rent to be paid every twelve months, and, if not paid
 when due, Interest @ 5 per cent., per annum, will
 be charged.
Stamped Warrants, 1/- each, for any weight of Iron.

Potatoes
PERISHABLE.
342—60,000—9—90.
THE FURNESS RAILWAYS.
Date 31/10/ 189 9
From *BASK-IN-CARTMEL*
To *Skipton Mid* Coy.
Via *L + M*
For *W A Procter*
No. of Wagon *1662* Owner *L*

1915/16 15,000 10/64.
O.S. 15019
SUGAR BEET 2 URGENT
LONDON & NORTH EASTERN RAILWAY.
Date
From
Sender's Name
To SELBY
Via
Consignee—YORKSHIRE SUGAR Co., Ltd.
Owner and Total
No. of Wagon Sheets

BRITISH RAILWAYS
THE RAILWAY EXECUTIVE
E.R.O. 48859
PIGEON TRAFFIC
TO

(231)
Great Northern Railway. *Bingham* Station.
THE ELECTRIC TELEGRAPH COMPANY.
No. 88 *Feb 22* 18 69
Received the following Railway Message :—
PREFIX *D.B.*
From Mr. *Chapman* *N. G.* Station,
To Mr. *Nicholson* *B. S.* Station

Send horse box next train horse waiting.
Reply.

Letter sent 9/50 train to M.C.

Received at 9 H. 50 M. 9 M. *RN*

Clerk in Charge of Telegraph Office

ABOVE LEFT
Wagon label, 92 x 97mm.

ABOVE
Wagon label, 103 x 126mm.

CENTRE LEFT
Window sticker (detail);
whole sticker, 102 x 150mm.

LEFT
Telegram, 218 x 172mm.

FACING PAGE

ABOVE LEFT
Wagon label, 76 x 110mm.

ABOVE RIGHT
Wagon label, 75 x 126mm.

RIGHT
Waybills and a consignment note.
The tip of the iceberg of the
documentation necessary for the
movement of goods. Different waybills
were required for the various categories
to be carried. A long distance run could
be over a number of company's
systems, in the originating company,
private owner or other companies'
wagons. Computation of moneys due to
individual companies was carried out
by the Railway Clearing House to
whom copies of all relevant documents
were sent.
A powerful argument for the grouping
and final unification of the railways.
Sizes (from top to bottom) 123 x
260mm; 145 x 191mm; 111 x 280mm;
210 x 250mm; 172 x 220mm; 150 x
293mm.

476 V 46 3,000 1/15.

GREAT NORTHERN RAILWAY.

Owner and No. of Wagon _50371_ Date_____ 191

er and No. of Sheets
and Undersheets

From LONDON King's Cross)

Marken **M. & G N.**

Via Peterboro,' Wisbech & South Lynn.

Contents ___VEG ETIES___

MANCHESTER, SHEFFIELD, AND LINCOLNSHIRE RAILWAY.

(291 a)

GRAIN. 86

Wagon No. _1075_ Under
Sheet No. _8720 18752_

Date _9 11 99_

From _Brigg_

To _Skipton Mid_
Sheffield

Contents _50 Hs Wheat_ For _W J Bairstow_

(29 a) (29 a)
GOODS.

Station, No. No.

185 . No.

BRISTOL AND EXETER RAILWAY.

Station, 185

Address.	Goods.	Tons. cwt. qrs. lbs.	Amount.		Name and Address of Consignee.	Goods or Cattle.	Tons. cwt. qrs. lbs.	Rate.	£ s. d.

Total - -

Conveyance of the above

ide,

Pounds

For the Bristol and

Mineral Way Bill.
238/5,000/8/1919.

No. _5_

NORTH BRITISH RAILWAY—COAL WAY-BILL.

FROM BLAIRADAM COLLIERIES.

To _Milnathort_ via

Per o'clock Train _4 - 2 - 19 03_ Arrived 19

(25)

LYNN AND FAKENHAM RAILWAY. Prog. No. _34_

PARCELS WAY BILL } From _Lynn_ Station. To _Aimslouth_ Station.

No _108_ } _3 20_ Train. Via _Aug 12_ 188_1_

FROM	FOR	No. of Articles	Description	Paid	Paid out	To pay	Reference to sheet or stock book
L Dolben			_Ma_				

Est. 926—1,000—3/28

MIDLAND & GREAT NORTHERN RAILWAYS JOINT COMMITTEE. Pro. No._____ ◇ 168C

No. 13.—Consignment Note for Carbide of Calcium, Calcium Phosphide, Zinc Phosphide, Calcium Silicide, Holmes' Patent Signal Lights, and the Water Light Company's Patent Marine and Land Lights (each and all of which are hereinafter referred to as Carbide of Calcium or allied traffics) when carried by Merchandise train.

THE MIDLAND & GREAT NORTHERN RAILWAYS JOINT COMMITTEE hereby give notice that they are not common carriers of Carbide of Calcium or allied traffics, and they do not undertake the carriage thereof except upon the terms of the following special Contract:—

150

SOUTH DEVON RAILWAY.

RECEIVING OFFICE WAY BILL.

PARCELS FORWARDED from _30 Torwood Street_ Office or Receiving House,

Tuesday , the _20_ day of _October_ 1863

at _6_ P M

	Consignor.	Consignee.	Article.	Paid out.	Paid.	Remarks.

Cleator and Workington Junction Railway.

LOCAL COAL, COKE AND OTHER MINERALS.

Way Bill No._____ From_____ To_____ Date_____ 19

Owners and Nos. of Wagons.	Total Number of Wagons.	Consign-ment Note No.	Sender.	Consignee.	Description.	Furness Wagons.		L. & N. W. Wagons.		J. S. Wagons.		C. & W. Wagons.		O. W.
						T.	C.	T.	C.	T.	C.	T.	C.	T.

THE ILLUSTRATED LONDON NEWS

REGISTERED AT THE GENERAL POST-OFFICE FOR TRANSMISSION ABROAD.

No. 2527.—VOL. XCI. SATURDAY, SEPTEMBER 24, 1887. TWO WHOLE SHEETS } SIXPENCE. By Post, 6½D.

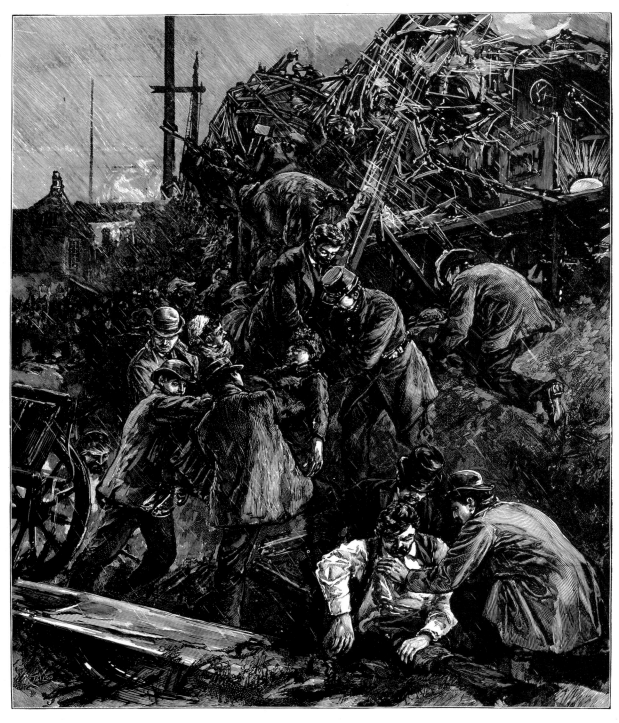

THE RAILWAY DISASTER AT HEXTHORPE, NEAR DONCASTER: EXTRICATING THE DEAD AND WOUNDED.

FROM A SKETCH BY AN EYE-WITNESS, MR. WALTER J. STUART.

Keeping things moving

'Behind each engine let there be second and third class carriages, so that, in the event of a smash, second and third class lives only would be sacrificed.
Let there be a van full of stokers before the first class carriages; for, as the directors appear to be liberal of the stokers' lives, it is presumed that every railway company has such a glut of them that they can be spared easily.
As some of the carriages are said to oscillate, from being too heavy at the top, let a few copies of 'Martinuzzi' be placed as ballast at the bottom'.
Punch, 1842.

LEFT
The nightmare.
Illustrated London News front page engraving 'The Railway Disaster at Hexthorpe'. 402 x 280mm, 1887.

BELOW
The dream.
Illustrated London News engraving.
'The Mail Train'.
Actual size, 1854.

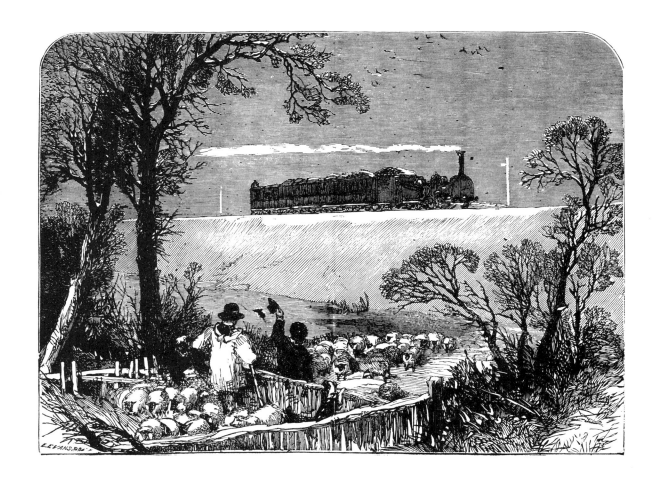

NEWCASTLE UPON TYNE AND CARLISLE
RAILWAY.

THE Directors of the Newcastle upon Tyne and Carlisle Railway Company announce to the Public, with deep Regret, that they are compelled to discontinue, for the present, the Use of Locomotive Engines. At the Time when this great Work, The Newcastle and Carlisle Railway, was originally projected, the Locomotive Engine was of rude Construction, and its practical Utility being doubtful, a Clause was inserted in the Act, prohibiting its Use. The Improvements, which have since taken Place in the Construction of those Engines, have removed all reasonable Objection to them; and have established the Fact, that no Railway can be enjoyed beneficially by the Public without the Use of the Locomotive Steam Engine. Under these Circumstances, the Directors determined to apply to the Legislature for the repeal of the Restrictive Clause, and, in the mean Time, with the Concurrence of the Land Owners, with one Exception, they have used Locomotive Steam Power on that Part of the Line which has been opened. One Individual insists upon the Prohibition being enforced against the Company, and has obtained an Injunction of the Court of Chancery for that Purpose. The Directors therefore have no Alternative but to give up the Use of the Railway, and wait the Result of their Application to the Legislature.

Newcastle upon Tyne, March 28, 1835.

Akenheads, Printers, Newcastle.

GREAT NORTHERN RAILWAY.

The **PUBLIC** is respectfully informed that in consequence of the Trains of the **GREAT NORTHERN RAILWAY COMPANY** having been prevented from proceeding to **LEEDS** by the **METHLEY JUNCTION,** they will run between **DONCASTER, WAKEFIELD, NORMANTON,** and **LEEDS,** by the **LANCASHIRE AND YORKSHIRE RAILWAY** as follows, until further Notice; and that in all other respects the Trains will correspond with the published Time Bills.

DOWN TRAINS.	1 1 2 3 Parlm	2 1 2 3 Parlm	3 1 2 3 Parlm	4 1 2	5 1 2 3 Parlm	6 1 2 3 Parlm	7	1 1 2 3 Parlm	2 1 2 3 Parlm
DONCASTER, arrival from BOSTON, LINCOLN, &c..	8 58	11 53	2 25	5 10	7 15	8 50	5 17
departure	7 45	9 5	11 35	2 10	5 20	7 35	8 25	5 20
Stockbridge	7 49	9 9	11 39	2 13	5 24	7 39	8 29	5 24
Askern	8 1	9 21	11 51	2 25	5 36	7 51	8 41	5 36
Norton	8 3	9 23	11 53	2 27	5 38	7 53	8 43	5 38
Womersley	8 11	9 31	12 1	2 34	5 46	8 1	8 51	5 46
KNOTTINGLEY, arrival	8 20	9 41	12 11	2 43	5 56	8 11	9 1	5 56
departure	8 23	9 43	12 13	2 45	5 58	8 13	9 3	5 58
PONTEFRACT	8 27	9 47	12 17	2 48	6 2	8 17	9 7	6 2
WAKEFIELD	8 55	10 15	12 45	3 15	6 30	8 45	9 35	6 30
LEEDS	9 35	10 55	1 25	3 55	7 10	10 15	7 10
NORMANTON	9 10
MANCHESTER	11 10	12 55	3 45	6 10	9 25	11 10	1 30	9 25

UP TRAINS.	1 1 2 3 Parlm	2* 1 2 3 Parlm	3 1 2	4* 1 2 3 Parlm	5* 1 2 3 Parlm	6* 1 2 3 Parlm	1 1 2 3 Parlm	2* 1 2 3 Parlm
LEEDS.........departure	5 20	8 30	11 0	1 35	4 45	7 0	10 0	7 0
NORMANTON	7 0	11 15	5 15
WAKEFIELD	7 10	9 10	11 40	2 15	5 25	7 40	10 40	7 40
PONTEFACT	7 36	9 41	12 11	2 43	5 56	8 11	11 11	8 11
KNOTTINGLEY	7 40	9 45	12 15	2 47	6 0	8 15	11 15	8 15
Womersley	7 50	9 56	12 26	2 57	6 11	8 26	11 26	8 26
Norton	8 1	10 6	12 36	3 7	6 21	8 36	11 36	8 36
Askern	8 3	10 8	12 38	3 9	6 23	8 38	11 38	8 38
Stockbridge	8 13	10 20	12 50	3 21	6 35	8 50	11 50	8 50
DONCASTERarrival	8 16	10 23	12 55	3 25	6 38	8 55	11 53	8 55
departure for BAWTRY, RETFORD, &c.	8 20	10 25	11 53	3 51	6 40	11 55

* 1st and 2nd Class only beyond Retford.

Superintendent's Office, Lincoln,
4th September, 1849.

BY ORDER,
JOHN DENNISTON.

ROBERT HARTLEY, PRINTER, HIGH-STREET, DONCASTER.

NEWCASTLE
AND
CARLISLE
RAILWAY.

THE DIRECTORS of the NEWCASTLE UPON TYNE AND CARLISLE RAILWAY have the liveliest Satisfaction in announcing that Mr Bacon Grey, yielding his legal Rights to the Feeling of the Public, in a Manner highly honourable to himself, has abandoned his Injunction by which the Company is restrained from using Locomotive Engines, and has withdrawn his Opposition to the Bill now before Parliament.

In Consequence of this satisfactory Arrangement the Use of the Railway will be resumed on WEDNESDAY FIRST, from which Day the Company's Trains of Carriages will set out at the Hours formerly announced, viz.:—From Blaydon and Hexham each Day at 8 and 11 o'Clock in the Forenoon, and 2 and 5 o'Clock in the Afternoon. For the present the Trains will not travel on Sundays.

MATTHEW PLUMMER,
CHAIRMAN.

Newcastle upon Tyne, 4th May, 1835.

Mitchells, Printers, Newcastle.

ABOVE LEFT
Stop!
Notice, 216 x 267mm, 1835.

ABOVE
Go!
Notice, 400 x 323mm, 1835.

BELOW LEFT
Stop and go!
Notice, 216 x 279mm, 1849.

All courtesy National Railway Museum

Bodmin and Wadebridge Railway.

No. 332 March 17th 1874

Mr. *Tippell*

1 Pint Cocoa to

Please to supply for the use of the
BODMIN AND WADEBRIDGE RAILWAY:

W. Such
W. Pendray
Thos. Werry
Thos. Bunney
J. Williams
J. Hicks
W. Knight
Jos. Grigg

H. Kyd
Supt.

also
1 Do Julian
J. Hewitt
Captn & Crew
5 pints

First sitting

One seat reserved in Restaurant Car

Please take this card (and your railway ticket) with you

Refreshment for workers and customers.

LEFT
Staff cocoa requisition memo.
Actual size, 1874.

BELOW
The East Anglian restaurant car services had the menus printed
daily.
215 x 140mm, 1935.
Courtesy Michael Brooks

BELOW LEFT
Restaurant Car ticket.
Actual size, c.1975.

RIGHT
Railway hotels had some of the finest restaurants in the United
Kingdom.
Printers' proof, 342 x 280mm, 1956.

MENU

NORWICH

LONDON AND NORTH EASTERN RAILWAY

Pompadour Restaurant

CARTE DU JOUR

LE DINER

CARTE DU JOUR

HORS D'ŒUVRE

Huîtres Natives (12)	18/6
Caviar (1 oz.)	18/6
Foie Gras (2)	32/–
Charcuterie Française	7/6
Saumon Fumé	7/6
Homard Marie Rose	7/6
Cocktail Florida	4/–
Thon à l'Huile	3/6
Pâté Maison	4/–
Saucissons au Choix	5/–
Cassolette de Crevettes	4/–
Jambon Fumé	8/6
Viande de Grison	7/6
Melon Glacé	3/6
Hors d'Œuvre Variés	3/6

POTAGES

Consommé Double, en Gelée	3/–
Petite Marmite	5/–
Tortue Verte Royale	5/–
Crème Reine, St. Germain, Aurore	3/–
Bisque d'Homard	4/–
Minestrone	3/–

ŒUFS

Brouillés, Variés	5/–
Pochés Washington	4/6
Cocotte Périgueux	4/6
Sur le Plat	4/6
Omelettes: au Choix	5/–

FARINEUX

Rizotto à l'Italienne	5/6
Ravioli Maison	5/6
Spaghetti Bolognaise	5/6
Nouilles au Parmesan	5/6

POISSONS

Truite Cleopatra	10/6
Sole Véronique	12/6
Sole Colbert	12/6
Délice de Sole Cubat	9/6
Délice de Sole May Wong	9/6
Turbotin Hollandaise	9/6
Julienne de Sole Murat	10/6
Demi Homard Froid	10/6
Homard Américaine (2)	21/6
Saumon d'Ecosse	12/6

ENTREES

Suprême de Volaille Maréchale	14/6
Poulet Sauté Chasseur	14/6
Ris de Veau Gastronome	10/6
Langue de Bœuf Florentine au Madère	8/6
Caneton Bigarrade (1)	14/6
Escalope Holstein	10/6
Côte de Porc Badoise	10/6
Tête de Veau Sauce Vinaigrette	8/6
Coq au Vin (2)	30/–

ROTIS

Poussin Polonaise (2)	20/–
Caneton à l'Anglaise (4)	60/–
Surrey au Lard (4)	50/–
Carré d'Agneau Persillé (2)	25/–
Gibier en Saison	

GRILLADES

Filet de Bœuf	14/6
Steak Vert Pré	12/6
Côtelette d'Agneau	12/6
Mixed Grill	12/6
Jambon Grillé Miroir	8/6
Chop d'Agneau	10/6
Porterhouse Steak (2)	35/–

BUFFET

Poularde, Dindonneau	12/6
Jambon de York	8/6
Côte de Bœuf	7/6
Langue Ecarlate	7/6
Ballottine de Porc	7/6
Volaille à la Gelée	12/6
Galantine de Poularde	7/6
Bœuf Pressé	7/6
Agneau	7/6

SALADES

Laitue, Panachée, Saison	3/–
Légumes	3/6
Française, Endives	3/–
Japonaise	4/–

LEGUMES

Petits Pois au Beurre	3/–
Petit Pois à la Française	3/–
Epinards en Branche	3/6
Haricots Verts Frais	3/6
Laitues Braisées	3/–
Chou-fleur Hollandaise	3/–
Carottes Vichy	2/6
Pommes Nature, Sautées, Purée, Frites	2/–
Champignons Sautés	3/6
Choux de Bruxelles	2/6
Endives au Jus	3/6
Céleris au Jus	3/–

ENTREMETS

Pêche Melba	4/–
Poire Belle Hélène	4/–
Macédoine de Fruits Frais	4/–
Coupe Georgette	4/–
Meringue Glacée Chantilly	3/6
Crème Caramel	3/–
Omelette Confiture	5/–
Crêpes au Citron	3/–
Omelette Surprise (2)	12/6
Soufflé au Chocolat (2)	10/6
Crème Double	2/–

SAVOURIES

Croûte Ivanhoe	3/–
Canapé Ecossaise	3/–
Champignons sur Pain Grillé	3/–
Croûte Galloise	3/–
Canapé Windsor	3/–
Beignets au Gruyère	3/–
Fromages Assortis	2/–
Fruits de Saison	

Caledonian Hotel, Edinburgh

Wages cheque caption: MARYPORT AND CARLISLE RAILWAY COMPANY.

№ 2133 · Maryport, 14th March 1912.

The London Joint Stock Bank Limited
MARYPORT

Pay to Wages, Week ending 10th instant.

the sum named below on the Receipt being presented through a Banker, duly signed and dated

Thos. Blain SECRETARY CHAIRMAN

Received from the MARYPORT AND CARLISLE RAILWAY COMPANY

the sum of Five hundred and fifteen pounds, six shillings and two pence

in discharge of account as per particulars furnished

Signature
Date 14 MA

C £515.6.2. Cashier. 191

HEAD OFFICE: 5 PRINCES STREET, LONDON E C

G. F. 678.

MIDLAND RAILWAY.

———

NOT TO BE UNLOADED ON THIS SIDE.

He giveth and he taketh away.

Failure to shunt with care or unload on the correct side would render an employee liable to a deduction from wages under the Truck Act.

ABOVE
Wages cheque, 151 x 208mm, 1912.

LEFT
Wagon label, 120 x 167mm, c.1910.

BELOW
Wagon label, 75 x 305mm, 1921.

RIGHT
Circular, 290 x 180mm, 1897.

T. 821 1/4539 50,000 24/11/21

SHUNT WITH CARE

Great Northern Railway.

Circular 141 S.

TRUCK ACT, 1896.

In accordance with the Truck Act, 1896, Notice is hereby given, that the Company reserve the right to impose the following fines in respect of the acts or omissions mentioned below, and to deduct from the wages of their servants, and to retain the sums that may be imposed as fines :—

1. For inattention whilst on duty, absence from duty without leave, coming late on duty, leaving duty before proper time or before being relieved, coming on duty without proper rest, or otherwise unfit for duty, permitting relief by men unauthorised or unfit for duty

2. For insubordination or non-observance of the lawful orders of a superior officer, or for the use of abusive or offensive language whilst on duty, or for the wilful misrepresentation or suppression of facts in a verbal or written report, or for failing to report irregularities or accidents

2s. 6d.

3. For incivility or want of proper courtesy or attention to Passengers or other members of the public

4. For negligence or misconduct by which damage or delay is, or may be, caused to trains or traffic

5. For negligence or misconduct by which loss is, or may be, caused to the Company, or by which damage or injury is, or may be, caused to luggage, parcels, animals, goods, or traffic, or to engines, vehicles, machines, signals, lamps, or other property of the Company

5s.

6. For negligence or misconduct whereby danger or risk of danger is, or may be, caused to human life

10s.

For a repetition of any of the above offences the fine may be doubled.

This notice cancels all previous notices.

HENRY OAKLEY,

GENERAL MANAGER.

King's Cross, August 16th, 1897.

No rails . . . no railway.

ABOVE
Crow Mills viaduct, Midland Railway.
Illustrated London News, 124 x 238mm, 1852.

BELOW
'Railway train in the snow' (site unspecified).
Illustrated London News, 164 x 232mm, 1854.

Mainly maintenance.

ABOVE RIGHT
Engineer's combined inspection engine and coach.
Postcard, actual size, 1905.

BELOW RIGHT
'Railway Equipment; a series of 50'.
Cigarette cards, actual size, 1937.

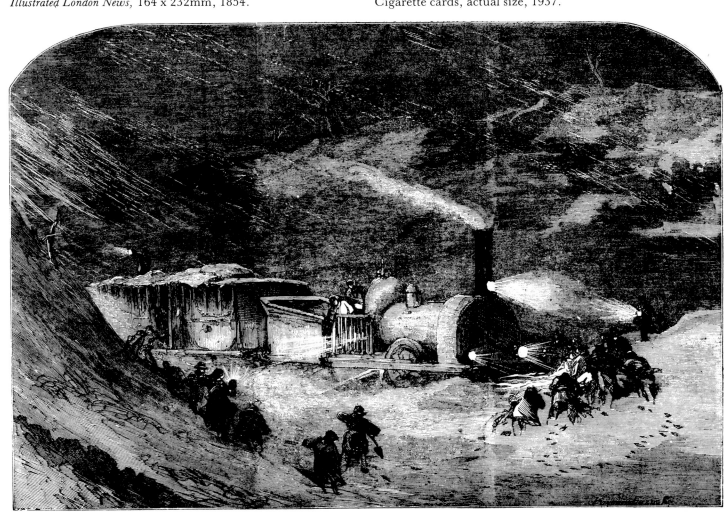

ENGINEER'S INSPECTION ENGINE AND COACH.

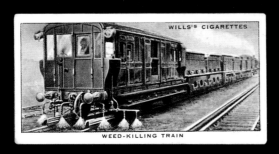
GANGER'S MOTOR TROLLEY

CORRECTING TRACK ALIGNMENT

MECHANICAL TRACK LAYER
AT WORK

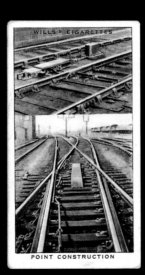
POINT CONSTRUCTION

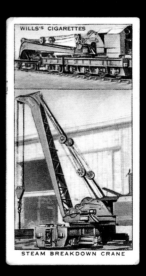
STEAM BREAKDOWN CRANE

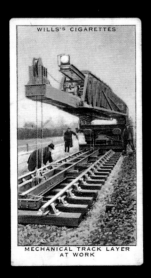
WEED-KILLING TRAIN

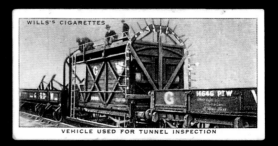
VEHICLE USED FOR TUNNEL INSPECTION

[1779]

THE GREAT NORTHERN RAILWAY.

ENGINEER'S OFFICE, *Peterbro'*

Memorandum to *Mr. J. O. Rhodes* *24th June* 1869
Bingham

Sir,

Referring to your letter of the 23rd inst.

I will send a man to attend to the sink. With respect to the Copper, I cannot do other than maintain without an order — I have sent your letter on to Mr. Johnson.

Yours obediently

C. M. Ogilvie

228 Aldermister Gd
Bermondsey
S.E.

Mr. Thompson,

Dear Sir, *March 20th 1905*

The roof upstairs in back room lets water in very bad; also washouse roof leaks bad. The hinges of the doors want repairing, in a bad condition. One door upstairs has fallen completely off. *Yours Truly, T. B. Eley*

MR C. E. MERCER
22 MAR 1905

DISTRICT RAILWAY.

NOTICE.

In the absence of the Ladies' Waiting Room Attendant the Station Inspector is authorised to look in occasionally to see that no improper use is made of this room.

(BY ORDER.)

MANAGERS OFFICE
St James Park Station S.W.

More maintenance.

ABOVE
Memorandum, 127 x 204mm, 1869.

LEFT
Postcard, 90 x 140mm, 1905.

BELOW
Prevention being better than cure.
Notice, 90 x 120mm, 1901.
Courtesy Jeffrey Spence

FACING PAGE
Dos and dont's

ABOVE LEFT
Notice, 228 x 284mm, 1879.

ABOVE RIGHT
Notice, 338 x 211mm, 1877.

CENTRE LEFT
Notice, 406 x 279mm, c.1910.

BELOW LEFT
Notice, 220 x 344mm, c.1900.

BELOW RIGHT
Press notice, actual size, 1887.

London and North Western and Great Western Joint Railways.

CAUTION.

JOHN SMITH, Bookmaker, 22, Primrose Street, Manchester, and JOHN WOOD, Carver and Gilder, 37, High Street, Macclesfield, were brought before the Magistrates at Chester, on the 27th ultimo, charged with PICKING-POCKETS at the General Railway Station, Chester, and were convicted and sentenced to THREE MONTHS' IMPRISONMENT WITH HARD LABOUR, and to PAY the COSTS OF THE COURT, or, in default, to be FURTHER IMPRISONED WITH HARD LABOUR FOR ONE MONTH.

SHREWSBURY,
5th MARCH, 1879.

BUNNY & DAVIES, PRINTERS, 25, HIGH STREET, SHREWSBURY.

GREAT WESTERN RAILWAY.

CAUTION.

THROWING STONES AT TRAINS.

A Man was tried at the Gloucester Assizes on the 1st inst., for Throwing Stones at a Train near Lawrence Hill Station, and being Convicted was Sentenced to Six Months Imprisonment with hard labor.

J. GRIERSON,
GENERAL MANAGER.

PADDINGTON STATION,
August 1877.

NORTH EASTERN RAILWAY

Smoking Strictly Prohibited.

DÉFENSE DE FUMER.

Rygning Strenkt Forbudt.

SE PROHIBE EL FUMAR.

禁喫烟

RÖKNING STRÄNGT FÖRBJUDET.

RØKNING FORBUDT.

КУРИТЬ СТРОГО ВОСПРЕЩАЕТСЯ.

RAUCHEN STRENGSTENS VERBOTEN.

ΑΥΣΤΗΡΩΣ ΑΠΑΓΟΡΕΒΕ ΤΑΙ ΤΟ ΚΑΠΝΙΣΜΑ

STRENGVERBODEN TE ROOKEN.

Severmente Prohibito d' Fumare.

MIDLAND RAILWAY COMPANY.

NOTICE.

Tenants are requested not to deposit Refuse on the Roadways.

Bemrose & Sons, Limited, Printers to the Company.

LEGAL HINTS FOR RAILWAY TRAVELLERS.

No Passenger can be convicted of any offence

1.—Who travels without having first paid his Fare and obtained a Ticket, (Dearden v. Townshend).

2.—Who having paid his Fare is unable to produce his Ticket, (Jennings v. G. N. Railway.)

3.—Who loses his Ticket, (Chilton v. London and Croydon Railway).

4.—Who refuses to show his Ticket, except before, or when travelling on the railroad, and not afterwards at the barrier, (Brown v. G.E.R., Sanders v. S.E.R.)

5.—Who travels in a carriage of a superior class to that for which he has paid his Fare, (Bentham v. Hoyle, Dyson v. L. & N.W.R.)

without proof of intention to defraud;

6.—No Passenger can be seized or detained (Baron Martin says for the 100th part of a minute), (Tollemache v. L. & S.W.R.) for a Breach of a Bye-Law, unless power is expressly given by Statute 8 and 9 vict., cap. 20. s. 154.

7.—No Passenger is compelled to give his name and address, until it is proved that he has committed an offence, 8 and 9 Vict, cap. 20, s. 154.

8.—Lost Property found by the Company is to be delivered up by them free of charge (G.W.R. and Met. Railway Co., v. Emanuel; Dimsdale v. L. and B. Railway, 3. F. and F. 167.)

9.—No proceedings can be taken to recover a Fare, until the Company have demanded the specific sum due, which need not be TENDERED (Brown v. G.E.R.)

10.—Any Servant of the Company, offending against any of the Bye-Laws, Rules, or Regulations, may be seized and conveyed, without Warrant or Summons, before a Magistrate, and by him be imprisoned for two months, or fined ten pounds (3 and 4 Vict. c 97, s. 13.

11.—It is a Breach of a Bye-Law to start a Train until search has been made amongst those wishing to travel to see who have the priority of the journey, and until due payment of Fares has been made to those who are left behind.

12.—To seize and detain illegally is both a criminal assault, and liable to heavy damages for false imprisonment (Eastern Co., Railway v. Broom, Goff v. G.N.R., Moore v. Met. Railway Co.)

13.—Railway Companies overcrowding their carriages, are liable in damages for Breach of Contract and Trespass, (Yetts v. L. & S.W.R.—See *Times*, Sept. 17th 1886, p. 5, column f.)

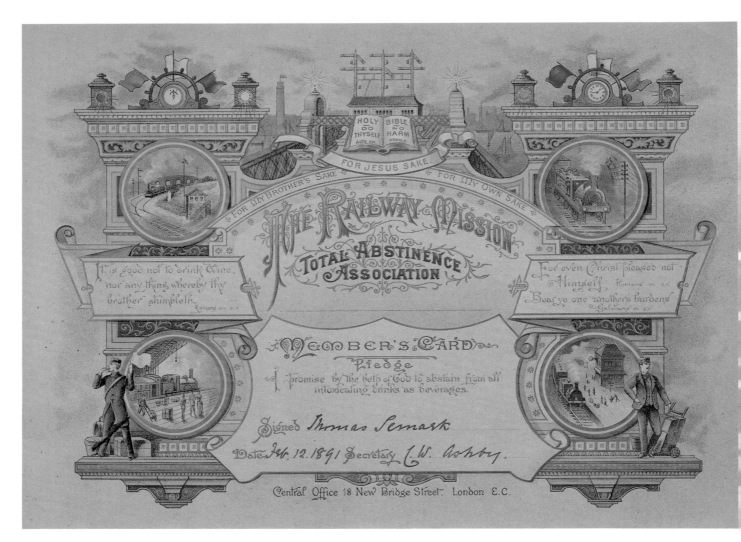

The war on alcoholism.

ABOVE
Member's card, 215 x 295mm, 1891.
Courtesy Roy Chambers

The wars on Germany.

BELOW
Carriage card, 260 x 610mm, 1917.

FACING PAGE

ABOVE LEFT
4pp leaflet cover, 132 x 110mm, 1917.

ABOVE RIGHT
Booklet cover, 330 x 204mm, 1939.

BELOW
Poster, 1006 x 1263mm, 1943.

WARNING!

DEFENCE OF
THE REALM.

Discussion in Public
of Naval and Military
matters may convey
information to the
Enemy.

**BE ON YOUR
GUARD.**

South Eastern and Chatham Railway.

PASSENGERS TO LOWER BLINDS.

During the period between half an hour after sunset
and half an hour before sunrise, Passengers in Railway
Carriages running on the Sections of the Line
scheduled at side hereof must keep the blinds
lowered so as to cover the windows.

The blinds may be lifted in case of necessity, when
the Train is at a standstill at a Station; but, if lifted,
they must be lowered again before the Train starts.

Lines to which this
Order applies.

GRAVESEND and PORT VICTORIA.
FAVERSHAM and RAMSGATE HBR.
QUEENBOROUGH and LEYSDOWN.
MINSTER, RAMSGATE and MARGATE.
MINSTER and DOVER.
KEARSNEY and DOVER.
SANDLING JUNC., FOLKESTONE JUNC.
and HARBOUR.
SANDLING JUNC. and SANDGATE.
APPLEDORE, LYDD, NEW ROMNEY and
DUNGENESS.
APPLEDORE and HASTINGS.
CROWHURST and HASTINGS.
CANTERBURY WEST and WHITSTABLE
HARBOUR.

T.C.S. 1.

CODE
USED IN DESPATCHING

TELEGRAPH MESSAGES

UPON

RAILWAY COMPANIES' BUSINESS.

Special Codes
in connection with the movement of
Government Traffic.

The following additions to the Pamphlet of Special Codes, dated 9th August, 1915, operate as from 1st September, 1917.

H. CUFF SMART,.

Secretary.

RAILWAY CLEARING HOUSE,

August, 1917.

N. EVAC 3.

LONDON & NORTH EASTERN RAILWAY

NORTH EASTERN AREA

EVACUATION OF CIVIL POPULATION

FROM

NEWCASTLE

AND

GATESHEAD

IN THE EVENT OF AN EMERGENCY

DETAILS OF

DETRAINING ARRANGEMENTS AND INSTRUCTIONS

EVACUEES FROM EACH SCHOOL

ENTRAINING AND DETRAINING STATIONS

WITH TIMES OF DEPARTURE AND ARRIVAL

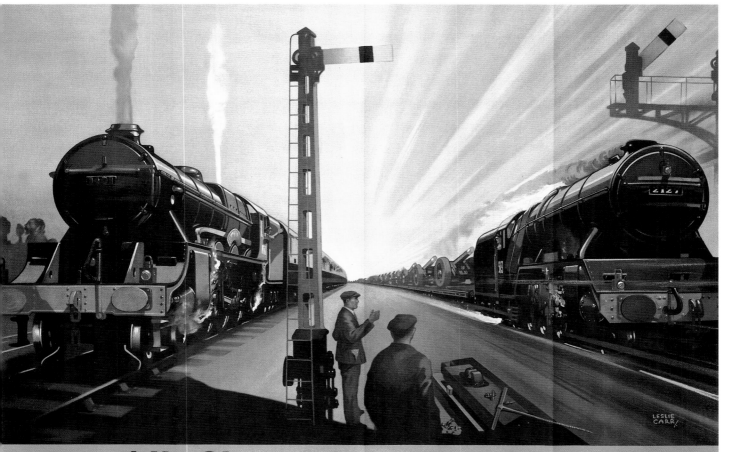

All Clear for the Guns
ON
BRITISH RAILWAYS

LOST

On the Rail Road between Preston and Birmingham, on Friday, 9th of September,

A LARGE
PORTMANTEAU,

of Black Leather, with a Painted Cover, marked in white letters "*G. Puzzi,*" and on the Portmanteau itself a Brass Plate engraved "*G. Puzzi,*" containing a white leather Portfolio, with Trinkets and Jewellery, and a variety of Papers; also a large quantity of Wearing Apparel and Linen marked with the initials "G. P." Also the amount of 150 New Sovereigns, and a quantity of Silver, the amount not exactly known. Among the Trinkets was a large Gold Seal, marked with a double " P."

Whoever will give information of the above loss to Mr. WALTER, 56, Davies Street, Berkeley Square, London, that will lead to the recovery of the Property---or if Stolen, the conviction of the Offender or Offenders---shall be most handsomely Rewarded.

Septr. 15, 1842. London: Wm. Davy, Printer, Gilbert-st., Oxford-st.

Lost. . . .

Contrasting personal disasters.

LEFT
A treasure chest.
Notice, 187 x 222mm, 1842.
Courtesy Ephemera Society

BELOW
A week's housekeeping money?
Inquiry form, 170 x 215mm, 1870.

. . .and found.

RIGHT
Live game and umbrellas.
Lost property book, Market Bosworth, Ashby and Nuneaton Joint Railway.
374 x 232mm, 1884.

[No. 59.]

No._____ Lancashire and Yorkshire Railway Company. *Janry 5th 1870*

ESPECIAL INQUIRY FROM *Ramford Junction* STATION.

To Mr. *Sutton* of *Wigan* _____ Station,

for Mrs. *Widdow* _____ Luggage,

Consisting of *A brown purse containing about eleven shillings supposed to be left in a third class carriage or dropped on the platform at Victoria*

Directed *ml.*

Passenger per *12 = 20 pm* Train *Janry 5th 1870*

from *Manchester* to *Liverpool*

☞ WHEN FOUND FORWARD TO *Ramford Junction H Hindle*

☞ Replies to be written across.

170

Date	Number of Train.	Number of Article.	Description of Article.	By whom Found.
17 Oct 23		1	Blot Conty live Duck	Ex Nuneaton

January 1884

1	1884 Jany Jany 7 64	1	Black Box. addressed Mr Carson Bridge of allan with brown leather strap round it, marked on top in large white letters B.C. & bearing Cal. Co's label "Coventry from Bridge of Allan"	Ex Nuneaton

April 1884.

2.	Aplr 18.	1	Rug Trunk. tied in one bundle.	Ex Heather.
3	„ 29	1	Macintosh	Ex Ashby
4	May 14	1	Umbrella & gur Let	In Booking Hall
5	June 16	1	Dark colored anilla umbrella with bone hook	Ex Nuneaton
6	June 17	1	Dark brown umbrella	found in 8/39 am June 17
		1	Black alpaca	
7	July 31.	X	Umbrella with white hazel stick in hook marked W R on handle.	found in Booking Hall.

September 1884.

8	Sept 3.	1	Carpet Bag	Ex Gloucester.

October 1884
Nil

November 1884.

Nov 8	10 40 am	1	Hare.	found in 3d class carriage, of 10 10 am

December 1884

9		1	Tin Box.	Ex Faint Hill
10.		1	Small blue cardboard box.	Ex Suarestone.
11		1	Tin Box & Bag	Ex Nuneaton

Something to celebrate

'*The lumb'ring stage scarce yielded pride of place*
To swifter transit against time to race;
The white-wing'd spirit, Steam, with bridle rein'd,
Not yet its proud supremacy had gained,
Nor girdled earth with countless bands of steel
That weld the nations in one common weal.
This new enchantment science now had wrought,
The seal of Royal favour fain besought,
And thus the Sov'reign's pleasure 'twas to test
The "marvel of the age" at its behest.
And straightway o'er the line the message sped,
The honour'd roll PHLEGETHON *proudly led,*
And hist'ry tells how this red-letter'd day
A "Royal train" first spann'd the iron way!
No regal pageant deck'd the simple scene,
Or stately splendour hail'd the coming Queen;
Nay, half in secret — lest a people's prayers
Importune prudence and foretell their fears —
(For in these early days the multitude
with wond'ring awe the fiery monster view'd)
In fairest flower of youth She came to grace
This latest triumph over time and space!'

N.E. Stilus, *Railway Magazine*, 1901.
'In Memoriam — Victoria', Slough to Paddington, June 13, 1842.

RIGHT
Notice, 430 x 339mm, 1855.

BELOW
Great Eastern Railway locomotive
decorated for the wedding train of
King Edward VII when he was the
Prince of Wales in 1863.
Colour plate supplement to the
coronation issue of the
Locomotive Magazine. 217 x 380mm,
1902.

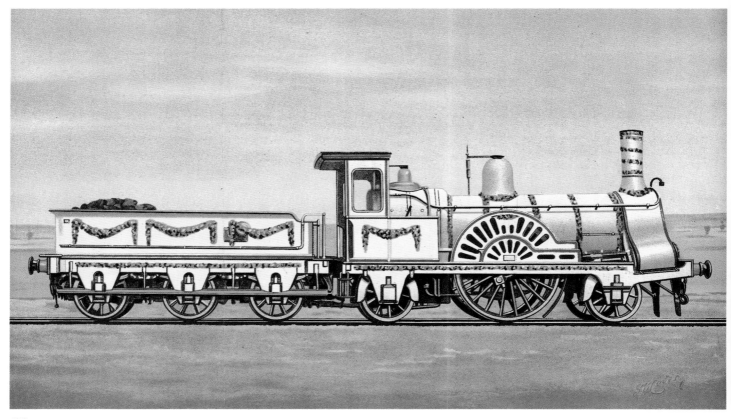

EAST GRINSTEAD.

OPENING THE
RAILWAY!

On the arrival of the quarter-past One o'Clock Train, the Officials will proceed to the Crown Inn, headed by a

BAND OF MUSIC,

WHERE A

COLD COLLATION WILL BE PROVIDED.

CHAIR TO BE TAKEN AT HALF-PAST ONE O'CLOCK.

TICKETS, 2s. 6d. each, to be had at the Bar.

☞ The INHABITANTS of the TOWN and NEIGHBOURHOOD are especially invited to be present.

A PROFESSIONAL SINGER,

FROM LONDON, IS ENGAGED FOR THE OCCASION.

Refreshments will also be provided on a piece of Ground near the Railway Terminus, by Mrs. Head & Son.

EAST GRINSTEAD,
JULY 5TH, 1855.

PRINTED AT THE OFFICE OF J. SMITH, EAST GRINSTEAD.

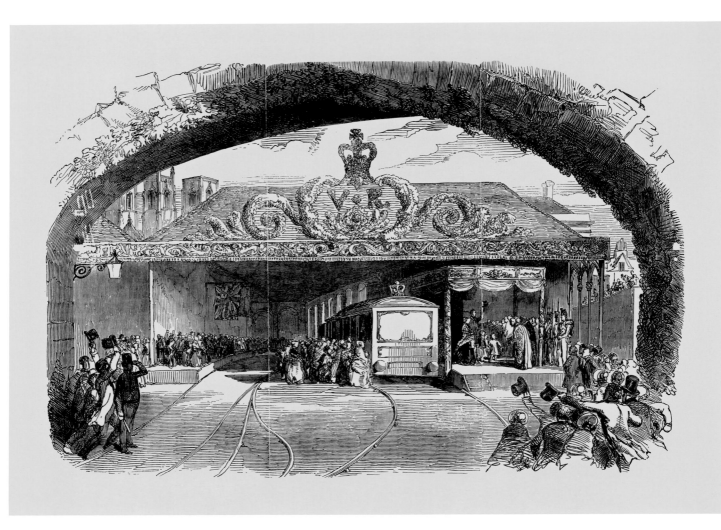

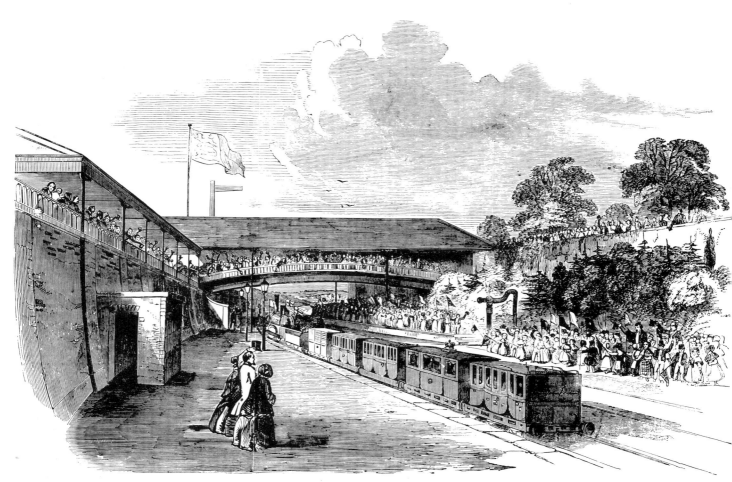

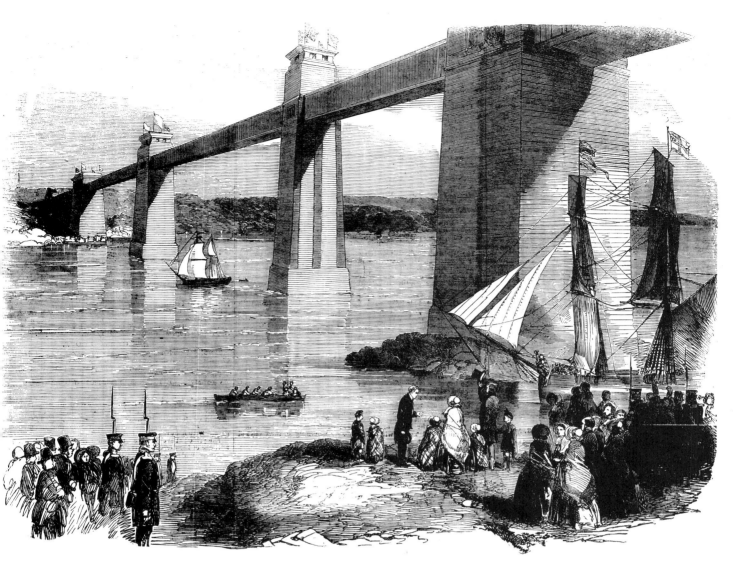

FACING PAGE

A royal progress; the return of the court from the Highlands.

ABOVE
Presentation of the address to Queen Victoria at York station. The artist had problems with the trackwork.
148 x 220mm, 1849.

BELOW
Leaving Cheltenham station.
149 x 230mm, 1849.

THIS PAGE

Her Majesty's visit to the Chester and Holyhead Railway's Britannia tubular bridge.

ABOVE
The royal party on site.
172 x 230mm, 1852.

BELOW
Prince Albert, the Prince of Wales and Robert Stephenson on the roof of the bridge.
Actual size, 1852.

Engravings: *Illustrated London News*

LONDON AND NORTH WESTERN RAILWAY.

ARRANGEMENT OF CARRIAGES
COMPOSING
THEIR MAJESTIES' TRAIN
From EUSTON to BALLATER,
ON FRIDAY, THE 27TH, AND SATURDAY, THE 28TH SEPTEMBER, 1901.

	GUARD.	FOR MEN SERVANTS.	FOR MEN SERVANTS.	DRESSERS AND LADIES' MAIDS.	THE PRINCE AND PRINCESS OF CORNWALL AND YORK.	PRINCESS VICTORIA OF WALES. HON. CHARLOTTE KNOLLYS.	Their Majesties The King and Queen.	CAPT. HON. SEYMOUR FORTESCUE. LIEUT.-COL. DAVIDSON. HON. H. STONOR.	DIRECTORS.	DIRECTORS.	GUARD.
ENGINE.	VAN. No. 210.	CARRIAGE No. 870.	SALOON. No. 72.	SALOON. No. 73.	SALOON. No. 59.	SALOON. No. 50.	Royal Saloons Nos. 131 and 153.	SALOON. No. 56.	SALOON. No. 180.	CARRIAGE No. 306.	VAN. No. 272.

< 511 feet >

McCorquodale & Co., Limited, Cardington Street, London.

ABOVE
Card, 185 x 305mm, 1901.

BELOW
4pp folder, 248 x 163mm, 1928.

GREAT WESTERN RAILWAY.

TIME TABLE
FOR
The Journey of Their Majesties the King and Queen of Afghanistan From Paddington to Swindon
On Wednesday, March 21st, 1928.

FORWARD JOURNEY.

DISTANCE FROM PADDINGTON	STATIONS.		TIMES.
Miles.			
—	PADDINGTON	dep.	1.30 P.M.
24¼	MAIDENHEAD	pass	1.57 P.M.
36	READING	,,	2.10 P.M.
53	DIDCOT	,,	2.28 P.M.
77¼	SWINDON (Station)	,,	2.54 P.M.
77¼	SWINDON (Carriage Works)	arr.	2.55 P.M.

RETURN JOURNEY.

DISTANCE FROM SWINDON WORKS.	STATIONS.		TIMES.
Miles.			
—	SWINDON (Locomotive Works)	dep.	4.15 P.M.
¾	SWINDON (Station)	pass	4.17 P.M.
25	DIDCOT	,,	4.42 P.M.
42	READING	,,	5.1 P.M.
53¾	MAIDENHEAD	,,	5.16 P.M.
78	PADDINGTON	arr.	5.45 P.M.

FELIX J. C. POLE,

PADDINGTON STATION. General Manager.

خط آهن غربی کبیر

فهرست حرکت موکب همایونی اعلیحضرتین پادشاه و ملکه افغانستان
روز چهارشنبه ۲۱ مارچ ۱۹۲۸
از ایستگاه پادنگتون به سوندون

مسافت از پادنگتون	ایستگاه	وقت
میل	پادنگتون حرکت	۳-۱
۲۴¼	میدین هد عبور	۱-۵۷
۳۶	رایدینگ	۲-۱۰
۵۳	دیدکوت	۲-۲۸
۷۷¼	سوندون (ایستگاه)	۲-۵۴
۷۷¼	سوندون (فابریک ارابه سازی)	۲-۵۵

فهرست مراجعت

مسافت	ایستگاه	وقت
	سوندون (فابریک لوکوموتیف سازی)	۴-۱۵
¾	سوندون	۴-۱۷
۲۵	دیدکوت	۴-۴۲
۴۲	رایدینگ	۵-۱
۵۳¾	میدین هد	۵-۱۶
۷۸	پادنگتون	۵-۴۵

مدیر کل فلیکس ج. س. پول

ایستگاه پادنگتون

(*c*) Another competent Engineer's man must also, if practicable, be stationed on the top of the tunnel at each ventilating shaft at least one hour before the Royal Train is due to pass, and remain until re-called by the man stationed at the end of the tunnel from which the Royal Train has emerged.

30. (*a*) The Engineer will arrange for men to be stationed along the railway on the outside of the road upon which the Royal train is passing, at intervals of about a quarter of a mile, and patrol the line, each man taking say, one-eighth of a mile in each direction and meeting his neighbour, so that, in the event of anything happening, such as goods falling from passing trains, any obstruction would certainly be noticed and removed as soon as possible, or the line protected. Each opening of all under-bridges must be examined by the patrols as they pass these structures. The men should take up their position **AN HOUR** before the train is due, and remain until it has passed, to see that everything is in proper order. Each man should be provided with a red and green flag—both of which should be kept rolled up—or, where necessary, with a hand lamp properly trimmed and lighted. Neither flags nor hand lamp must be exhibited to an approaching train except for the purpose of signalling to a driver in case of emergency. Each man should also be provided with six detonators, and at tunnels with a hand lamp properly trimmed and lighted.

Patrolling the line.

(*b*) In case of fog, platelayers appointed as fogmen must go to their posts, and the patrolling of the line and the manning of occupation crossings must be done as far as possible by spare men.

Fogmen.

31. The public must be excluded, as far as possible, from the Company's premises, unless they are there on business.

Stations to be kept private.

32. *The Servants of the Company are to perform the necessary work on the platforms without noise, and no cheering or other demonstration must be allowed.*

Stations to be kept quiet.

33. Permanent Way, Signal and Telegraph Inspectors, and Signal and Telegraph Linesmen should be stationed at their Headquarters, or at the most important point on the route, and be on duty at least one hour before and half an hour after the passing of the Royal train.

Permanent way, &c., inspectors and signal, &c., linesmen.

Behind the scenes.

The logistics of moving a royal train involved virtually all the company staff employed along the route. This 16pp booklet was issued by the Great Central Railway for the Banbury to York section of a royal journey from Windsor to Fencehouses. Actual size, 1913.

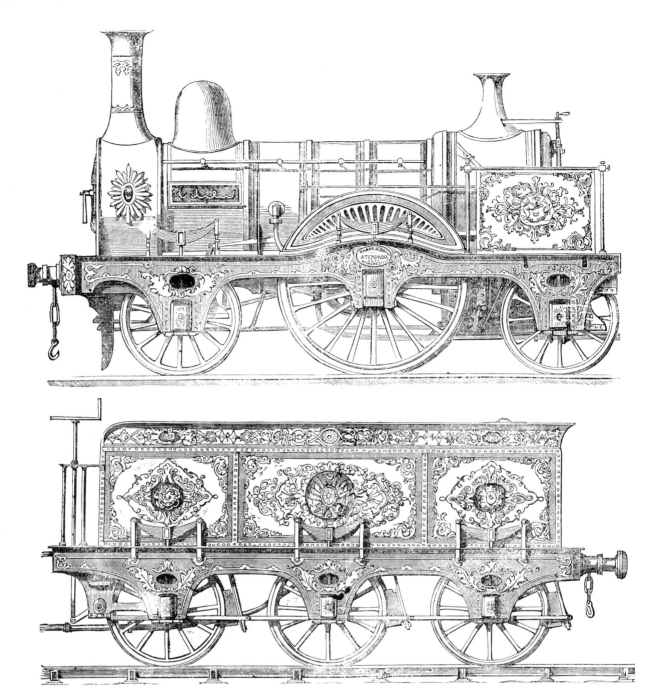

ABOVE

A celebration in locomotive building.
Illustrated London News.
Actual size, 1856.

The caption reads: 'We engrave the express
locomotive engine and tender, constructed by
Messrs. Sharp, Stewart, and Co., of the Atlas
Works, Manchester, for the Pasha
of Egypt. The decorations are accurately
delineated; but the engine in particular
is further ornamented by the substitution
of polished brass hoops, splashers and
general mountings, for the ordinary iron
ones. The name, written in Egyptian
letters is SAÏDIA.'

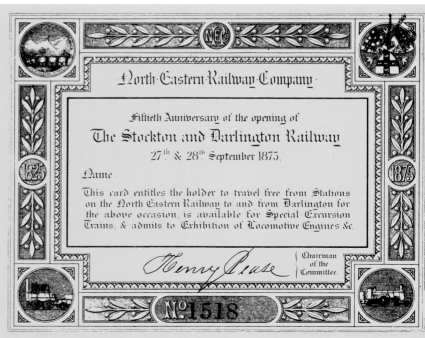

North·Eastern·Railway·Company·

Fiftieth Anniversary of the opening of

The Stockton and Darlington Railway

27th & 28th September 1875.

Name

This card entitles the holder to travel free from Stations
on the North Eastern Railway to and from Darlington for
the above occasion, is available for Special Excursion
Trains, & admits to Exhibition of Locomotive Engines &c.

Henry Pease Chairman
 of the
 Committee.

No. 1518

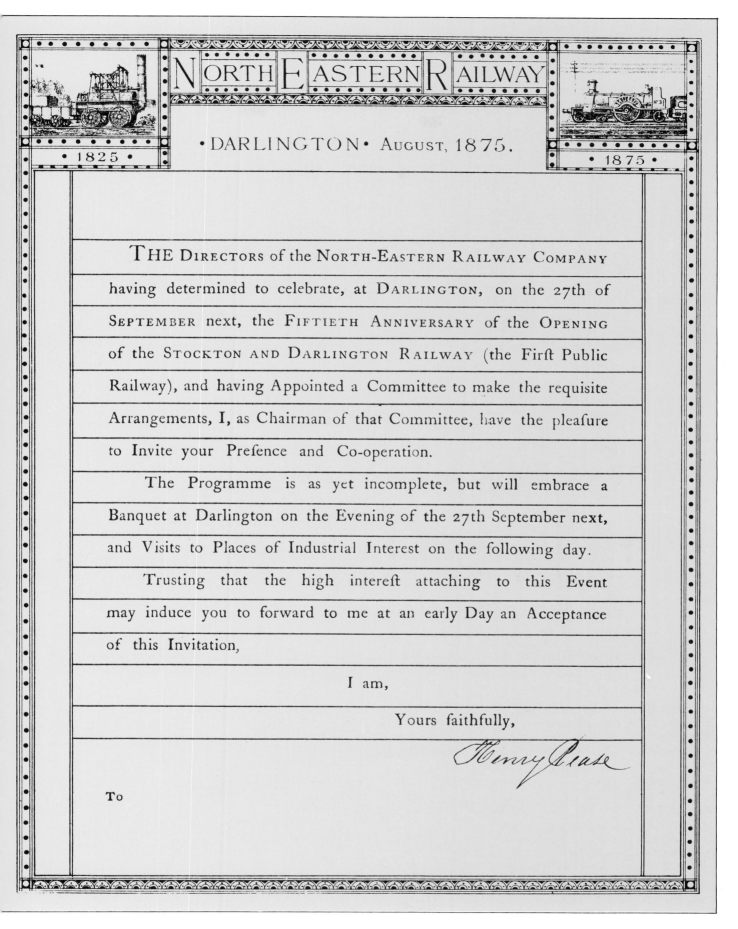

NORTH EASTERN RAILWAY

•DARLINGTON• AUGUST, 1875.

•1825• •1875•

THE DIRECTORS of the NORTH-EASTERN RAILWAY COMPANY having determined to celebrate, at DARLINGTON, on the 27th of SEPTEMBER next, the FIFTIETH ANNIVERSARY of the OPENING of the STOCKTON AND DARLINGTON RAILWAY (the Firſt Public Railway), and having Appointed a Committee to make the requisite Arrangements, I, as Chairman of that Committee, have the pleaſure to Invite your Preſence and Co-operation.

The Programme is as yet incomplete, but will embrace a Banquet at Darlington on the Evening of the 27th September next, and Visits to Places of Industrial Interest on the following day.

Trusting that the high intereſt attaching to this Event may induce you to forward to me at an early Day an Acceptance of this Invitation,

I am,

Yours faithfully,

Henry Pease

To

Most of The Stockton and Darlington Railway 50th anniversary celebration literature carried two thematic illustrations: appropriately 'Locomotion' which hauled the train on the opening day with, oddly, the Great Northern company's 'Single' express engine to represent 50 years of progress.

ABOVE
Invitation folder, actual size, 1875.

FACING PAGE BELOW
Free travel ticket to and from Darlington from stations on the North Eastern Railway.
110 x 140mm, 1875.

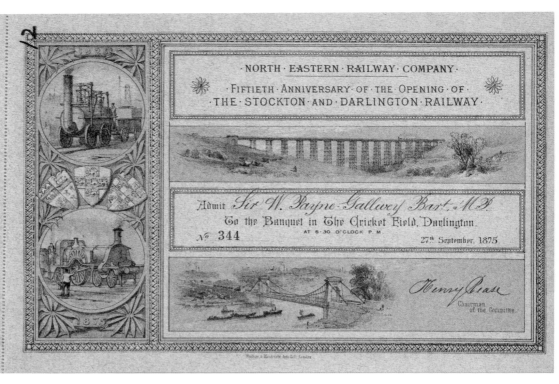

Stockton and Darlington Railway 50th anniversary.

ABOVE
Admission card, 170 x 327mm.

BELOW LEFT
Fireworks programme (leaflet), 219 x 140mm.

BELOW
Special train arrangements card with reception seating plan on the reverse side. Actual size.

NORTH - EASTERN RAILWAY.

FIFTIETH ANNIVERSARY OF THE OPENING OF THE STOCKTON AND DARLINGTON RAILWAY.

PROGRAMME OF

FIREWORKS

(By Messrs. C. T. Brock & Co., Pyrotechnists to the Crystal Palace),

IN A FIELD ADJOINING VICTORIA ROAD,

MONDAY, SEPTEMBER 27th, at 10 p.m.
TUESDAY, SEPTEMBER 28th, at 8 p.m.

1—Salute of 50 Ærial Maroons.
2—Illumination by 50 large Crystal Palace Lights.
3—Revolving Devices and Cloud of Jewels and Stars discharged from 25 Shells.
4—Special Device, The No. 1 ENGINE.
5—Batteries of Saucissons.
6—Revolving Wheels, 16 feet in diameter.
7—Discharge of 50 Half-pound Rockets.
8—Six Revolving Fountains, with Coloured Jets.
9—Flight of 20 Parachutes, with Flashes of Magnesium.
10—Ascent of Balloons, with Magnesium Lights, discharging Stars, and finishing with a fall of Shooting Stars.
11—Grand display of Crystal Palace Shells, specially to exhibit every colour known to Pyrotechny.
12—Flight of Fiery Pigeons.
13—Ascent of Gas Balloon, with Coloured Fireworks.
14—Set Piece—The Globe and Star.
15—Batteries of Mines of Serpents.
16—Special Device—The ENGINE of 1875.
17—Batteries of Saucissons.
18—Flight of Silver Tourbillons, or Fiery Whirlwinds.
19—Flight of Twinkling Stars.
20—Batteries of 100 Roman Candles.
21—Discharge of Magnesium Shell 8 inches in diameter.
22—Great Cascade of Silver Fire.
23—Batteries of Silver Saucissons.
24—Grand finale Girandole of 600 large Coloured Rockets.

NORTH-EASTERN RAILWAY. /8

Special Train arrangements for Railway Anniversary at Darlington, on the 27th and 28th September, 1875.

MONDAY, SEPTEMBER 27th.

The 10 A.M. Scotch Express from King's Cross, timed to leave York at 2.35 P.M., will stop at Darlington for Passengers from South of York only.

Special Trains will run to Darlington as follows :—

From West Hartlepool at 10.25 A.M. From Newcastle at noon
„ Leeds „ 10.30 A.M. „ South Shields „ „
„ York „ 11.0 A.M. „ Sunderland „ 12.15 P.M.

Note—Invitation tickets will not be available by the South Express leaving Newcastle at 1 35 P.M.

In the evening, Special Trains will be run from Darlington as under, viz.:—

Time.	Station from.	DESTINATION.
10 15 P.M.	Bank Top	Ripon, Harrogate, and Leeds.
10 30 „	Do.	Durham and Newcastle.
10 45 „	Do.	Sunderland and South Shields.
11 0 „	Do.	York and intermediate Stations.
11 15 „	Do.	Croft and Richmond Branch.
11 0 „	North Road	Shildon, Bishop Auckland, and Crook.
11 0 „	Do.	Preston Junction and Hartlepool.
11 15 „	Do.	Gainford, Barnard Castle, and Middleton-in-Teesdale
11 35 „	Do.	Stockton, Middlesbro', Guisbro', Redcar, and Saltburn.

TUESDAY, SEPTEMBER 28th.

Special Trains will run as under :—

Time.	Station from.	DESTINATION.
11 20 A.M.	Darlington, North Road	Stockton, Middlesbro', Redcar, & Saltburn.
1 30 P.M.	Middlesbro'	Redcar and Saltburn.
3 45 „	Saltburn	Redcar, Middlesbro', Stockton, & Darlington.
9 30 „	Darlington, North Road	Shildon and Bishop Auckland.

Guests, upon this occasion, can travel by the above, or by the ordinary trains announced in the Company's Time Bill.

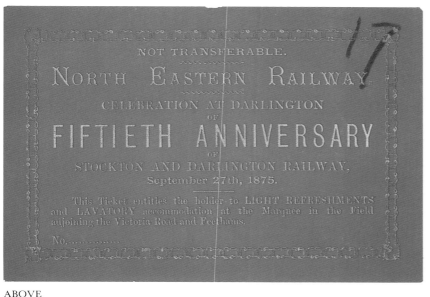

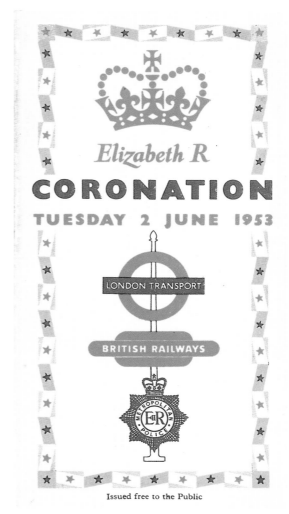

ABOVE

Stockton and Darlington Railway 50th anniversary.
Refreshment and lavatory card, actual size.

BELOW

Stockton and Darlington Railway centenary.
Programme cover, 212 x 140mm, 1925.

BELOW RIGHT

Stockton and Darlington Railway 150th anniversary.
Programme cover, 210 x 148mm, 1975.

ABOVE RIGHT

Folder cover; route map and special arrangements.
Open sheet size: 449 x 577mm, 1953.

Issued free to the Public

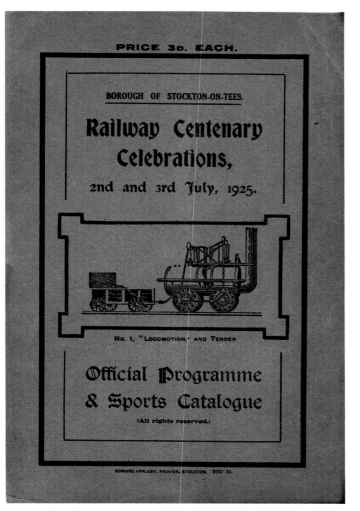

CENTENARY CELEBRATIONS. L.M.S. RAILWAY. LIVERPOOL. SEPTEMBER, 1930.
"LION" & REPLICA COACHES. LIVERPOOL & MANCHESTER RAILWAY. 1830.

ABOVE
Souvenir booklet.
The introduction made claim to being
the oldest line in the U.K.
Actual size, 1904.

BELOW
Liverpool and Manchester Railway
Centenary; the oldest 'true' railway?
Postcard, actual size, 1930.

FACING PAGE
Metropolitan Railway Centenary, the
oldest underground railway.
Concertina folder, actual size, 1963.

UNDERGROUND RAILWAY

CENTENARY

PARADE

The Public are respectfully informed that on

Thursday 23 May

100 YEARS OF UNDERGROUND RAILWAY TRAVEL WILL BE CELEBRATED AT

NEASDEN

by a **GRAND PARADE** of some

STEAM & ELECTRIC LOCOMOTIVE ENGINES

Passenger Carriages and Miscellaneous Rolling Stock

1863 | 1963

The content of **PROGRAMME** is as follows:—

[1] Locomotive No 23 and [7] A stock
contractors wagons [8] Pre 1938 tube stock

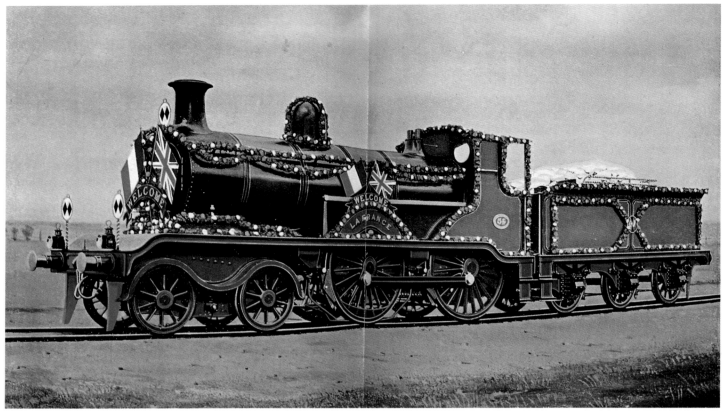

ABOVE

London Brighton and South Coast
Railway locomotive 'La France'
decorated for a special Pullman train
conveying officers and men of the
French fleet, 146 x 215mm, 1905.
Colour supplement, *Locomotive
Magazine.*

BELOW

War or no war, some things demanded
ceremonial treatment.
Programme folder, 222 x 165mm, 1942.
Courtesy Michael Brooks

FACING PAGE

Menu cover, actual size, 1937.

THE PENINSULAR & ORIENTAL STEAM NAVIGATION COMPANY

In 1837, The Peninsular Steam Navigation Company secured their first contract for the carriage of Mails between England and Ports of the Spanish Peninsula.

In 1840, under Royal Charter "Oriental" was added to the Company's name and an agreement made to extend the Mail Service to Egypt and India, Southampton then became the established Port of the P. & O.

H.M. Government made the Port of Brindisi the exclusive route for Mails about 1880-1881, when Southampton ceased to be the Mail Port of the P. & O. Company.

The Port of Southampton prior to the outbreak of war was, however, regularly utilized by departures for the Far East and by some thousands of passengers embarking and disembarking during the Cruising Season by the P. & O. vessels.

The P. & O. House Flag, reproduced on the engine, dates back to the founding of the Company or indeed before that, to the little sailing ships run by the founders to the Ports of Spain and Portugal. In the insurrection against the Queen of Portugal, and later in the Carlist rising against the Queen of Spain, the founders of the P. & O. gave every possible assistance to the party of the Royal Houses. In recognition of this they adopted as their flag the Royal Blue and White of Portugal, diagonally quartered with the Red and Yellow of Spain.

The other engines of this class will be named as under, each bearing a replica of the House Flag of the Shipping Line concerned. They have been chosen by reason of their association with Southampton Docks, which are owned and managed by the Southern Railway. No. 1 "Channel Packet," No. 2 "Union Castle," No. 3 "Royal Mail," No. 4 "Cunard White Star," No. 5 "Canadian Pacific," are already in service.

Aberdeen & Commonwealth
Orient
Shaw Savill
Blue Star

The tenders of these
engines were made at
Ashford works.

SOUTHERN
MIXED TRAFFIC LOCOMOTIVES
"Merchant Navy" Class

Naming Ceremony
OF
"P. & O."
AT
ASHFORD (Kent)
Thursday, 4th June, 1942
BY
Sir William Currie
Chairman
The Peninsular & Oriental Steam Navigation Company
accompanied by Southern Railway Chairman, Mr. R. Holland Martin, and
General Manager, Mr. E. J. Missenden

MENU

THE CORONATION
THE FIRST STREAMLINE TRAIN
KING'S CROSS FOR SCOTLAND

LINER

GREAT NORTHERN RAILWAY.

TRANSMISSION OF GREENWICH TIME BY ELECTRIC TELEGRAPH.
Circular No. 2855a.

NOTICE.

The correct time will be transmitted over the various circuits constituting the Great Northern Telegraphic System at 10.0 a.m. daily (Sundays excepted).

At two minutes before that hour all communications must cease.

The forwarding Stations will move the Needle slowly to the left and right. Spell the word "time," then hold the Needle permanently over to the left, until 10.0 a.m. then signal the word "ten."

The clocks must be immediately regulated.

When from any electrical defect the time signal is not received from Greenwich, the words "*No Current*" must be transmitted by each forwarding Station, and a record of the circumstance must be kept in the Telegraph Clerk's Diary, or in the remarks column of the Signalman's Block Telegraph Book, at both the forwarding and receiving Stations.

King's Cross Office (K C) will receive time from the Central Telegraph Station, and forward it on the Retford, Hitchin, Wood Green and High Barnet Circuits.

King's Cross Goods Office (K G) will receive time from King's Cross, and transmit it on the Peterboro' Circuit.

King's Cross, West Box (B X) will receive time from King's Cross, and transmit it on the Barnet (Main Line) and Alexandra Palace Circuits.

King's Cross East Box (U B) will receive time from King's Cross, and transmit it on the Holloway South Circuit.

Finchley will receive time from King's Cross, and transmit it on the Edgware Circuit.

Finsbury Park (Box 4) will receive time from King's Cross, and transmit it on the Finsbury Park (Box 1) Circuit.

Wood Green South will receive time from King's Cross, and transmit it on the Enfield and Hatfield North Circuits.

Barnet South will receive time from King's Cross, and transmit it on the Welwyn Circuit.

Hatfield South will receive time from King's Cross, and transmit it on the Hertford and Dunstable Circuits.

Hatfield North will receive time from King's Cross, and transmit it on the Sandy North Circuit.

Welwyn will receive time from King's Cross, and transmit it on the St. Neot's North Circuit.

Hitchin Office will receive time from King's Cross, and transmit it on the Peterboro' and Cambridge Circuits.

St. Neot's South will receive time from Hatfield North, and transmit it on the Langford and Westwood Circuits.

Sandy South will receive time from Welwyn, and transmit it on the Peterboro' North Circuit.

Huntingdon South will receive time from Hitchin, and transmit it on the Crescent Junction Circuit.

Holme will receive time from Sandy South, and transmit it on the Ramsey Circuit.

Crescent Junction will receive time from Sandy, and transmit it on the Werrington Junction Circuit.

Peterboro' Office will receive time from King's Cross, and transmit it on the York, Grantham North, Essendine North, Doncaster (via Loop), Grimsby and Spalding Circuits.

Essendine South will receive time from Peterboro' and transmit it on the Stamford and Sleaford Circuits.

Essendine North will receive time from Peterboro' and transmit it on the Grantham Office Circuit.

Grantham Office will receive time from King's Cross, and transmit it on the Nottingham, Bingham, Newark North, Newark South and Boston (No. 2) Circuits.

Newark South will receive time from Peterboro' and transmit it on the Stathern and Melton Circuits.

Retford Office will receive time from King's Cross, and transmit it on the Newark Junction, Newark South, Grantham, Dove Junction, Doncaster Office, Rossington, York and Bradford Circuits.

The end

'*The Ministry of Transport with its army of two-thousand-a-year men, has been trying desperately hard to justify its existence; all it has done has had exactly the opposite effect. One has only to read its proposals for the future of the railways to find one's self unconsciously muttering the late Lord Fisher's pitiless phrase, "Sack the lot."*''

H.J. Jennings, *The Fortnightly Review*, 1920.

HOUSE OF COMMONS.—WEDNESDAY.
MR. HUDSON.

Mr. HUDSON complained of the allusions made with respect to him last night by Mr. Duncombe, and particularly because no notice had been given to him of the intention of making such allusions. He had never tampered with any member of the House, and on his honour he denied the charge. He was charged with disgorging, but that was merely by a legal construction. His position was morally right, but legally wrong; and he defied anyone to show anything against him, from his cradle to the present hour. He had enjoyed the confidence of the world, but he now experienced the bitterness of the reverse. He was ready to unravel everything, and he courted inquiry. The press was against him; he had been the subject of vituperation; but he had the consolation to know that all the works which he had projected or promoted were successful, and he would leave to posterity to do him justice. If money had been his sole object, he could, with the power which he had, have accumulated money to any amount. The honourable member was deeply affected.

The House adjourned at five minutes to one o'clock.

ABOVE RIGHT
End of a tycoon.
George Hudson, the Railway King's speech in the House of Commons as reported by the *Illustrated London News*. Actual size, 1854.

RIGHT
End of a bridge.
The Tay bridge disaster as seen by *Penny Illustrated*.
220 x 180mm, 1879.
Courtesy John Lewis

FACING PAGE
End of time chaos.
Circular, 330 x 200mm, 1881.

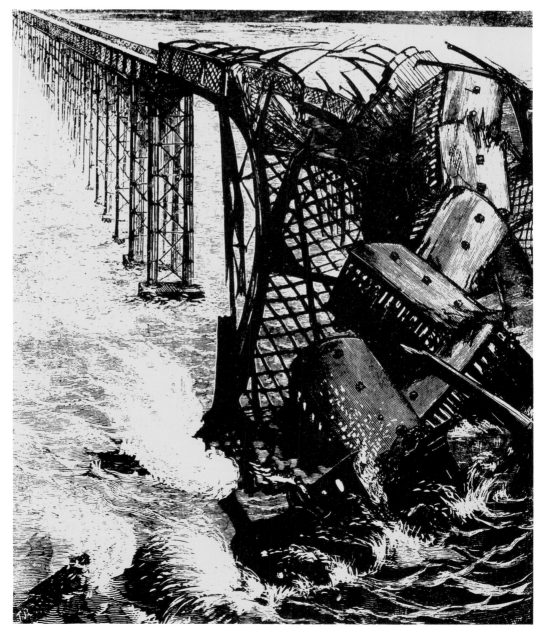

London Brighton and South Coast Railway.

SEPTEMBER TRAIN SERVICE, 1890.

CLOSING OF
CENTRAL CROYDON STATION

On and from **Monday, September 1st, 1890,**
THE
CENTRAL CROYDON STATION

will be entirely closed, and at the same time the Trains now running to and from Central Croydon will not be continued beyond New Croydon, to and from which latter Station the same service of London Brighton and South Coast, London and North Western, and Great Eastern Companies' Trains, will still be given exactly as shown in the Time Books and Time Bills in force up to and including September 30th, 1890.

(By Order) **A. SARLE,**

LONDON BRIDGE TERMINUS,
August, 1890.

Secretary and General Manager.

5,000—12-8-90. Waterlow and Sons Limited, Printers, London Wall, London.

ABOVE
End of steam locomotive building.
Booklet, 210 x 139mm, 1960.

ABOVE RIGHT
End resting place.
Booklet, 216 x 140mm, 1956.

CENTRE RIGHT
End of steam.
Combined entrance, special train and all day travel ticket. Folder, 80 x 100mm, 1971.

BELOW RIGHT
End of a train...
...containing a satchel pocket into which a series of views of the town are folded.
Postcard, 88 x 143mm, 1912.
Courtesy Amoret Tanner

FACING PAGE
End of a station.
Notice, 330 x 210mm, 1890.

GREAT WESTERN RAILWAY.

NOTICE

OF THE

CONVERSION OF GAUGE

ON THE

MINEHEAD RAILWAY.

THE LINE FROM NORTON FITZWARREN JUNCTION TO MINEHEAD

WILL BE PARTLY CLOSED

On MONDAY, the 30th October, 1882,

For the purpose of conversion from the Broad to the Narrow Gauge, and on that day only one Passenger Train will be run in each direction at the following times :—

Down.			P.M.	Up.			P.M.
Taunton	1 50	Minehead	2 10
Norton Fitzwarren...		...	1 55	Dunster	2 20
Bishop's Lydeard	2 13	Blue Anchor	2 31
Crowcombe...	2 37	Washford	2 44
Stogumber	2 51	Watchet	3 0
Williton	3 15	Williton	3 15
Watchet	3 30	Stogumber	3 30
Washford	3 46	Crowcombe	3 43
Blue Anchor	3 59	Bishop's Lydeard	4 5	
Dunster	4 10	Norton Fitzwarren	...	4 20	
Minehead	4 20	Taunton	4 25

On Tuesday, 31st October,

The Ordinary Service of Passenger Trains will be run as per published Time Tables.

NOTICE AS TO GOODS TRAFFIC.

Intending senders of Goods, Coal, or Mineral Traffic to Stations between Norton Fitzwarren and Minehead are requested to take notice that, between the 26th October and 2nd November inclusive the delivery of such Traffic cannot be effected.

No heavy Goods Traffic will be received from the Public at any of the Stations between Bishop's Lydeard and Minehead inclusive, after Thursday, the 26th October, until Friday, the 3rd November ; and no Goods Traffic of any description will be received from the Public at those Stations after 10.0 a.m. on Saturday, 28th October, until Tuesday, 31st October, at 12.0 noon.

All Goods remaining in Trucks at the above-named Stations at 12.0 noon on Friday, the 27th October, will be unloaded at the Consignees' risk.

J. GRIERSON,

General Manager.

PADDINGTON,
23rd October, 1882.

LEFT
End of the broad gauge.
Circular, 346 x 213mm, 1882.

RIGHT
End of a railway.
Advertisement, 290 x 170mm, 1960.

BELOW RIGHT
End of a branch line.
Commemorative cover,
100 x 230mm, 1971.

BELOW
End of an engine.
Poster, 1066 x 606mm, 1927.

Messrs.

THOS. W. WARD LTD

Celebrated and Widely Esteemed

DEALERS IN SCRAP METAL

take Considerable Pride in Announcing that they
have been Entrusted with an Undertaking of Uncommon Magnitude
viz. the Dismantling of the World-Renowned

MUMBLES RAILWAY

this being indisputably the Oldest Railway Line in the World
for the Conveyance of Ladies and Gentlemen of Quality.

There being certain Items, which some may consider to be of
Historical Interest, the Company is prepared to consider sympathetically
Requests for such from Museums, Societies and like Bodies.

THOS. W. WARD LTD

Established 1878

DISMANTLERS TO INDUSTRY

Head Office: Albion Works, Sheffield. *London Office:* Brettenham House, W.C.2

G.P. Misc. 4.

See the last of an old Friend!

"GLADSTONE" (1882)

is to be preserved in
S. Kensington Museum.

To-day she is in

No. 12 Platform

with the

"LORD NELSON" (1926)

Britain's most powerful passenger engine.

Inspect them both!

Admission 3d.

(devoted to Railway Orphanage. Woking.)

BRITISH RAILWAYS

NORTH EASTERN REGION

THIS CERTIFICATE records that on the occasion of your retirement the Area Board and Management desire to congratulate you upon the completion of years' employment, and wish you health and happiness in your retirement.

They also wish to place on record their high appreciation of the service which you have rendered to the railways and to the public during that period.

General Manager

Head of Department

District Officer

End of a career.
Retirement certificate, 305 x 240mm, 1955.

Index

Aberdeen: 117.
Accidents: 39, 156.
Accident insurance: 121.
Accident prevention: 43, 67.
Account (invoice): 110.
Ackermann: 62.
Adams, W.: 58, 64.
Admission card: 180.
Advertisements: 70, 71, 87, 88, 90, 98, 119, 120, 123,
 143 (ticket), 191.
A.E.C.: 99.
Air Services: 97.
Aldington, C.: 47.
Anniversaries: 178, 179, 180, 181.
Application form: 139.
Apprenticeship indenture: 36.
Arrol, W.: 104.
Ashby and Nuneaton Joint Railway: 171.
Associated Society of Locomotive Engineers and
 Firemen: *Frontispiece.*
Athenaeum (Leicester): 34.
Atlas works: 178.
Austin Wood, Brown: 88.
Australasian Pacific Mail Steam Packet Company:
 23.
Aylesbury Railway: 24.

Bailey, E.H., RA: 35.
Baker Street and Waterloo Railway: 81.
Battle Station: 107.
Beaconsfield: 98.
Beeton's Young English Woman: 116.
Bennet and Rosher's patent carriage: 67.
Bermondsey: 103.
Bewick, Thomas: 82.
Birkenhead and Manchester Railway: 149.
Birmingham: 9, 10, 11, 107.
Birmingham and Derby Railway: 15.
Birmingham and Gloucester Railway: 15.
Birmingham Station: 101, 107.
Blackie & Co.: 66.
Blackmore, Captain: 93.
Blackwall Station: 107.
Blairadam Collieries: 155.
Board of Trade: 16.
Bodmin and Wadebridge Railway: 160.
Booklets: 11, 21, 29, 42, 61, 76, 78, 91, 95, 96, 109,
 113, 117, 118, 120, 121, 141, 169, 177, 181, 182,
 189.
Bookmark: 108.
Boston, Sleaford and Midland Counties Railway: 17.
Bouch, Thomas: 104, 106.
Bradshaw, George: 126, 127.
Brandling Junction Railway: 30, 146.
Brandon: 27.
Breakdown crane: 165.

Brentford: 72.
Brighton and Continental Steam Packet Company:
 93.
Bristol and Birmingham Railway: 128.
Bristol and Exeter Railway: 129, 155.
Bristol and Gloucester Railway: 15.
Bristol and North Somerset Railway: 19.
Britannia tubular bridge: 175.
British Rail: 91, 109, 119, 133, 141, 144, 145, 154,
 160, 161, 181, 189, 192.
British Railways (war grouping): 169.
British Transport Commission: 189.
Brixton extension of Victoria Line: 28.
Broad gauge: 13, 54, 55, 190.
Broadsheet: 54, 55.
Bromyard: 33.
Brown, Marshall & Co.: 66.
Brunel, I.K.: 13, 14, 15, 23, 54, 55.
Brunel, Sir M.I.: 21.
Buffet car: 77.
Bury, Curtis and Kennedy: 52.

Cab inspector: 44.
Calais: 95.
Calais-Douvres: 95.
Caledonian Hotel: 161.
Caledonian Railway: 128, 150.
Caledonian, West Cumberland and Furness Railway:
 11.
Calendar: 149.
Call of share receipts: 18, 19.
Cambrian Railway: 13.
Car card: 28.
Card cut-out: 81.
Cards: 22, 41, 176, 180, 181.
Carmarthen: 32.
Carriage building: 78, 79.
Carriage fittings: 70.
Carriage heating: 65, 70.
Carriage notices: 80, 168.
Carriage works: 78, 79.
Carriers, (goods): 146, 148, 149.
Cartouches: 114, 119, 120.
Caslon: 2, 38, 66, 82, 84.
Cassel's maps: 119.
Cattle wagons: 84, 85.
Centenaries: 62, 181, 182, 183.
Central Croydon Station: 188.
Central London Railway: 112.
Certificates: *Frontispiece:* 111, 168, 192.
Chaldron wagons: 82.
Chancery Lane Station: 112.
Charabanc: 98.
Cheadle (Staffordshire) Railway: 33.
Cheltenham and Great Western Union Railway: 15.
Cheltenham Station: 174.
Cheshire Lines Committee: 128, 145, 150.
Chester and Birkenhead Railway: 18.
Chester and Holyhead Railway: 126, 175.
Cheque: 162.
Churchward, G.J.: 47.

London and South Western Ry.
787 TO WORPLEDON
Queen's Road

London and South Western Ry.
787
From WATERLOO TO
Rushey Platt

London and South Western Ry.
787
FROM WATERLOO TO
ST. KEW HIGHWAY

Strikes: 40, 41.
Superannuation fund: 47.
Swansea and Mumbles Railway: 182, 191.
Swindon Works: 189.

London and South Western Ry.
From WATERLOO TO
Tipton St. John's

Tariff (dining car): 76.
 (Midland Grand Hotel), 109.
Tay Bridge: 104, 105, 187.
Telegram: 154
Telegraphic code: 169.
Thames tunnel: 21.
Theatre bill: 48.
Thompson, J. & I., 146.
Tickets: 24, 28, 29, 77, 130, 136-145, 151, 160, 178,
 189.
Tilt Bridge: 108.
Time bill: 122.
Timetables: 26, 31, 94, 97, 123, 124, 125, 126, 127,
 158, 176, 180, 190.
Totmonslow: 33.
Tottenham Court Road Station: 112.
Track laying: 165.
Trade card: 56.
Trafalgar (Greenwich): 96.
Train arrangements card: 180.
Train ferries: 93, 94, 95.
Transfer certificate: 16.
Transfer, coat of arms: 6.
Travelling bag: 116.
Troops by railway: 10.
Truck Act: 163.
Tunnel Inspection: 165.
Tunnels: 4, 5, 21, 22, 100.
Tynedale tourist guide: 118.

London and South Western Ry.
From TO
Umberleigh

Uniforms: 43, 44, 45, 46, 49.
Union Bank of London: 111.

London and South Western Ry
WORPLESDON TO
VAUXHALL

Vale of Neath Railway: 54, 55.
Viaducts: 102, 103, 164.
Victoria (Pullman car): 68.
Victoria Line: 28.
Victoria Station, Norwich: 27.

Wages: 46, 47, 162.
Wagon labels: 153, 154, 155, 162.
Walschaert's valve gear: 60.
Wapping: 21.
War: 168, 169.
Ward, T.W. Ltd.: 191.
Warrant (pig iron): 153.
Watercress beds: 102.
Waterloo Station: 76.
Water pick-up apparatus: 56.
Waveney Valley Railway: 12.
Waybills: 150, 155.
Wearmouth: 30.
Wedding train locomotive: 172.
Weed killing train: 165.
Weedon: 10.
Weekly holiday season tickets: 77.
Wells: 27.
Westbourne Park: 72.
Westinghouse brake: 56.
West London Railway: 4.
Wharncliffe viaduct: 102.
Wheelbarrow (ceremonial): 19.
White Hart Inn, Aylesbury: 24.
White's Leeds directory: 88.
Widows and orphans fund: 47.
Window stickers: 75, 154.
Wirral Railway: 20, 144.
Wishaw and Coltness Railway: 122.
Wolverton works: 36.
Wymondham: 27.

London and South Western Ry.
FROM WATERLOO TO
YEALMPTON

Yealmpton: 33.
York and North Midland Railway: 136, 141, 142.
York carriage and wagon works: 78, 79.
York, Newcastle and Berwick Railway: 136, 141.
York Station: 174.

Editor's Note
*The following railway companies, appearing in the text
and/or illustrations, are indexed under individual titles.*

Acknowledgements

My first debt of gratitude must go to Grizelda
and John Lewis without whose constant
encouragement this book would never have
materialised.

I would particularly like to thank the following
individuals (in alphabetical order) who have
unstintingly helped with information and/or
loan of material: Michael Brooks, Sylvia
Calvert, Roy Chambers, Leslie Horrocks of
Beaconsfield Historical Society, Maurice
Rickards and the Ephemera Society, John
Schroder, Jeffrey Spence and Amoret Tanner.

Reproductions from public collections are
acknowledged in the caption to the illustration.

Finally I must show my appreciation to Peter
Greenhalf for his photographic skills in copying
some very difficult originals.

The Antique Collectors' Club

The Antique Collectors' Club was formed in 1966 and now has a five figure membership spread throughout the world. It publishes the only independently run monthly antiques magazine *Antique Collecting* which caters for those collectors who are interested in widening their knowledge of antiques, both by greater awareness of quality and by discussion of the factors which influence the price that is likely to be asked. The Antique Collectors' Club pioneered the provision of information on prices for collectors and the magazine still leads in the provision of detailed articles on a variety of subjects.

It was in response to the enormous demand for information on ''what to pay'' that the price guide series was introduced in 1968 with the first edition of *The Price Guide to Antique Furniture* (completely revised, 1978 and 1989), a book which broke new ground by illustrating the more common types of antique furniture, the sort that collectors could buy in shops and at auctions rather than the rare museum pieces which had previously been used (and still to a large extent are used) to make up the limited amount of illustrations in books published by commercial publishers. Many other price guides have followed, all copiously illustrated, and greatly appreciated by collectors for the valuable information they contain, quite apart from prices. The Antique Collectors' Club also publishes other books on antiques, including horology and art reference works, and a full book list is available.

Club membership, which is open to all collectors, costs £17.50 per annum. Members receive free of charge *Antique Collecting,* the Club's magazine (published ten times a year), which contains well-illustrated articles dealing with the practical aspects of collecting not normally dealt with by magazines. Prices, features of value, investment potential, fakes and forgeries are all given prominence in the magazine.

Among other facilities available to members are private buying and selling facilities, the longest list of ''For Sales'' of any antiques magazine, an annual ceramics conference and the opportunity to meet other collectors at their local antique collectors' clubs. There are over eighty in Britain and more than a dozen overseas. Members may also buy the Club's publications at special pre-publication prices.

As its motto implies, the Club is an organisation designed to help collectors get the most out of their hobby: it is informal and friendly and gives enormous enjoyment to all concerned.

For Collectors — By Collectors — About Collecting

The Antique Collectors' Club, 5 Church Street, Woodbridge, Suffolk

REAR ENDPAPER
'Express'. Card game, 1945/6.
Card size: 58 x 88mm.

H30 871 961 8

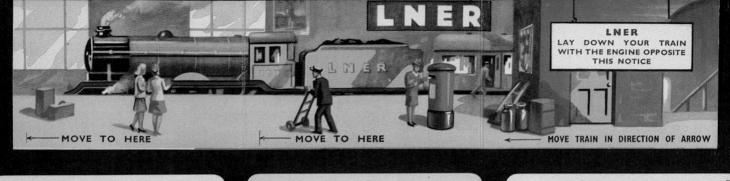

← MOVE TO HERE ← MOVE TO HERE ← MOVE TRAIN IN DIRECTION OF ARROW

LNER D

LNER E

POOL E

INTERCHANGEABLE WITH ANY ENGINE

POOL GV

INTERCHANGEABLE WITH ANY 3rd CLASS COACH or PASSENGER GUARD'S VAN

LMS E

LNER 1st C

LNER 3rd C

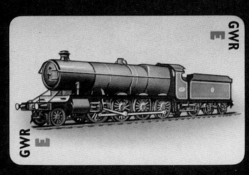

GWR E

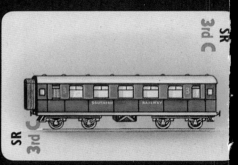

SR 3rd C

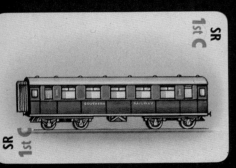

SR 1st C

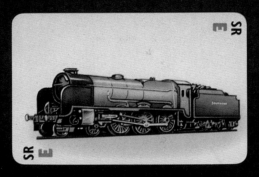

SR E

SR P

← MOVE TO HERE ← MOVE TO HERE MOVE TRAIN IN DIRECTION OF ARROW